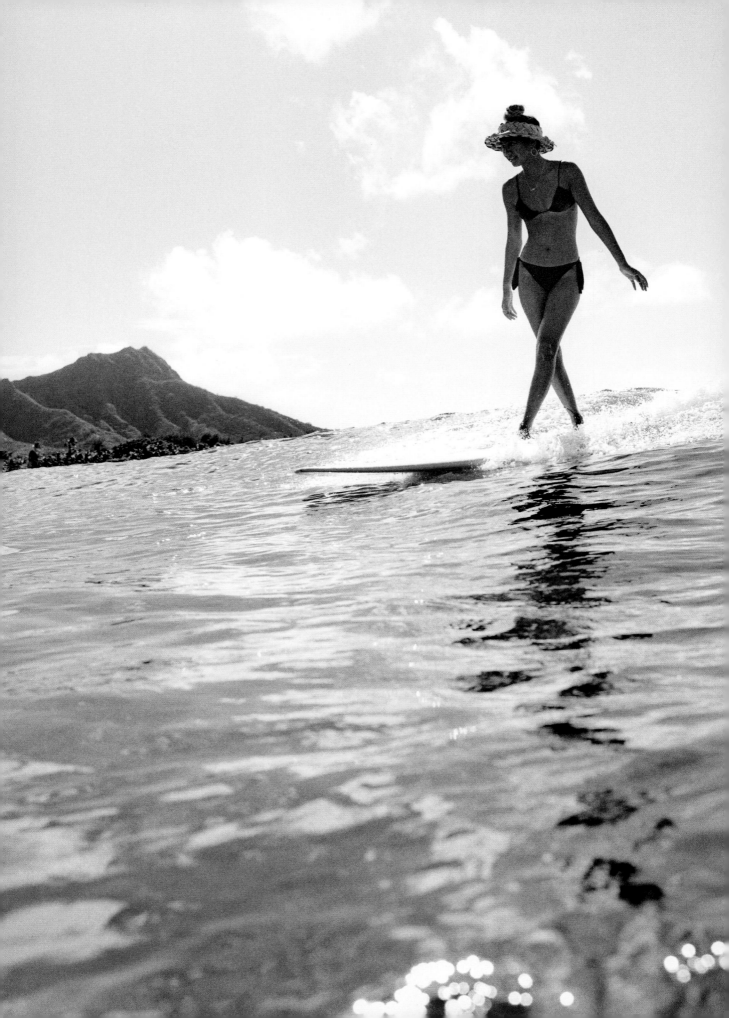

women *making* WAVES

Trailblazing Surfers in and out of the Water

Lara Einzig
WITH JESSICA HUNDLEY

PHOTOGRAPHY
Ana Catarina, Naoko Hara, Evie Johnstone, Ally B. Martin, Anne Menke,
Cait Miers, Camille Robiou du Pont, Nicole Sweet, Cécilia Thibier

TEN SPEED PRESS
California | New York

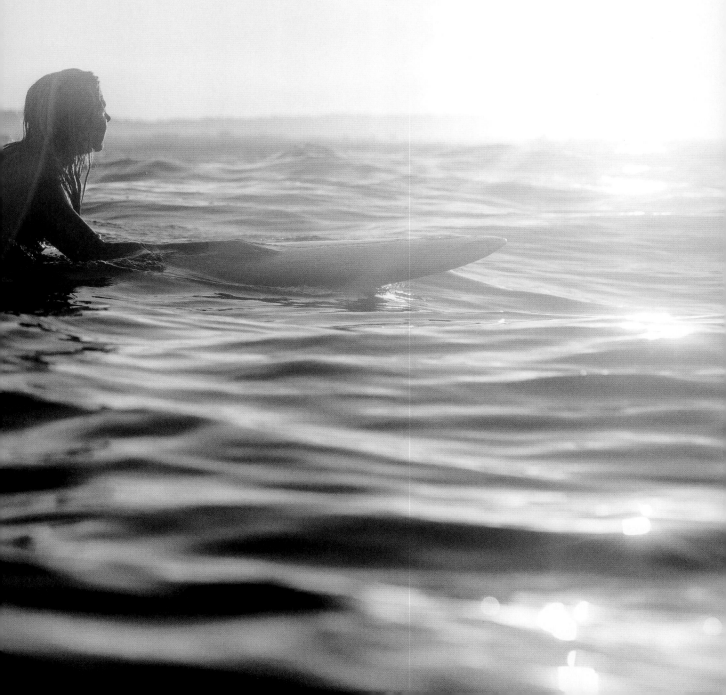

FOR JULIA

Send one for me, Jules.
Just for me.

CONTENTS

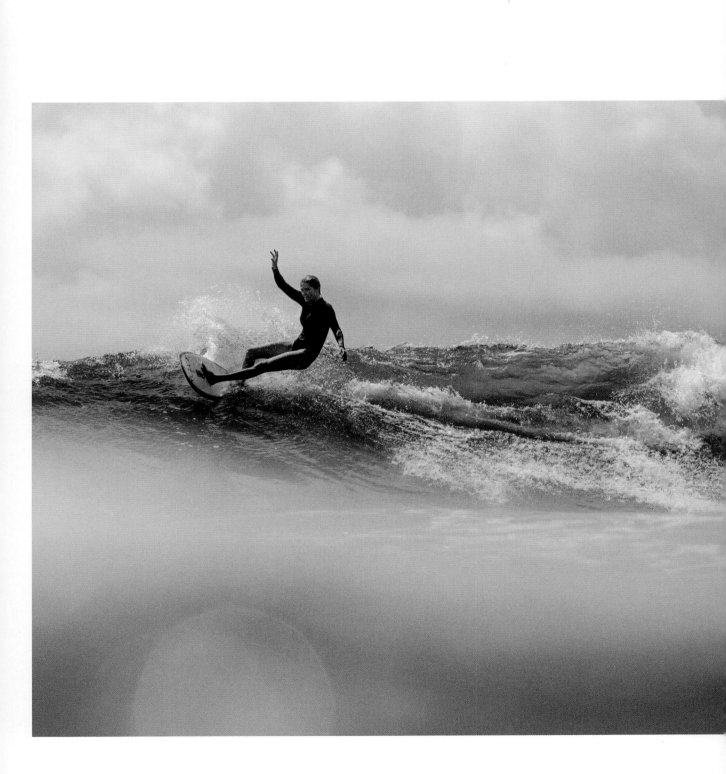

INTRODUCTION

I was born and raised on the East Coast of Australia, where endless summers were spent at the beach with an extended clan of cousins, aunts, uncles, and grand-parents. We were the typical Aussie beach family—a large, rambunctious crew of groms, all salty hair, deep tans, weather-beaten feet that hadn't seen shoes in weeks, zinc-smeared faces in Day-Glo colors, faded togs, frothing for our next adventure in the waves.

We were kids of the "Slip-Slop-Slap" generation, the iconic sun protection ad campaign that was drilled into every Aussie's con-sciousness from a young age—"slip on a shirt, slop on sunscreen, and slap on a hat!" While my male cousins surfed shortboards at a rather perilous and unpredictable beach break at Warana on the Sunshine Coast of Queensland, my sisters and I would happily boogie board and swim alongside them for hours on end. Back then, it seemed like surfing wasn't really for girls. The only surfer girls I ever saw were the pros on TV—Layne Beachley, Wendy Botha, Pam Burridge, Lisa Andersen. And although I was a fully fledged waterbaby having successfully navigated my way through almost every water sport available, I had accepted that surfing was out of reach, not for me—a boy's thing.

It was only many years later, after a twelve-year career in London's fashion scene, that I decided it was time I learned to surf. My career in fashion marketing ran the gamut from wildly creative collaborations with global industry icons to the

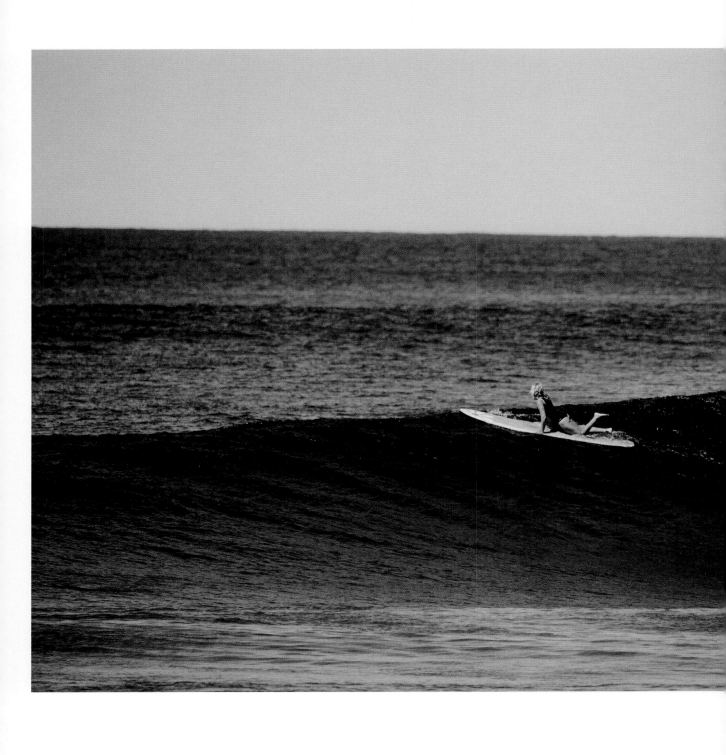

unrelenting hamster wheel of newness and innovation. We had moved our young family to Los Angeles, and initially my need to be in the water was fueled by grief. I had just lost my youngest sister, Julia, to the devastating effects of mental illness back in Australia, and the ocean of sadness, shock, and sense of loss were debilitating. I felt closer to her when I was in or near the ocean, and like many of the women profiled in this book, I knew instinctively that the ocean would heal me.

Some months later, while floating on my board at County Line (a rite-of-passage wave just north of Malibu), I came to a decision that has since steered my life: I would never go back to working for someone else's dream, on someone else's schedule. From this point on, my life—and my career—would be on my terms. Only then was I able to fully understand and truly feel a fundamental connection to the ocean, to nature itself. This was the moment that changed everything.

And so the healing began. I started my own business while caring for my young family, and in the stolen moments in between, I surfed. Lessons in Santa Monica soon turned into solo sessions up and down the Pacific Coast Highway, no matter the weather or conditions. I surfed dawn patrol, after school drop-offs, weekends, whenever I could get my fix, and when I wasn't surfing, I was dreaming about my next wave. I had become a waterwoman, and the obsession ran deep. Drawn to this new Californian community on the water, I dove back into surf culture. I found a home on Bay Street, the epicenter of Dogtown and Z-Boys, and traveled to Hawaii's North Shore. With firsthand experience of these legendary breaks, cult documentaries like *View from a Blue Moon, Andy Irons: Kissed by God, Step into Liquid, Momentum,* and *The Endless Summer* took on a more familiar perspective, and I found unexpected inspiration the deeper I went.

What I didn't find represented, though, were the women. So many of the stories were cast through the male lens, and the exhausted clichés of bikini-clad girls on the beach were ever present. Where were the empowered female surfers I met in the lineup? The generous, supportive, funny, determined women changing out of their wetsuits in the parking lot, getting ready for work after a two-hour session at Rincon? I wanted to know who these women were, to find out their stories, why they surfed. What is this potent draw that collectively captivates and compels our lives to a logistical feat of dawn raids and cumbersome equipment? That empowers us to engage with a competitive, crowded, and sometimes aggressive playing field? That compels us to battle with and submit to Mother Nature in all her unpredictability?

As a female surfer, how do you wrestle with the idea that, although you will often be outnumbered, you not only deserve to be in that lineup but were born for it? Women and water have long been intertwined culturally and symbolically, representing birth, rebirth, transformation, and creation. In ancient communities, water was often considered a feminine realm inhabited by mythological beings illustrating the deep connection between women and water, perhaps echoing the continuous role that women have played in protecting marine life.

Professionally, women surfers have long experienced inequality and misrepresentation, but collectively they are reshaping the landscape. It has taken many years and the determined efforts of countless women, many of whom are profiled in this book, to challenge the status quo. Female surfers are at last being recognized on equal footing with their male counterparts. Men and women now compete for equal prize money in all World Surf League tournaments, and sponsorship opportunities are improving. These sponsorships allow pro women surfers to dedicate themselves more fully to their sport rather than compromising their training and competition with contractually binding bikini photo shoots. Social media has allowed many female surfers to build their own powerhouse brands and set up nonprofits, eco-resorts, surf wear companies—and ultimately change the rules of the game.

Few surf books exist about women, but that doesn't mean women haven't always been in the water. Female surfers have always had a resounding voice and an empathic presence within the surf community. Today their voices are growing louder, and people are hearing them more clearly. And for good reason. The women I met in the lineup and those included in this book share commonalities that transcend surfing: strength, resilience, courage, determination, curiosity, and style. They share an independent spirit and an authenticity that is encapsulated in their attitude. Often nonconforming and offbeat, sometimes irreverent and rule-breaking, and always tough and opinionated—frankly, in the lineup, we are given very little choice in the matter! It's these qualities and alternative perspectives that will not only inspire more women to surf but perhaps help shift the dial on some of the world's most pressing and urgent issues.

This book honors and celebrates the trailblazers and the wave makers. I wanted to explore the existential commonalities among female surfers, to pick apart the traditions of the subculture, using their voices to share memorable, compelling, purposeful

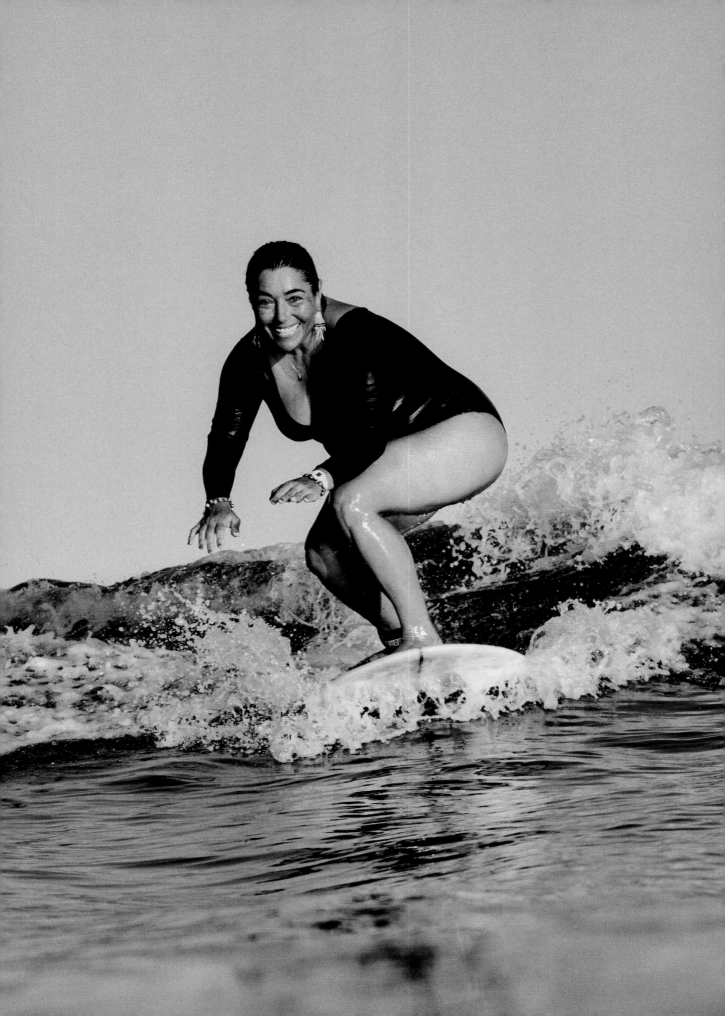

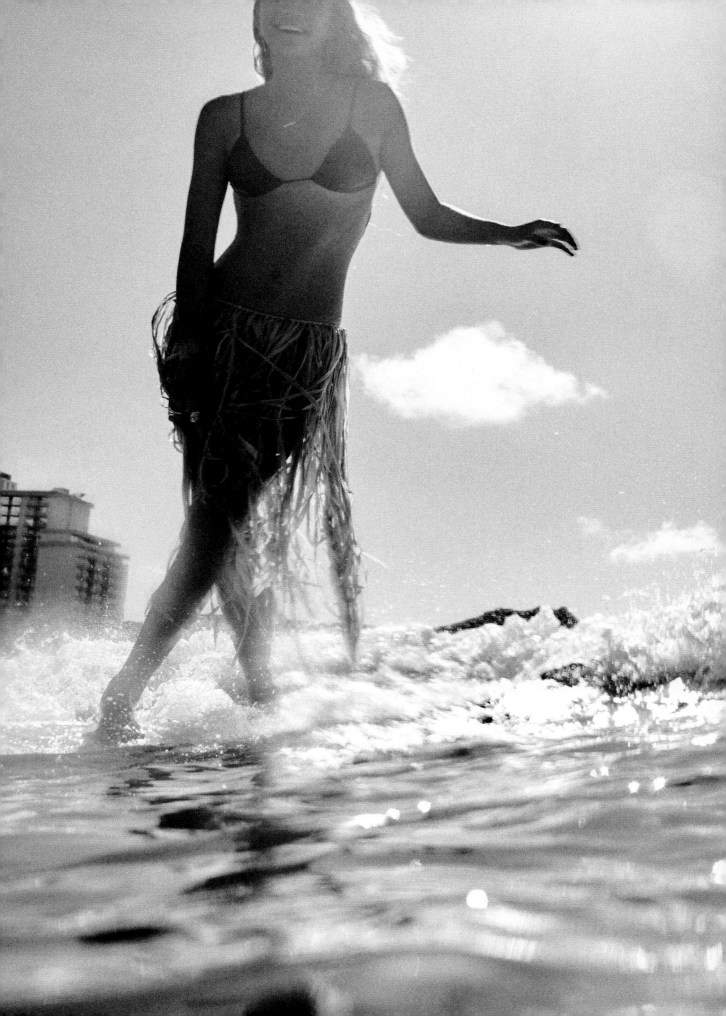

stories and messages. Their words offer up learnings and advice to those pondering their own surf life. Their experiences shred stereotypes and flip paradigms. Ultimately, this book showcases the real women who are redefining surf culture with inspirational stories and inimitable style both in and out of the water.

The women featured here are an eclectic, diverse group from around the world, each with their own intimate relationship to the ocean. They are *real* women: diverse in age, ethnicity, religion, backgrounds, opinions, and surfing abilities. I met with world champions, big-wave record-holders, mothers, adventurers, industry leaders, artists, doctors, and activists. They are riding giants, defying norms, dismantling the establishment, fighting for diversity and equality, and calling out injustices. What connects these women is the sisterhood of surfing. They may take to the water for vastly different reasons, but the practice offers them each the same profound reward. Surfing is simultaneously challenging, calming, healing, and humbling. It both magnifies and microscopically sharpens your focus. It reveals a strength from within that otherwise might remain hidden. And it offers a space for meditation and perspective. Each time you enter the water, you return to the shore—transformed.

Just imagine the forces of change we can inspire and create when we mobilize this dynamic vanguard, acknowledge the definitive truth that the future is female, and understand that surfing is not only a sport—it's a way to change the world.

—*Lara Einzig,* Venice, California

The *The* GROUND-BREAKERS

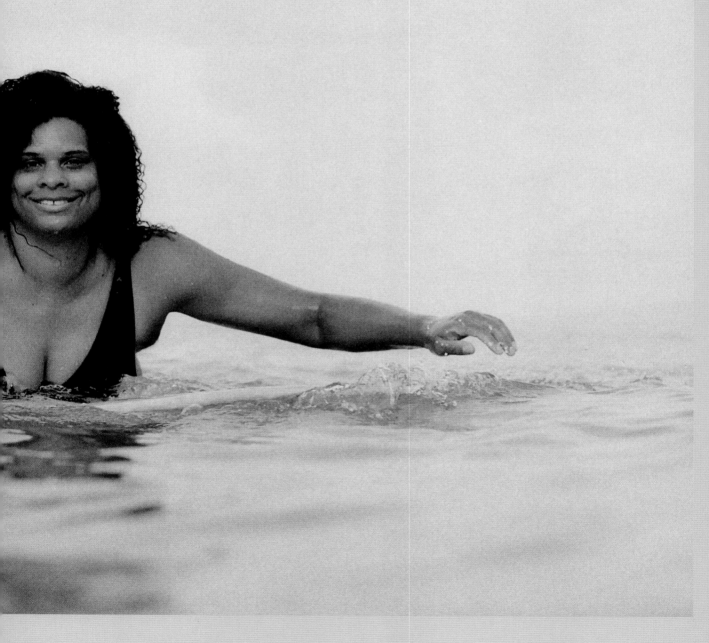

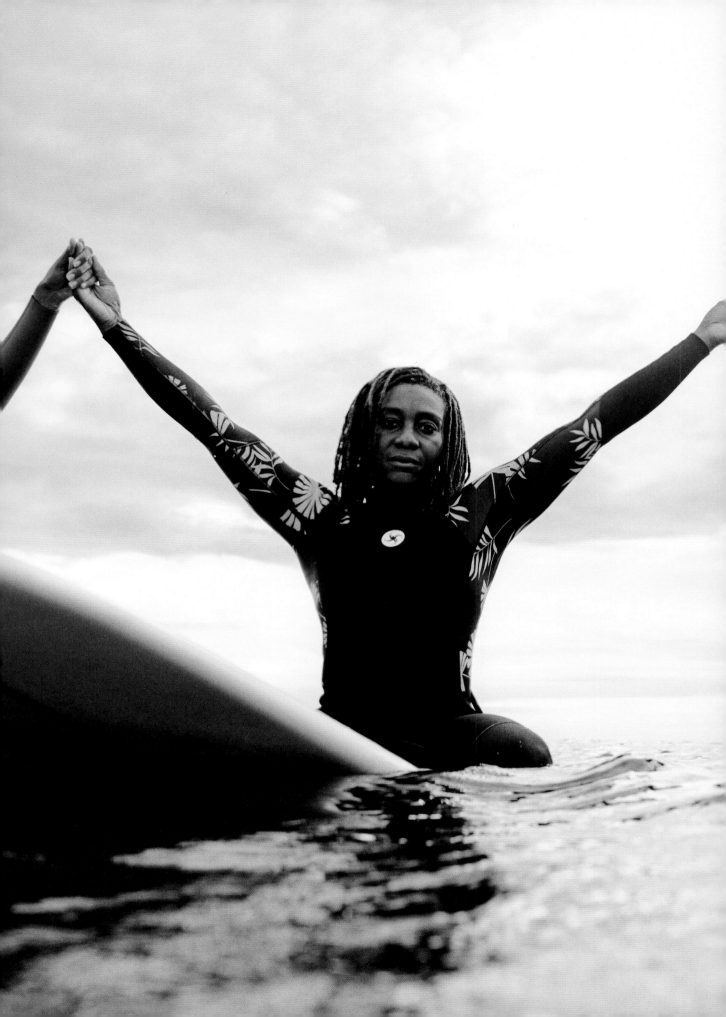

Natalie J. GREENHILL, MD

New York City, United States

O n any given morning at Rockaway Beach, you'll find Dr. Natalie J. Greenhill on her board, surfing the unexpected stretch where the Atlantic breaks on the edge of urban Queens. Until recently, surfing in the heart of New York City was relegated to a few renegades and local diehards, but now the Far Rockaways have become a respite for people like Natalie, who often arrives straight from her overnight shifts as a trauma surgeon, paddling out as the winter sun breaks over the Manhattan skyline.

This postwork surf baptismal was a release from the intense stress of the operating room, where Natalie deals, quite literally, with life and death. "I would come straight home from the hospital, I would drop out of my scrubs, throw on my wetsuit, grab my board, and surf," she says. "The peace that I got from that was amazing. Having that outlet and being able to just be in that space where your mind goes blank. For me it's meditative. It takes your mind away from whatever else is going on. Surfing is one of the few things that can do that." That sense of calm emanates from Natalie herself, a gentleness that

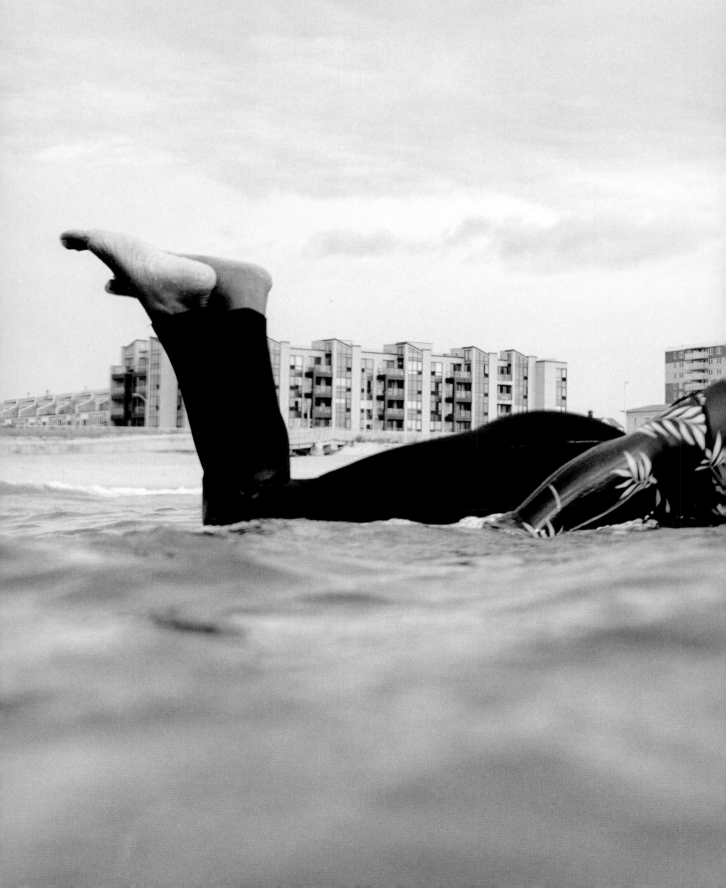

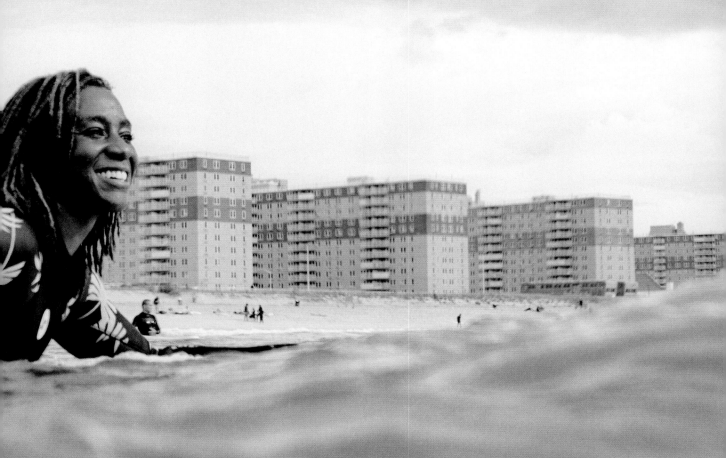

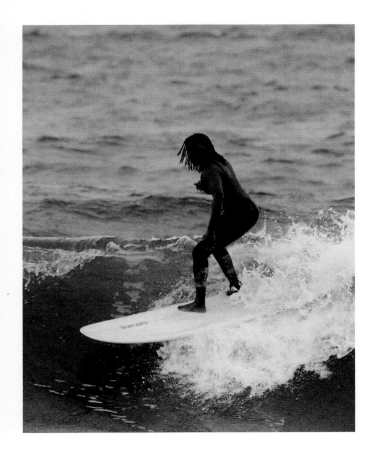

"I want young girls or young boys to be able to see me. I want them to know that I exist so that it can inspire them to become what they want, even if people might tell them it's not possible."

People don't know this about the Rockaways . . .

It has the most amazing sunset views from the bay.

Hardest-won lesson you've learned about being a surgeon . . .

Always trust yourself.

A place you would love to explore . . .

The continent of Africa because it is the birthplace of humankind.

How do we inspire young female leaders?

By example and with humility.

underlies her approach to both work and to life. Surfing has offered her a place of retreat and restoration that has helped her meet the demands of a full and active life.

Raised in Detroit, Michigan, Natalie has spent her medical career working in hospitals around the country. While working as a general surgeon in a trauma unit in New York, a colleague mentioned a local break. "I said, 'Tell me more.' That's when I discovered that, yes, there is surfing in New York. I always thought of surfing as California, Hawaii, or what I randomly saw in movies." Natalie's interest in the sport was suitably piqued, and she set off on vacation to Costa Rica where she learned to surf and became completely enamored. Upon her return to New York, Natalie began to surf regularly at the Rockaways, a daily immersion that helped offset the stress of her profession. "General surgeons are the ones that live at the hospital and sleep at the hospital. And if you're the first Black female surgeon to be hired at a hospital, there is everything that comes along with being the first, 'being a trailblazer,'" she says. "There are a lot of extra stresses that you have to contend with that other people don't. I always felt the moment that I walked out of the house and walked into the door, it was like, I'm going to battle. That constant surge of going into battle every single day, it can be exhausting."

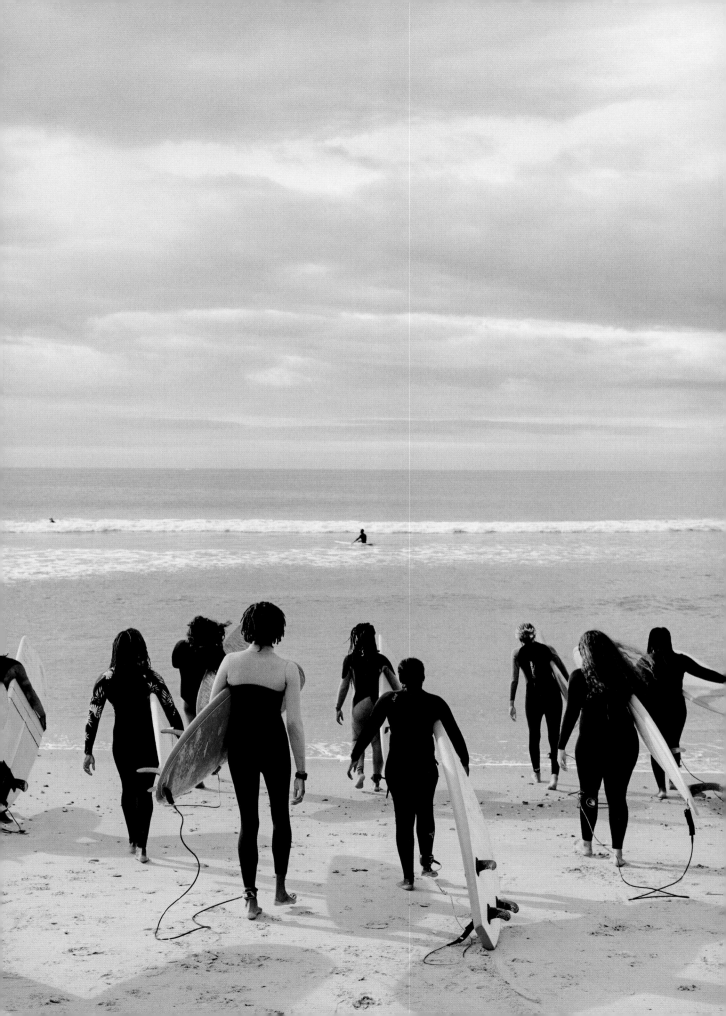

In part because of this exhaustion, Natalie felt she needed a reset. "I decided to take a surfing sabbatical and so I returned to Costa Rica," she says, "And I surfed my brains out. It was wonderful and it was healing." On her return to New York and back in the waves at Rockaway, Natalie again found that same sense of healing, in part in the water and in part through her tightly knit community of fellow surfers. "Surfing opened up new and deeply meaningful friendships," she explains of the relationships she developed in the water. "I never knew I'd meet so many new friends as an adult. We really bonded and connected around this thing that we're all equally obsessed over." She even met her husband in the water.

Realizing that her surf sessions at Rockaway (and beyond) had profoundly transformed her life, Natalie decided she needed to give back—to both the place and the practice. "Surfing is very therapeutic for me. It's my go to place for joy." Looking to share that feeling, she started by volunteering with Laru Beya Collective, an organization that mentors local neighborhood kids, raising funds for their wetsuits and boards and taking them out into the swell to learn the basics. "I see their happiness, I see their excitement and how quickly they just become really, really good," she says.

Natalie's hope for the collective is that it helps "narrow that gap and allow more kids to have the opportunity to learn how to surf and have that connectedness with water and the ocean and nature." Laru Beya now has a partnership with Patagonia and is part of a group of nonprofits fighting for passage of a statewide water safety bill in New York. If passed, it would make water safety education mandatory in grades K–12. "And hopefully, all children, regardless of their socioeconomic background, will learn how to swim, learn how to be safe around bodies of water," she says. "It will help to decrease that gap that we see in swimming proficiency based on where you're from or how you grew up. Unfortunately, the people who drown in Rockaway are primarily Black and Latino youth who have a higher likelihood of not having had the opportunity to learn how to swim."

Natalie is also on the board at the Surfrider Foundation, working on the brilliantly named JEDI Committee (justice, equity, diversity, and inclusion). "I'm involved in helping create protocols to help the organization become more inclusive and more diverse and to help introduce environmental activism to *all* people and not just to your idea of what a surfer is," she says. She admits that she herself may not fit most people's idea of a surfer, but for Natalie, defying these expectations has become second nature. "I remember being a little Black girl growing up in the '80s," she says. "I wanted to skateboard. I didn't see any other people like me who did it. No other girls did. And I was like, 'I don't care. I want to do it.' What does it mean to do what's expected of you? I never really gave validation to that, for better or worse. And doing that may have been a harder road, but I couldn't imagine not following what my heart wanted. When I set my mind to something, I know that I'm going to accomplish it."

And so she has. Not only in her medical career but in the water, on the waves, and in her role as mentor to the kind of young people who want to follow their heart, despite what the world might tell them. "I want young girls or young boys to be able to see me," she says. "I want them to know that I exist so that it can inspire them to become what they want, even if people might tell them it's not possible."

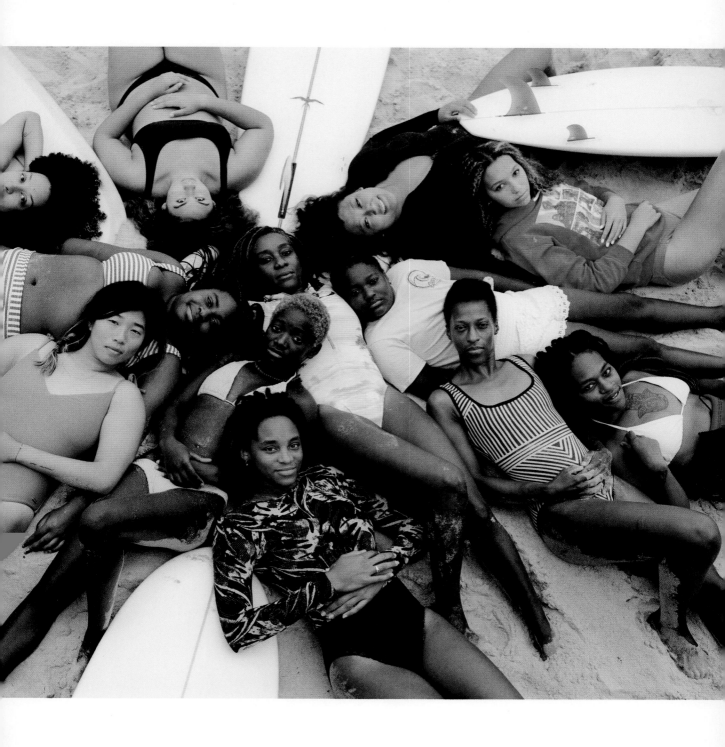

"What does it mean to do what's expected of you? I never really gave validation to that, for better or worse. And doing that may have been a harder road, but I couldn't imagine not following what my heart wanted. When I set my mind to something, I know that I'm going to accomplish it."

Joyce
HOFFMAN

San Juan Capistrano, United States

Fearlessness, focus, and determination are what define Joyce Hoffman. Over the past seven decades, she's revolutionized the surf world with a series of remarkable firsts. She was the first woman to win three back-to-back US Surf Championships from 1965 to 1967 (and she picked up a fourth in 1971). She was the first woman surfer to conquer the massive wave at Banzai Pipeline at Oahu's North Shore. She was the first woman to receive sponsorship endorsements (Triumph famously shipped the Spitfire sports car to Joyce's global competition locations, so she was always pictured driving the vehicle everywhere she went). She was one of the very first inductees into the International Surfing Hall of Fame. She was the first woman with a signature surfboard bearing her name—the Joyce Hoffman Hobie, a sturdy nine-footer tailor-made for nose-riding that she created in collaboration with iconic shaper Terry Martin. She was the first female ocean lifeguard in California and quite possibly in America. Oh, and she's also been a motocross

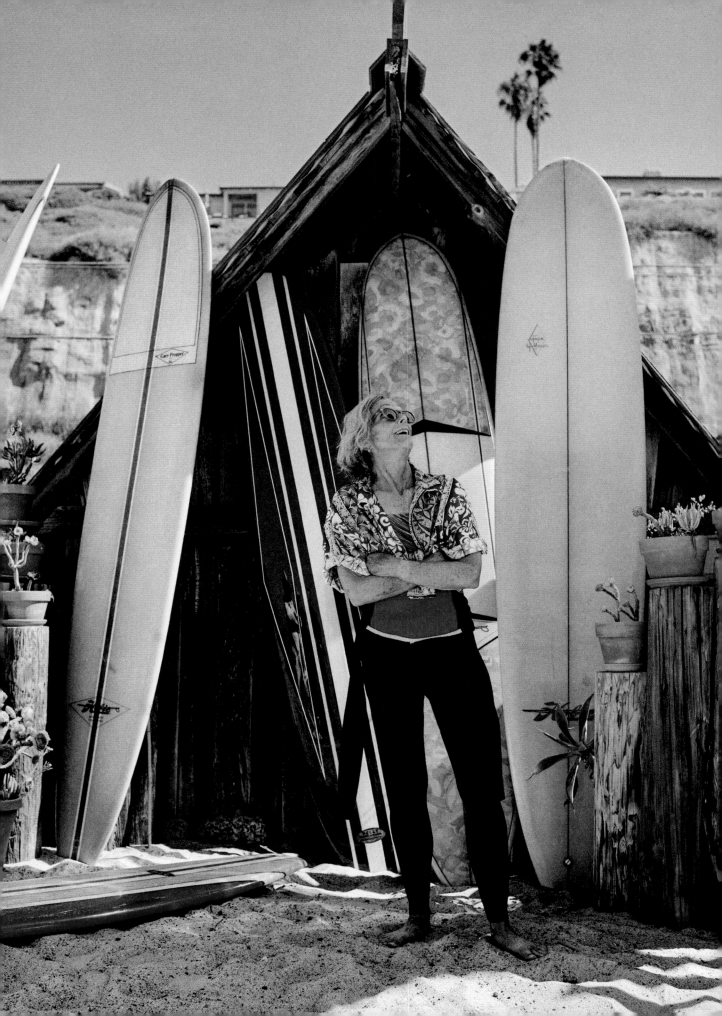

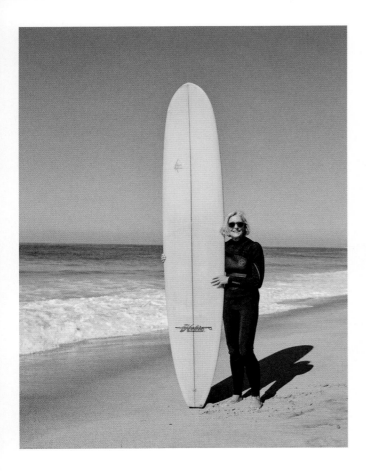

champion and a competition race car driver, and she's faced Great White sharks. Ask her if she is scared of anything and she answers, "Scared of what?"

Joyce came of age in an extraordinary place and time, a moment that now can only exist in our shared imaginations. Her childhood was spent cradled in a nostalgic, idealistic vision of 1950s California. She grew up on the southern coast, among the idyllic stretches of Doheny and San Onofre State Park, locales that shaped the legacy of American surf culture. Joyce got in the water every day, just steps away from her parents' beach house at Poche, in San Juan Capistrano. It's one in a string of charmingly ramshackle surf shacks mixed with modern compounds clustered along a respectable beach break. These were the nascent days of the "surfin' safari" era to come, of ragtag innocence, water-weathered boards stacked in the back of the Woody wagon, an endless summer of white-tipped waves and postcard sunsets.

Joyce spent days in the swell, exploring tidepools, diving for lobster, nights lit by beachside bonfires. "Orange County was a magical place back then," she says. "It was not crowded. The harbor hadn't been built at Dana Point and Doheny. I remember my dad surfing outside on the big swells." At San Onofre, water-weary kids dozed under thatched-palm shade structures, and tiki torches flickered against Day-Glo sunsets. It was a world Joyce's family played a large part in creating, from the sandy ground up. "It was certainly

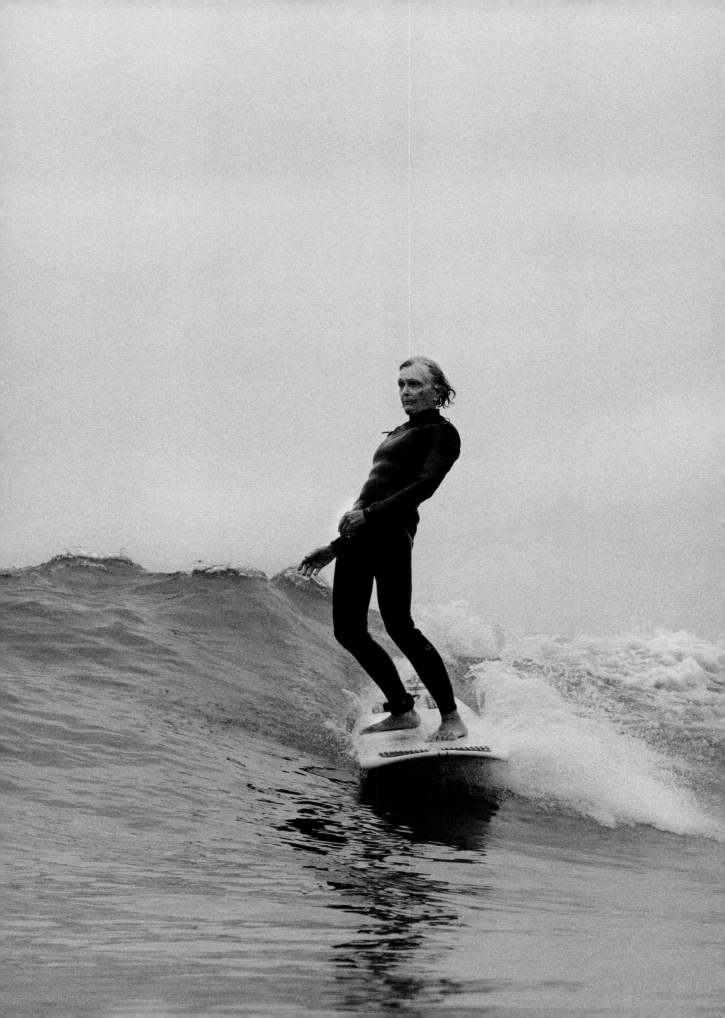

a much simpler time," she says. "Going down to San Onofre and spending the day with just a small handful of people, all who knew one another. Everybody would look out for everybody else's kids and tell your mom if you were misbehaving. We spent endless days in the sun and the surf, hanging out."

It was on these hometown waves that Joyce first began to surf competitively at age twelve. "I remember my first contest," she says. "It was at Doheny, and I was in the tandem competition with my dad. That was the first and last time I ever did tandem surfing with my dad, because I couldn't stand him deciding which way we were going, and me not having control over it." It wasn't long before Joyce was competing solo, traveling up and down the West Coast for contests. That need for control and a fierce and unrelenting focus quickly pushed her to the top of the sport. "If it hadn't been surfing, it would have been some other sport," she says. "I wanted to compete. And I was really driven. I worked out, I cross-trained when nobody did that. I practiced hours and hours every day. In those days, nobody was taking competition seriously in surfing because it wasn't like you were famous or made a lot of money. I think that's why I was able to be so successful—because I took it seriously. I trained more than anybody, I practiced more than anybody. If I just had a little bit of talent, I was calling it a win."

Those wins were plentiful, a long series of successes culminating in victories at the World Championships and the International Women's Surfing Championships. "I wanted to be the best I could be," she says. "And nothing was going to stand in my way." This approach has served Joyce well throughout her life, but her own

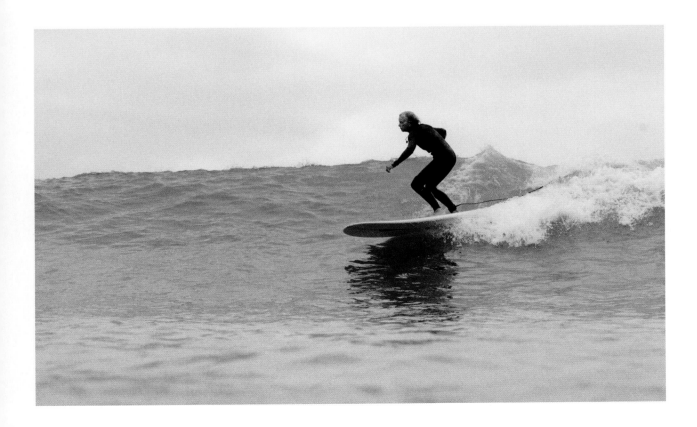

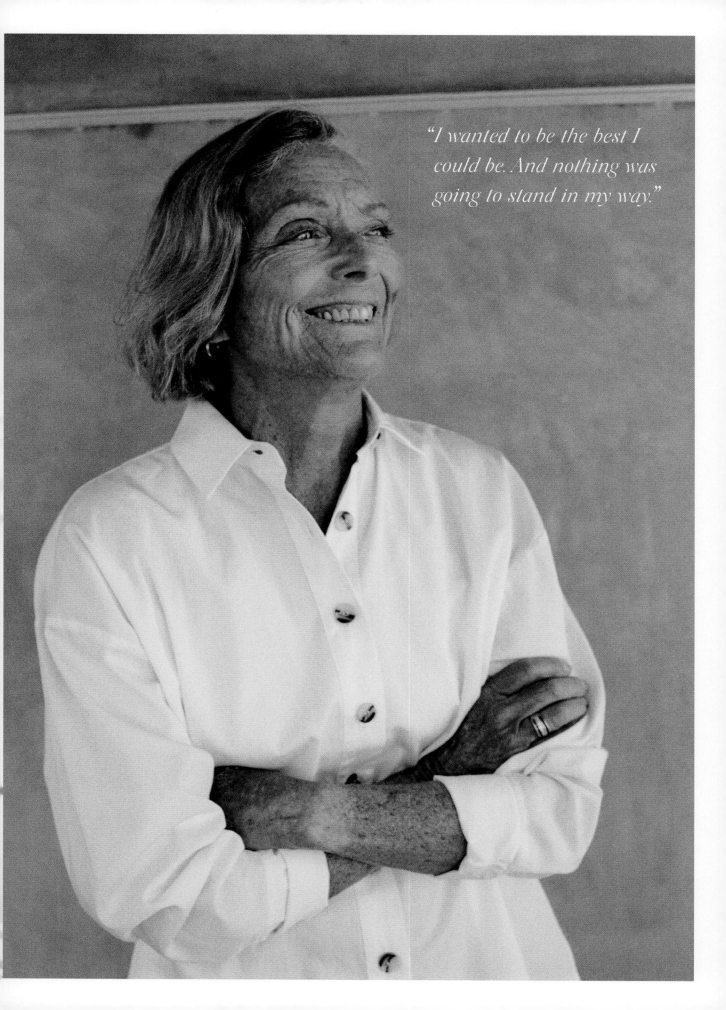

"I wanted to be the best I could be. And nothing was going to stand in my way."

grit-tooth determination and defiant independence were only part of what fueled her commitment to surfing and later to racing; her family also played a significant part. Both surfing and racing were sports she was drawn to after early encouragement from her stepfather, Walter Hoffman, who Joyce considered her true father.

Walter was a groundbreaker in his own right; he and his brother "Flippy" gained renown in the surf world as early pioneers of big-wave Hawaii. "I wouldn't have picked surfing if it wasn't for Walter coming into our life," Joyce says. "His own history with surfing, that's what set me on that trail. And he never told me I couldn't do any of those things because I was a girl." Joyce's grandparents were also very influential in surf culture. The founders of Hoffman California Fabrics (still run by the family today), they created distinctive textiles (think tropical Hawaiian and batik) for surf brands from Quiksilver to Billabong. Joyce's brother-in-law is renowned surfer Herbie Fletcher; her nephews are Nathan and Christian, third-generation pros.

Joyce has continued to live a life without compromise, inhibition, or apology. In the process, she's become a role model, mentor, and inspiration for countless surfers, both male and female. "I wanted to project a positive image for surfing, not just for myself but for the sport," she says. "I was very grateful for all that surfing gave me, and I wanted to be sure that I gave back as much as I could. I'm hoping that that made me a better person." Here, Joyce laughs, then says, "It made me what I am, whatever that is."

This matter-of-fact humility has marked her since the beginning. She is also the type of person who does not suffer fools and whose feet, when not on her board, are planted firmly on the ground. Talk to her about the challenges in her life, and she shrugs them off with a wry joke. Of the trials she faced as a woman in a man's world, she says, "Once the men saw that I could surf, they were always supportive. And I was inspired by them. They were the ones that I was always trying to emulate. I wanted to have big turns and ride the nose and big cutbacks. I loved the way they surfed."

Adversity, for Joyce, is something to be faced head-on, with a touch of dry humor. Of her run-in with a shark, for instance, she scoffs, "That was nothing. It wasn't even that big, maybe eight feet. Geez." She stopped racing cars only when she hit a wall going two hundred miles an hour. "I walked away without a scratch and figured that kind of luck probably wouldn't happen again." On her success in the sport of surfing, she often credits her family's support over her own innate skill. Even when discussing her now legendary status in the surf world, Joyce remains coolly self-effacing. Asked about the statue of her recently built at Dana Point's storied Waterman's Plaza, she deadpans, "I'm just worried about who's going to make sure that they keep the seagull shit off my head."

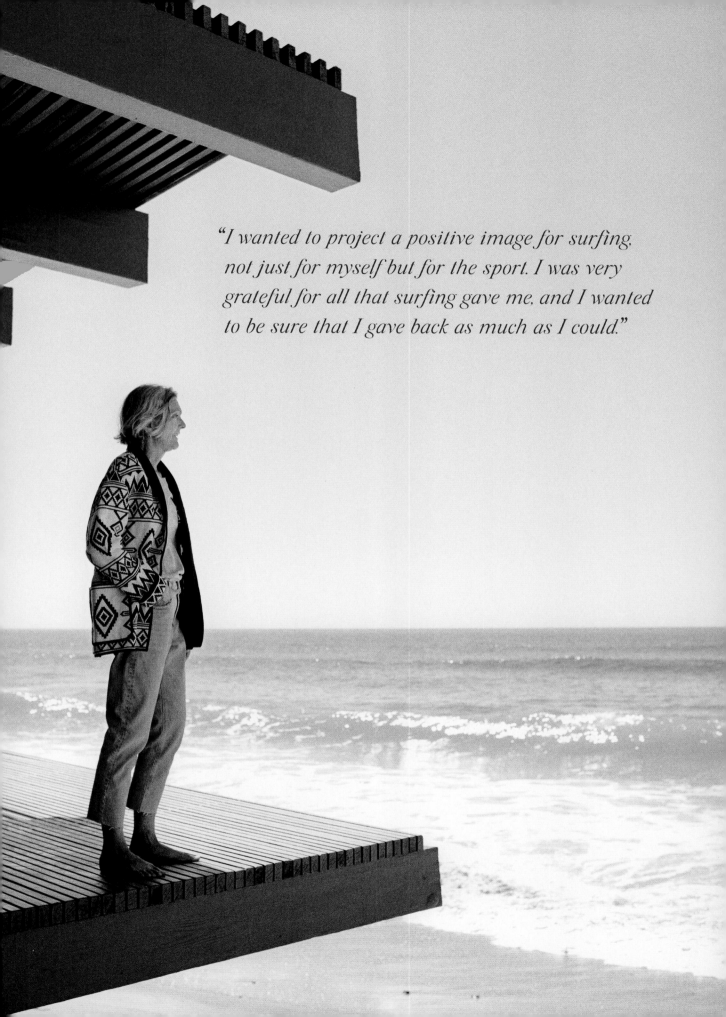

"I wanted to project a positive image for surfing, not just for myself but for the sport. I was very grateful for all that surfing gave me, and I wanted to be sure that I gave back as much as I could."

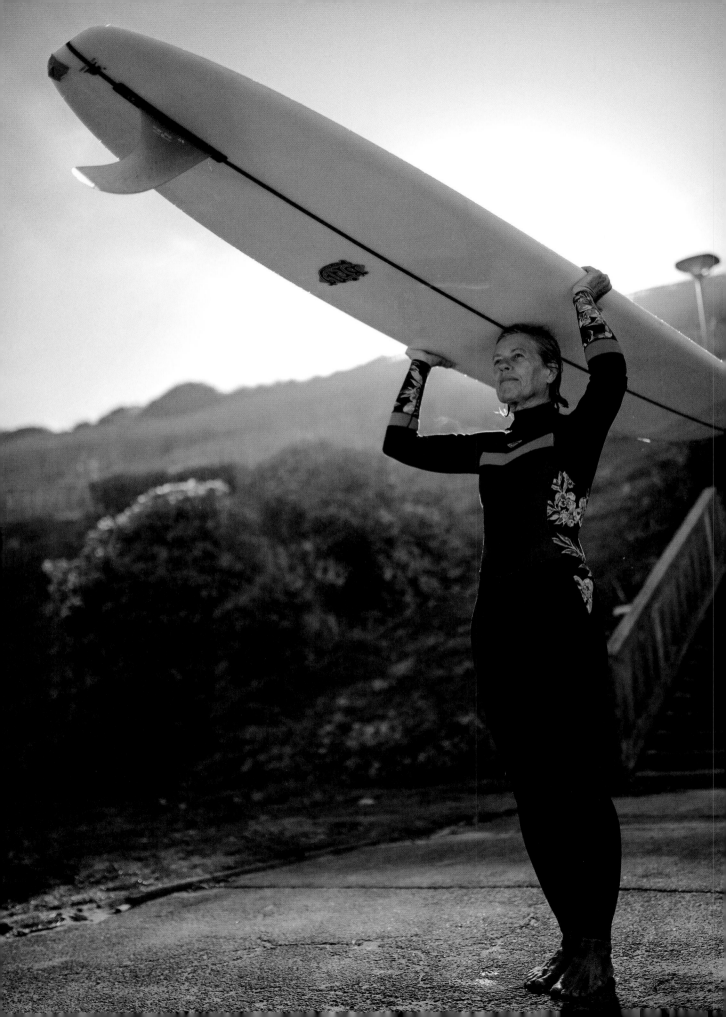

Maritxu
DARRIGRAND

Biarritz, France

Maritxu Darrigrand is a French surf champion, iconic surf wear innovator, dedicated enthusiast and promoter of surf culture, and hands-down one of the most important voices in pioneering and popularizing women's surfing in Europe. From her youth, bathing in the waters off the west coast of Africa, to her current cold-water ocean swims in Biarritz, France, the personal narrative of this inspirational *grande dame de surf* runs parallel to the evolution of surfing itself. "I have a long story because I'm seventy years old, so it's quite a big story," she says, with a laugh.

Maritxu was raised in Cameroon, but when she was sixteen, her family moved back to the Basque country of France, along a coast renowned for its yearlong swell. "I'm pretty much a girl who lived a childhood in the sun," she says. "That's why I got the love of water. I learned to swim very young, and I was not afraid of waves so I was pretty fearless with the ocean." When she first arrived in France as a teen, the beaches of Biarritz were undergoing a transformation.

"Because of my love of the ocean, I became aware of the environment. We had this quote: 'We don't destroy what you came to enjoy.'"

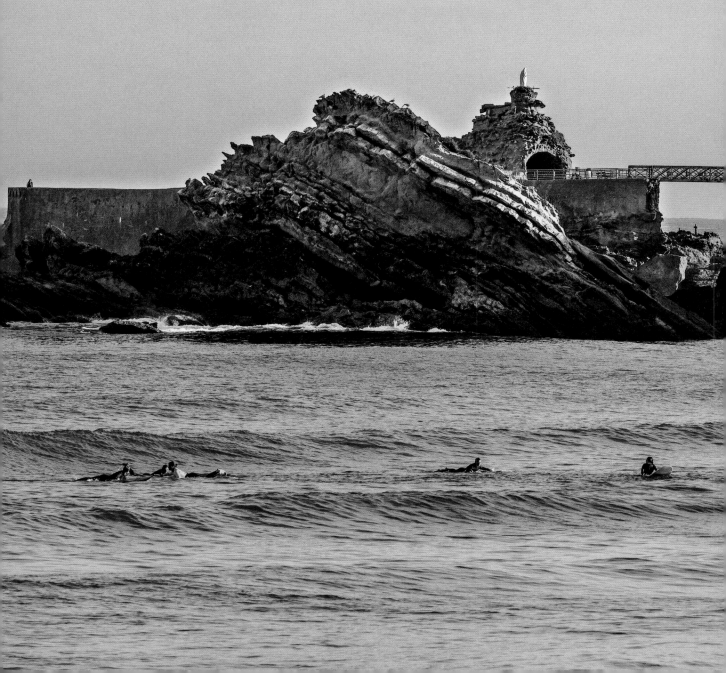

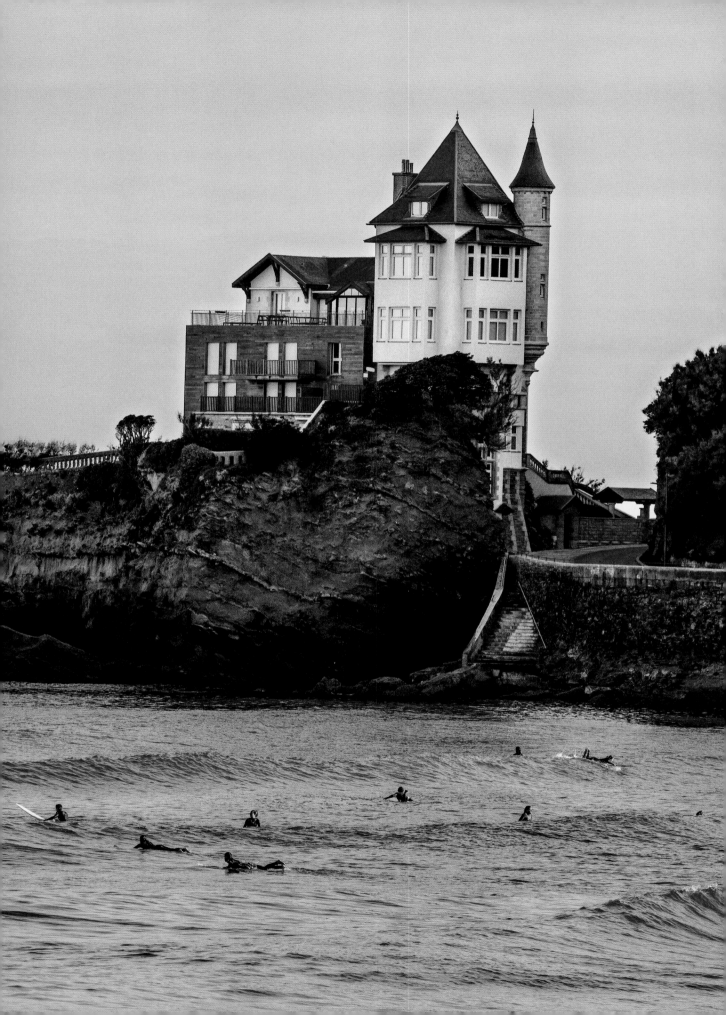

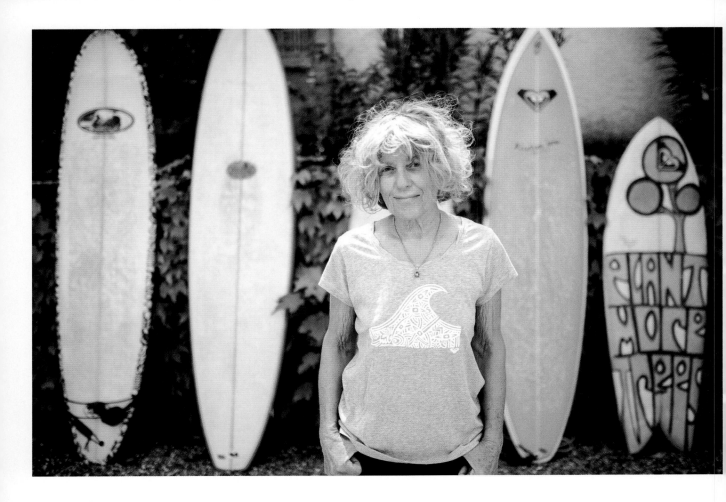

Once a rarified resort favored by European royalty, the 1960s saw the town evolving rapidly into an artist enclave and premiere surf destination.

"It was becoming the mecca of surfing in Europe," Maritxu says. "So there were all these beautiful surfers, a new lifestyle, all of this was coming to Biarritz. It was really very unique in Europe; it didn't happen anywhere else." Surfers and creatives from around the globe were visiting the coastal town, bringing with them the pulsing energy of the era's counterculture. The casual transience and liberated spirit of the community were particularly thrilling to Maritxu. "That whole scene was really attractive to me because it also meant traveling," she says. "And I had been traveling since I was born."

When she was offered the chance to explore the islands of the Pacific, Maritxu abandoned plans for university and made her escape. "I spent a few years in Hawaii in the 1970s, where it was pretty wild," she says. "And then in California, where I spent my time crewing on sailboats. I was there illegally. I didn't have a Green Card, but I still managed to crew a sailing race called the Transpacifique that goes from California to Tahiti and back again. That was in '74." Maritxu mentions these adventures lightly, as if they are nothing out of the ordinary. Romantic, daring, and cheerfully self-reliant, she is truly a woman of the world, seemingly

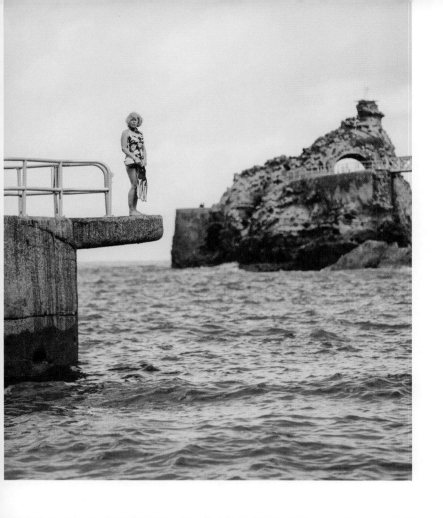

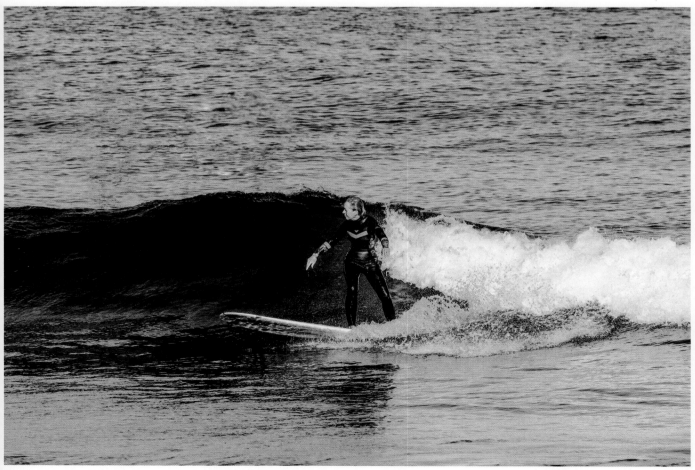

everywhere. It was in this spirit that Maritxu found herself on the island of Mauritius a few years later with a motley assortment of surfers. "They told me, 'You should start surfing,'" she says. One of the crew happened to be legendary American surfer Joey Cabell. "He had such a beautiful style. A beautiful man. He was the one who really pushed me into the waves. And that's when I really started surfing."

Just a year or so later, in 1978, at age twenty-seven, Maritxu decided to enter the French surf championships. And won. "Since then I was just completely crazy about surfing. I had to go surfing every day. I was the first one in the water," she says. Returning back home to Biarritz, Maritxu surfed by day, and at night she ran a small cinema, The Pax, where she and her friends would screen surf films. As the screening events grew in popularity, they created an ongoing surf film festival called Nuit de la Glisse. "It was a big movie show," she says. "We screened all over France and then after, all over Europe. It became very famous."

While searching for new surf films in California in 1979, Maritxu met Alan Green and John Law, the founders of Quiksilver. That meeting would prove pivotal. Maritxu became an early brand ambassador for the company, and in 1982 she brought the Quiksilver and Rip Curl brands back to Europe, as well as the iconic Lightning Bolt surfboards of the '70s. "That's how a new adventure began," she says. "We started importing their products. It was the beginning of a lifestyle and a new industry around surfing, which became so popular. I had no idea this was going to be that big! It all started in my house, an ancient farmhouse."

Maritxu eventually became head of marketing for Quiksilver in Europe, working alongside her sister, who headed up production. At the time, the brand catered exclusively to men, she says, "But we were always pushing to do some products for girls. We both could feel it was the beginning of a movement for girls to surf and snowboard like the boys." Maritxu's push for creating women's surf wear and snow gear would lead to the creation of the Roxy brand. "It was the right time," she says. "And it was just a perfect thing to do for me, because it reflected everything I was about. To be at the start of a new thing. That was perfect."

"Surfing taught me respect, determination. It gave me strength. And it gave me faith."

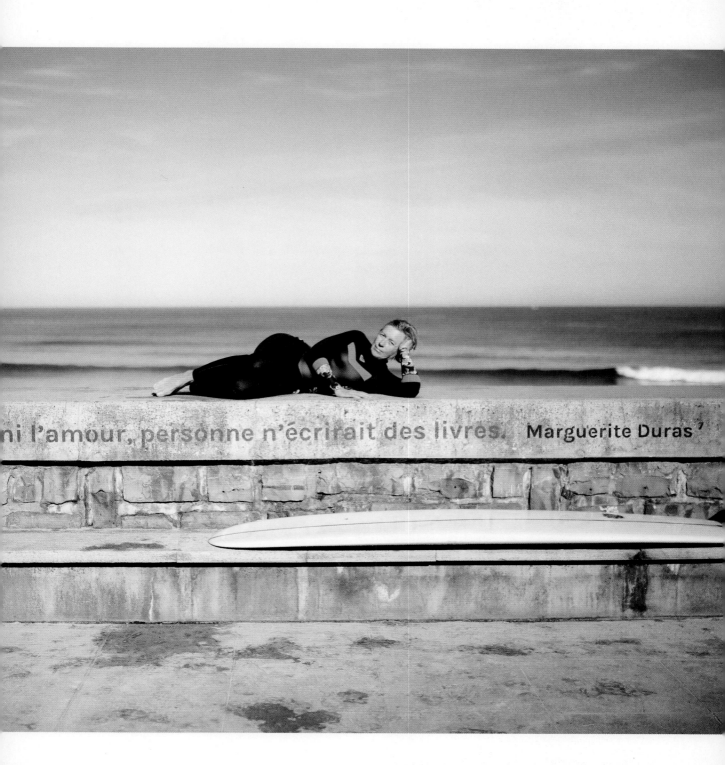

"If not for the ocean and for love, nobody would write books."
—Marguerite Duras

Maritxu, ever the curator and connector, decided that this new venture needed immersive events, specifically events for board-riding women. "I think I was the first one to create a stand-alone snowboarding event for girls," she says. "It was called the Chicken Jam." This was soon followed by the now famous female-focused Roxy Jam. "It was a great gathering of women surfers, snowboarders, windsurfers, skateboarders, and artists." Curating music and art, Maritxu held the first Roxy Jam in Biarritz in 2000, bringing together women from around the world. "I wanted women to be able to share things, to have fun together," she says. "It was much more than a surf contest. We had a surf-focused art exhibition and great bands playing on the beach."

All the funds generated by the art sold during the Jam festival were directed to Keep A Breast, a foundation Maritxu discovered in California. The foundation is dedicated to breast cancer awareness and prevention. It is a cause that is of immense importance to Maritxu, inspired largely by the death of one of her mentors and idols, the iconic Hawaiian surfer Rell Sunn. "I was lucky enough to stay with her in Makaha and really live the life of a waterwoman in Hawaii," she says. "She's the Queen of Makaha, the aunty of all the local kids, and of course she was super inspiring for me." A much beloved world surf champion, Sunn fought breast cancer for fifteen years and was on her surfboard throughout treatment and remission. "I never thought she could get sick," Maritxu says. "She was the first one that I knew closely who got breast cancer and died from it. She's always on my mind."

Through art shows, concerts, and other experiential outreach, Maritxu strives to encourage self-care and education, particularly for young women. "I'm passionate about prevention and helping young people to stay healthy," she says. In addition to her work with Keep A Breast, Maritxu has long been active in ocean conservation. During her time at Quiksilver, she established an environmental fund. "Because of my love of the ocean, I became aware of the environment. We had this quote: 'We don't destroy what you came to enjoy.'" Maritxu has sailed across the Pacific and around Antarctica, surfed breaks the world over, and continues to spend most of her time in the sea. "Surfing taught me respect, determination," she says. "It gave me strength. And it gave me faith."

Favorite places in the world to surf . . .

Fiji around Tavarua and Namotu Island when the water is pristine and so alive. Tiger Tail at G Land, and Morocco near Mirleft.

A quote to live by . . .

I want to live close to nature, see what it has to teach me, rather than realize at the time of my death that I did not live. —Inspired by Henry David Thoreau

Biggest challenge you've faced as a woman in your career . . .

Staying focused on what I thought was right and fighting for it.

Name a must-do for visitors to Biarritz.

Visit the marketplace in the center. Go to the lighthouse built in 1853— best view of Biarritz and out to Spain and Hossegor. Have a drink in Hotel du Palais, the former residence of Empress Eugenie and Napoleon III. See a basque ball game of cesta punta at the Jai Alai.

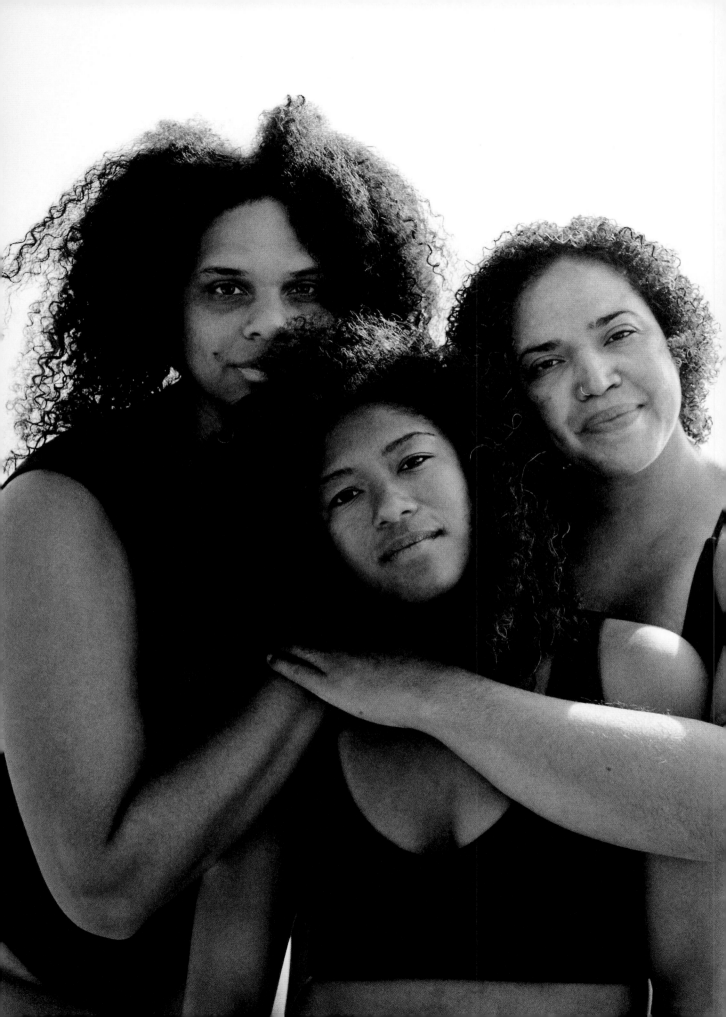

Textured
WAVES

Honolulu, Santa Cruz, San Diego, United States

I t is June 3, 2020, another cloudless afternoon in Encinitas, a small surfing enclave just north of San Diego. The sun is lowering into the Pacific as a crowd begins to gather on Moonlight State Beach. This stretch of sand usually attracts families with young kids, toys and coolers in tow; but today a different group gathers along the strand, waving hand-painted protest signs and clutching surfboards emblazoned with spray-painted slogans calling for racial justice. All across America, communities are reeling in the wake of George Floyd's horrific murder at the hands of a white police officer. In this beach town, the surf community has come together for the "Paddle Out for Unity," an event organized in part by a group of African American women known collectively as Textured Waves.

The three founders of Textured Waves live in the western United States, from California to Hawaii. Instagram brought together Chelsea Woody, Danielle Black Lyons, and Martina Duran, who saw in each other what they had rarely seen before—a woman of color with a profound love of water and riding waves. The revelation drew

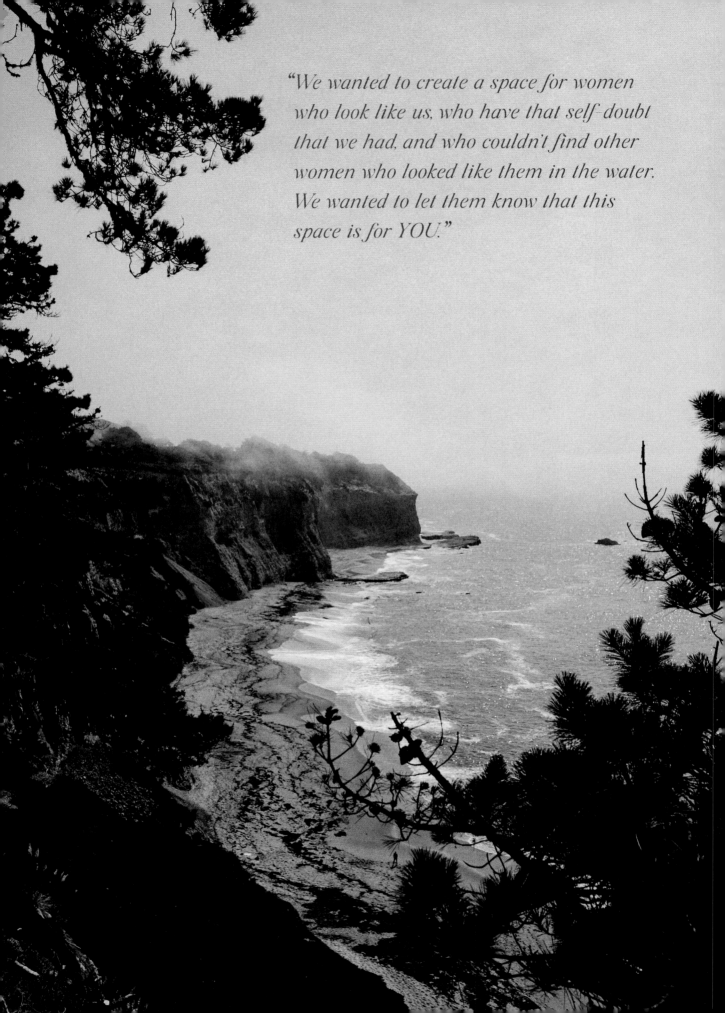

"*We wanted to create a space for women who look like us, who have that self-doubt that we had, and who couldn't find other women who looked like them in the water. We wanted to let them know that this space is for YOU.*"

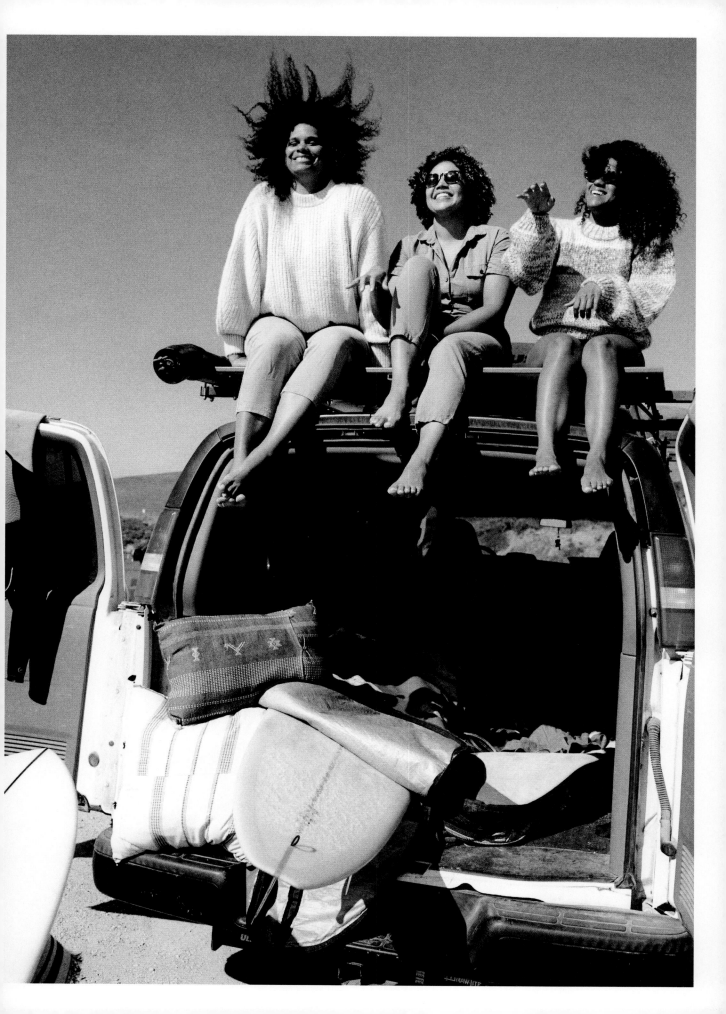

them together and inspired their mission. "We created Textured Waves so that we would have a community that was for women of all shades," says Danielle, a San Diego–based broadcaster. "We wanted to create a space for women who look like us, who have that self-doubt that we had, and who couldn't find other women who looked like them in the water. We wanted to let them know that this space is for YOU."

This desire was born of the struggles that the African American community has faced for centuries. The fight to overcome social barriers that stem from a deep and systemic racism as old as America itself continues today, long after the removal of legal barriers that prevented African Americans from accessing the ocean. These social obstacles are complex and far-reaching, from the blatantly ignorant (Danielle recalls being told she couldn't surf because "Black people don't float") to the patently absurd (discriminatory loopholes that allowed employers to discriminate against African American women who chose to wear their hair in a natural style). It was only in *2019* that the Crown Act was passed in California to put a legal end to this historical prejudice.

"Throughout history, laws and standards of beauty around our hair have kept African American women out of aquatic spaces," says Chelsea. "The Crown Act is important as we've often been

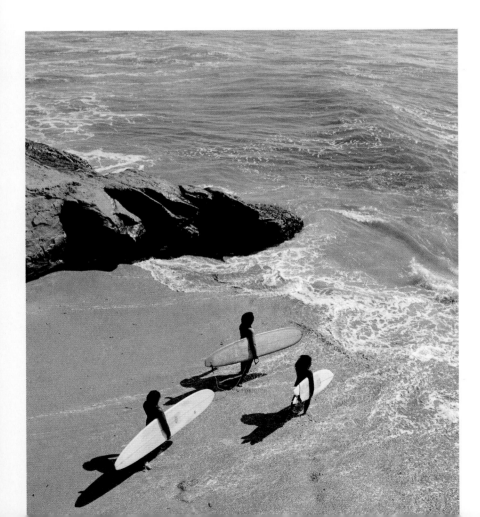

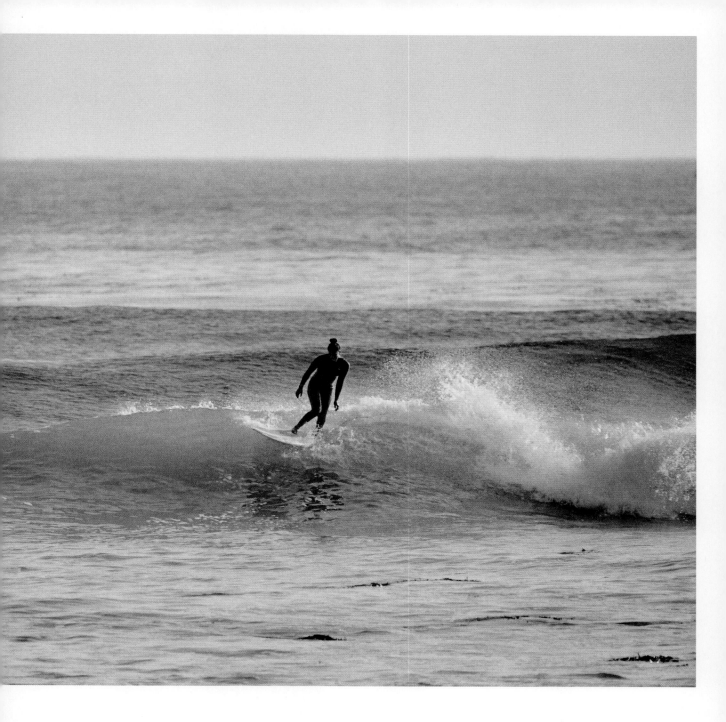

discriminated against in workplaces, schools, and in public for our hair. But our freedom of self-expression through our hair is where Black women find their strength." There is also profound intergenerational trauma regarding the ocean and what is known as the Middle Passage. "Many of our ancestors died coming over on boats through the slave trade in the US," says Danielle. "There are ancestral elements of trauma involved that will take generations to repair."

The three women found surfing at different points in their lives. Chelsea first surfed in 2014 on a trip to Indonesia with her husband. Martina grew up surfing in Florida, but it was during a trip to Costa Rica that "the rush first took me." For Danielle, who

Danielle Black Lyons

Chelsea Woody

Your surf kit . . .

We all carry conditioning products for our hair, surf wax, reef-safe sunscreen, lip balm, and a bottle of water—got to stay hydrated.

Most important challenge facing women today . . .

"Autonomy over our bodies, whether it is in healthcare, the workplace, or how we are treated in athletic realms."—Chelsea

Your secret skills . . .

"I'm pretty handy and I love power tools. My husband usually buys me tools for Mother's Day gifts. I built my son a clubhouse when he was small, and I also built our kitchen table from reclaimed barn wood."—Danielle

A quote to live by . . .

"Love yourself enough to know that another woman's accomplishments are not your failures."—Martina

Martina Duran

calls herself "a lifelong waterwoman," the discovery came when a friend let her borrow a board while on vacation in Hawaii when she was in college. "I felt like, 'Yes! *This* is what I'm supposed to be doing. Why didn't I do this sooner?' And then I realized there were many reasons why. It was access to the beach and not having equipment—not being able to ask my single mom to buy me an expensive surfboard and take me to the beach whenever I wanted to go. Surfing is very much a privileged sport."

This collective realization helped shape the vision for Textured Waves as a space of both encouragement and support. "Surfing is very personal for me. It's very soulful, and it's something that I love sharing with other women in my community," says Danielle. The collective has rapidly gained momentum, both online and through in-person events. The massive growth of interest in surfing, coupled with the racial uprisings of 2020, highlighted the potential impact the group could have in and out of the water. Textured Waves shines a light on previously ignored surfers of color—the overlooked, unsung sheroes—from all over the globe. It has become a broad and constantly evolving community of waterwomen, offering support and inspiration, simply by example.

"Community can show you what's possible," says Martina. "We're getting imagery out there to get the youth to understand surfing is a possibility for all, because when I was growing up, I didn't see that. I saw other people surfing, but something in my mind told me that that wasn't for me. And being an older person now, I understand that was because the media *told* me that it wasn't for me."

"We want to show women that this is something you can actually excel at," says Danielle. "If you can't see it, you can't be it. We want to inspire representation."

The Encinitas paddle out was attended by thousands of surfers of all ethnicities, each coming together to form a colossal circle of colorful boards on the evening tide. Photos and newscasts captured what was a powerful moment of hope and unity, but the women of Textured Waves know it was just the beginning, as there is still much more work to be done. "The first step to change is being aware of a problem," says Martina, "and that's where we are now. Racism will not be normalized anymore. We finally recognize that there is an American dream and an American reality, and that's different for different people in this country. But only time will tell if we follow through and continue to make those changes."

"*Racism will not be normalized anymore. We finally recognize that there is an American dream and an American reality, and that's different for different people in this country.*"

Achieving true diversity in the water is not going to happen overnight or indeed in a single lifetime. "It is going to take generations," says Chelsea, adding that in the meantime, "there are multiple ways to achieve the goal of diversifying the lineup. One is in the power of coming together to try to make that change into something long lasting. I think that's the beauty of this collective. I don't think there's any limit to what we can do."

"Our mission has always been to propagate the sport of surfing toward women of color," says Danielle. "Now we're also trying to figure how we can leave a legacy to pass down to the next generation."

In this way, the ultimate goal is to make Textured Waves itself redundant. As Chelsea explains: "We hope someday there isn't a need for Textured Waves because all women of all shades will be normalized in surf spaces and the surf industry." For the organization's founders, this means putting themselves out there—in the spotlight, on the waves, working alongside global surf brands and other nonprofits to push for more exposure and inclusion. And doing that means spending more time together and more time on the water—a place all three feel the most free.

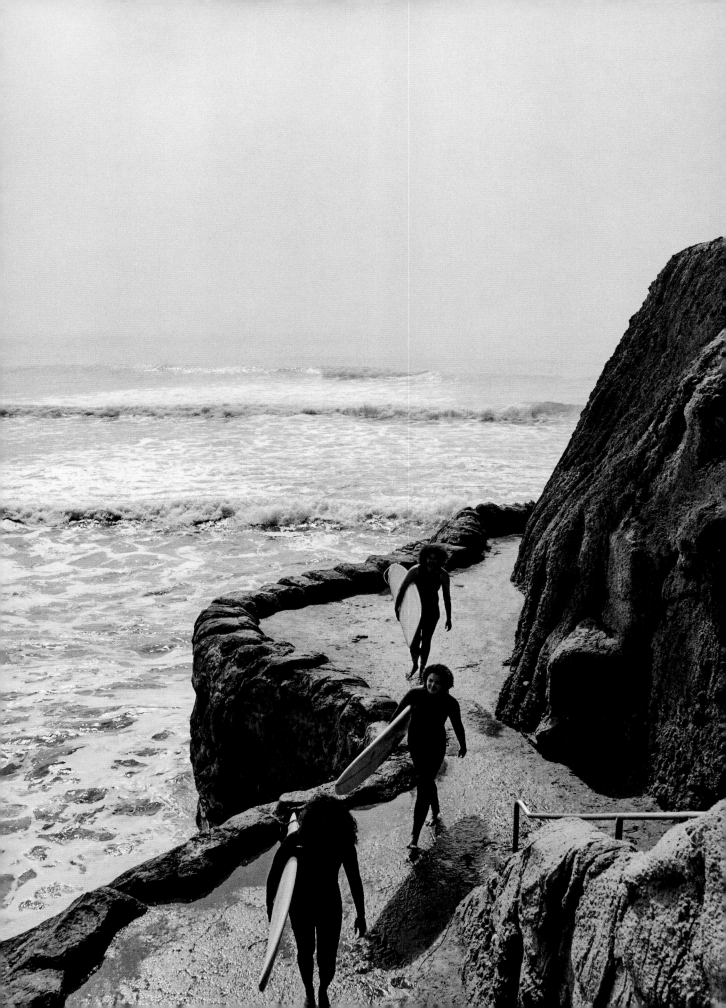

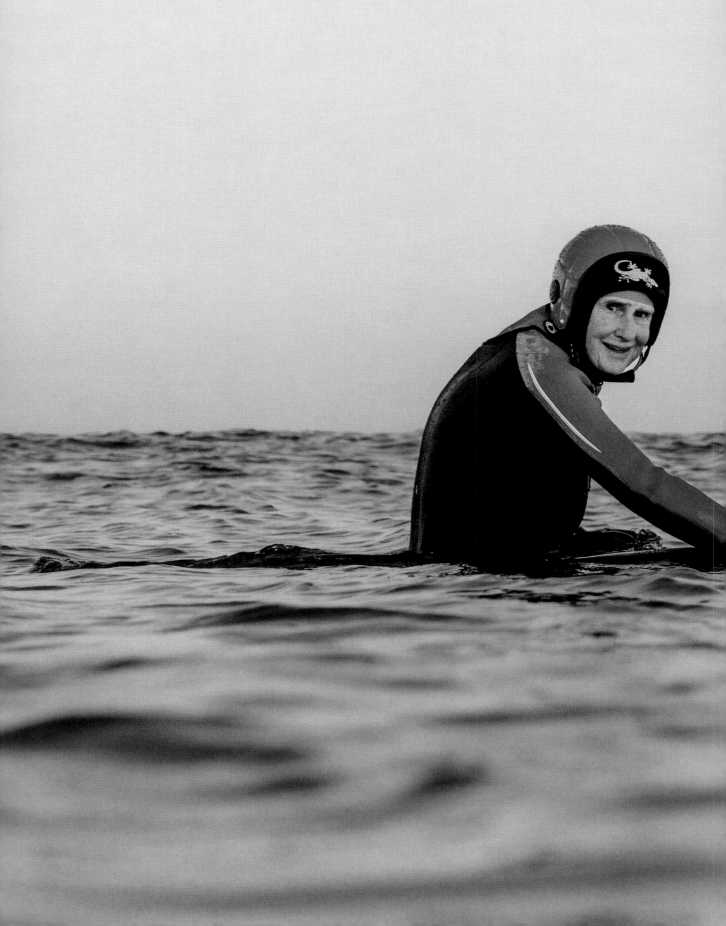

Gwyn HASLOCK

Cornwall, United Kingdom

Gwyn Haslock has a brisk, no-nonsense attitude and a distinctly British pragmatism that carries over into her surf life. Born in the final days of the Second World War, she grew up in a postwar country during the age of austerity but also a time of optimism. She was raised in a family where her interests and talents were cheerfully supported. "My mother and father were very good at encouraging me in what I wanted to do," she says. She learned to swim at the age of four on one of their regular outings to Cornwall's Tolcarne Beach, where the family owned a small, quintessentially British wooden beach hut close to the shore.

It was here that Gwyn first learned to surf, initially riding the smooth wood "bellyboards," that became popular in the 1950s. "Then in the 1960s, the lifeguards started to bring these bigger boards," she remembers. "We called them 'Malibu' boards." Gwyn quickly traded her belly rides for the thrill of stand-up surfing and was soon sharing waves with surfers from around the globe. "Cornwall is really nearly an island," she says. "We're surrounded by the sea. People came from all over—from Australia, South Africa, and the USA—and that influenced the local people."

In 1966, despite being the only female surfer in the area, Gwyn decided to enter her first competition. "There weren't any other lady competitors," she says. "I didn't really consider whether we were men or women. I just entered. I didn't win it. But I didn't go in to win anything." Gwyn had joined the contest merely to take part; not winning did little to shake her confidence. She simply got back on her board and tried again. This time, she won. And then

"There's a lot of women surfing now, which is good. There is elegance there. I think a lot of the women surfers are elegant and enthusiastic."

she kept on winning. "The Surf Life Saving body of Great Britain started to organize surfing contests in 1967," she says. "I was the first lady champion in that group. Then there was an organization called the Great Britain Surfing Federation; they started in 1969, and I was the first lady champion in that also."

Gwyn remains modest about these early victories, despite the fact she was an undeniably significant early pioneer of women's surfing. "I suppose I can claim I was the first British Ladies' Champion," she says, "but I just entered competitions to meet other surfers and to learn, really." When asked about the current evolution of women's surfing, she expresses delight about the modern waterwomen. "There's a lot of women surfing now, which is good," she says. "There is elegance there. I think a lot of the women surfers are elegant and enthusiastic."

For Gwyn, surfing always was, and still is, less about the competition and more about the freedom it affords. Her surf career was never fueled by a desire to be the first woman surfer or the best woman surfer. Surfing was a path to independence. These same sensations continue to draw Gwyn to the water today. She surfs because she loves it. "If I want to do something, I do it," she says. "I always just stuck to what I liked. I didn't go with what other people wanted."

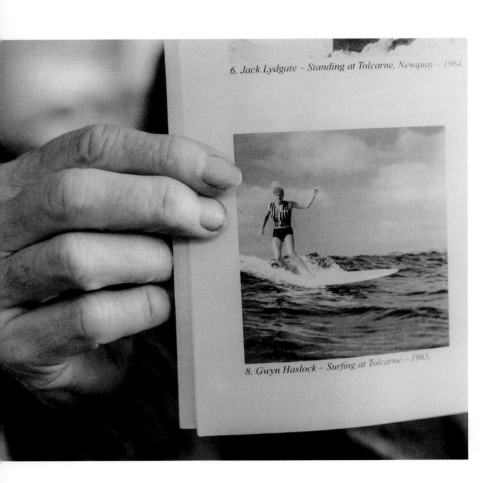

6. Jack Lydgate – Standing at Tolcarne, Newquay – 1964.

8. Gwyn Haslock – Surfing at Tolcarne – 1965.

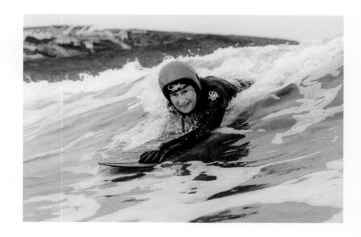

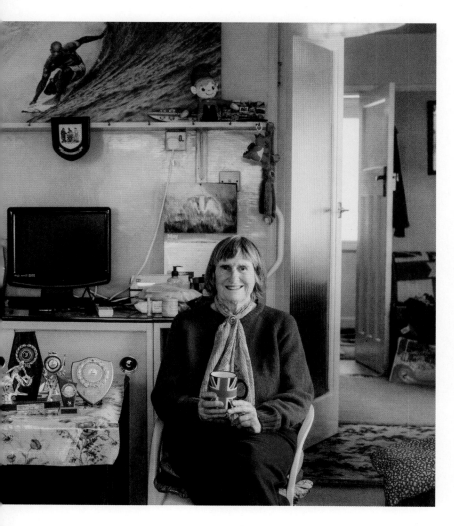

A break you most want to surf . . .

I'm happy with Cornwall breaks and when on holiday with my brother's family. Arrifina in Portugal. Hendaye in France. Rossnowlagh in Ireland, and Portrush in Northern Ireland.

Best piece of advice you've been given . . .

My mother said. "As long as one does not hurt others, do things that make you happy."

Your greatest strength . . .

Listen to others, but always listen to your inner self.

When I'm surfing I feel . . .

Peace, tranquility, and the power of nature.

The RADICAL ENVIRONMENTALISTS

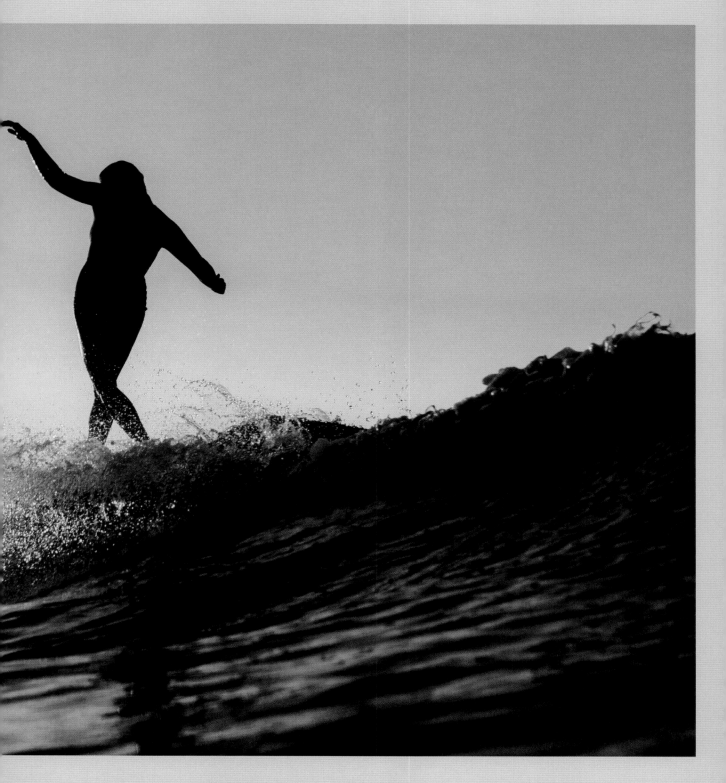

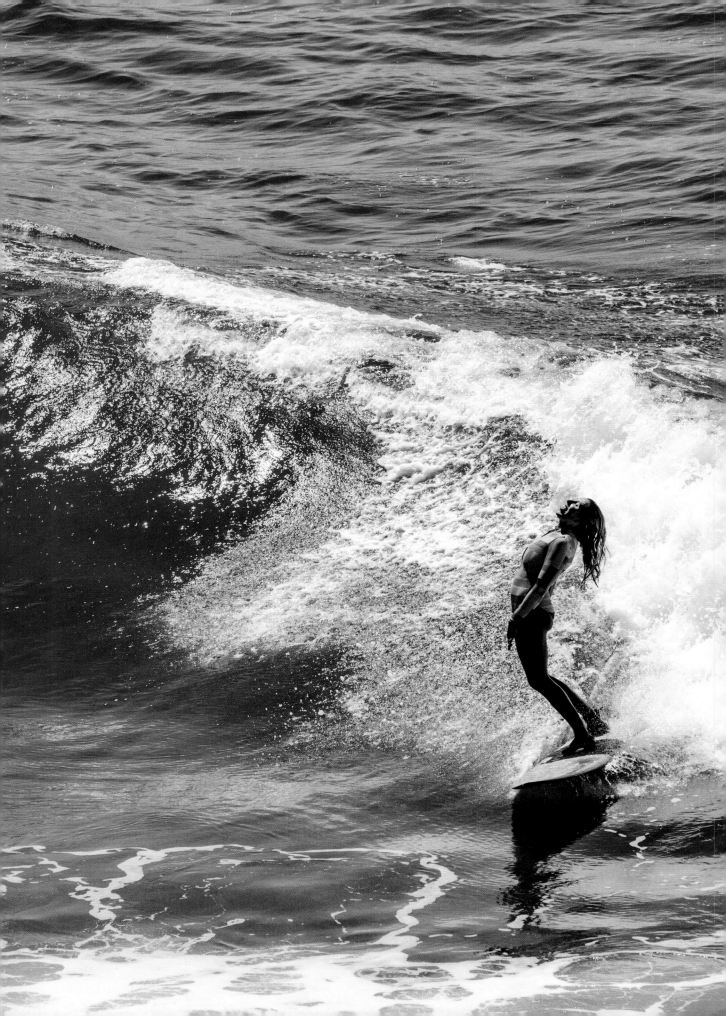

Lauren
HILL

Byron Bay, Australia

There's a saying among surfers: the best surfer is the happiest surfer. This is Lauren Hill. Smiling in the waters of famed Byron Bay, Lauren is the one hollering to friends to join her wave and whooping with encouragement as they kick out. Her presence on the water is formidable yet graceful as she draws lines with ease and charges faster than most.

This former US longboard champion left her log in the racks and transitioned to a new phase in her surf practice. It was an unexpected shift, one she attributes to a harrowing experience during a difficult pregnancy. Forced off her board for months of obligatory bed rest, Lauren fought for both her life and that of her unborn child. She reemerged at last with a healthy son and a desire—a need, really—to push herself further and faster in the water. On twin-fin midlength boards, she now drops into bigger waves, pulls into barrels, and takes more risks. And as a first-time mother in her thirties, she is "surfing more than I ever have in my life."

Lauren grew up on Anastasia, a coastal island off northern Florida, where she first ventured out to surf the gentle Atlantic swells in her early teens. She has long been captivated by the natural world and spent the past two decades exploring the intersection of environment, gender, and race. She is prolific—a professional freesurfer, writer, activist, producer, documentary maker, and cohost of *WaterPeople,* the podcast she created with her partner, environmentalist and fellow freesurfer David Rastovich. Through her work, Lauren challenges dominant themes and narratives around surf culture, environmental activism, permaculture education, and diversity.

"I've always felt a real responsibility to those often left out of surfing because of race, class, gender, sexual orientation, or ability," she says. "Just like a healthy ecosystem requires diversity to thrive, so does surf culture. Part of my purpose is to lift up other women. I want to make sure the 'sheroes' get recognized for the incredible contributions they've made to the surfing world and to culture at large."

For her groundbreaking book *She Surf*, Lauren spent a decade documenting the rich history of female surfers as well as the accomplishments of contemporary waterwomen across the globe.

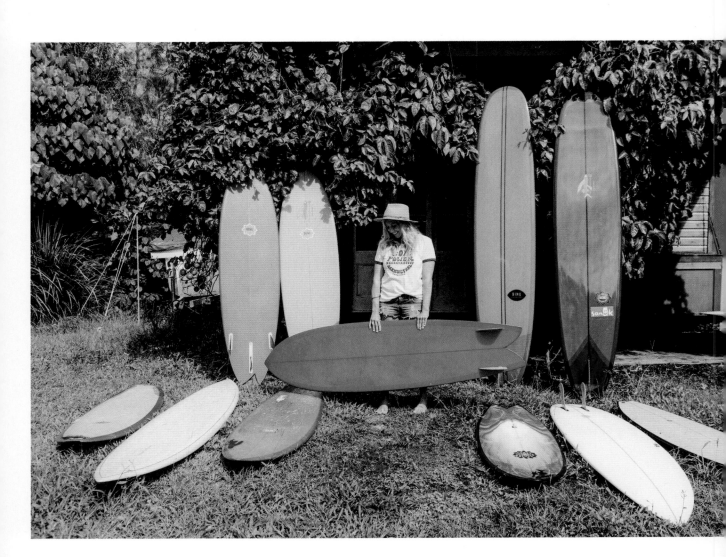

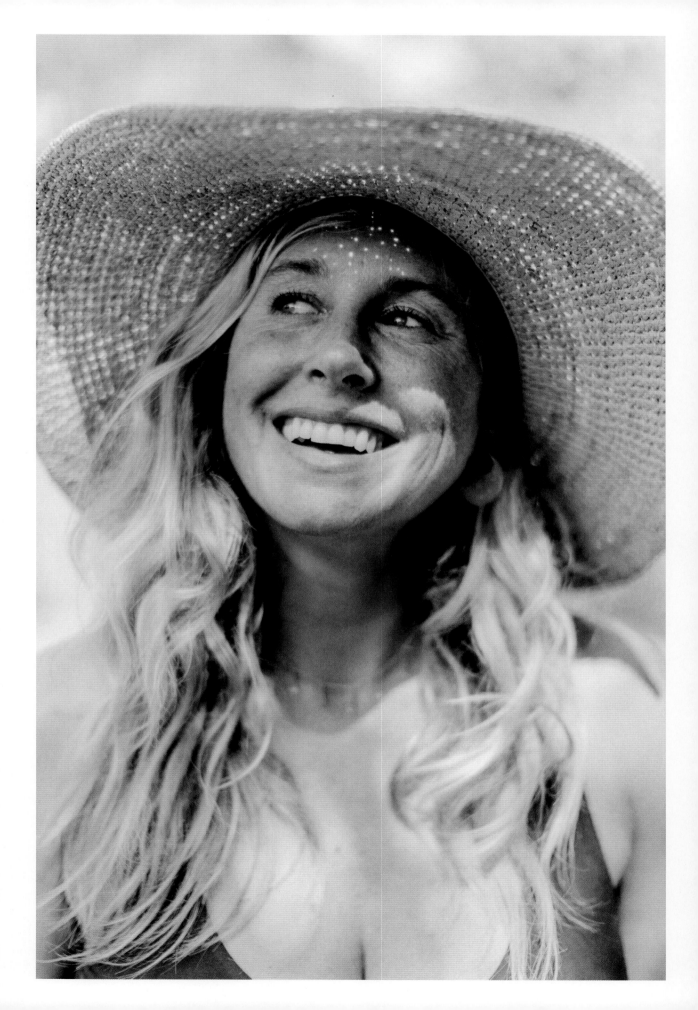

"Ecofeminism is about recognizing the pollution that is evident both in the environment and in culture as well. I'm interested in drawing parallels between the way we've historically treated the living world and the way we've treated women."

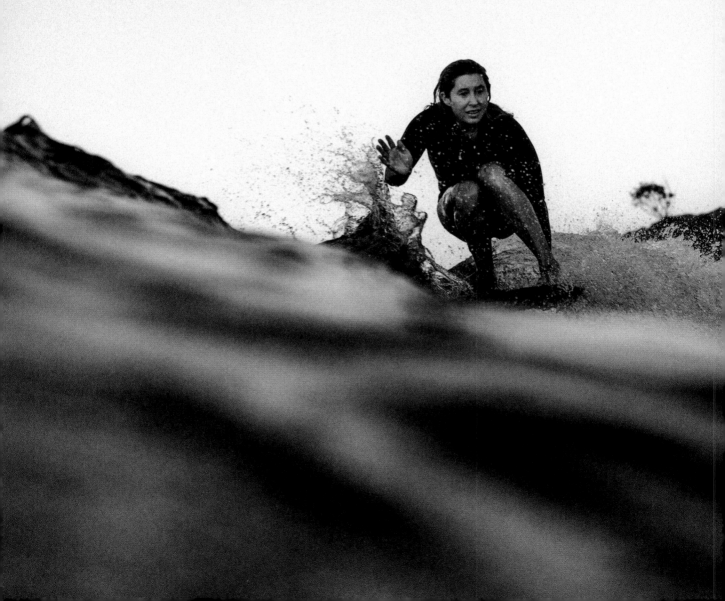

Advice for girls contemplating a life as a pro surfer . . .

Stay true to your surfing, but also follow those sparks of curiosity outside of the water. They'll help you become more fully yourself, which will only make you a better surfer.

Woman you most want to interview for your podcast, dead or alive . . .

Maui's mythical Princess Kelea, known as one of the most powerful and skilled surfers in the Hawaiian kingdom. According to legend, people used to gather on the beach to watch when she would paddle out. Kelea stayed true to her love of surfing— which led her away from lackluster life circumstances and into a life rich with love and waves.

What makes you feel powerful?

When I'm feeling strong in my body. Paddling into waves makes me feel powerful because I feel simultaneously connected to my physical form and to the swirling power of water around me, which connects me to all life that has ever existed on our planet.

A quote to live by . . .

"Happiness comes of the capacity to feel deeply, to enjoy simply, to think freely, to risk life, to be needed."
—Storm Jameson

Her hilarious short film, *Pear Shaped*, is a tongue-in-cheek look at the real life of women surfers. It went viral with its depictions of loose tampon strings and "nip slips," challenging the industry's exhausting "sexy" women surfer tropes.

Surfing also fed Lauren's fascination with biodiversity and shaped her academic path. She has degrees in environmental and social science and is currently completing a Masterclass with renowned permaculturist Geoff Lawton. Lauren has spearheaded a number of environmental and permaculture initiatives in Byron on her and David's land outside town—about twenty acres of temperate coastal rain forest. The pair practice what they preach, nurturing a thriving garden and a towering grove thick with trees they planted ten years ago. The family's hundred-year-old recycled timber house now sits amid lush growth, fruit trees, verdant forests, wild gardens, and a population of koalas and wallabies. "The trees are towering over us and fruiting and creating habitat," says Lauren, her voice hushed. "One of the beautiful things about living in a wild space, is you get to grow with it."

"I've always felt a real responsibility to those often left out of surfing because of race, class, gender, sexual orientation, or ability. Just like a healthy ecosystem requires diversity to thrive, so does surf culture. Part of my purpose is to lift up other women. I want to make sure the 'sheroes' get recognized for the incredible contributions they've made to the surfing world and to culture at large."

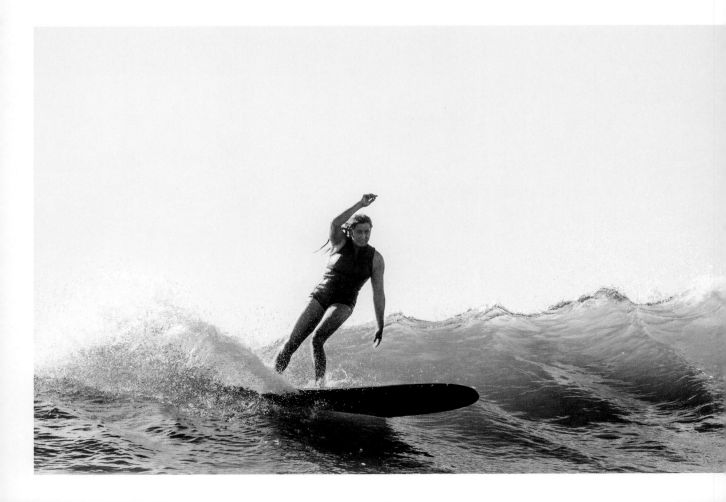

Still, she is quick to acknowledge those who have stewarded the land for millennia. "I can't talk about this community without talking about the people who have occupied this space for tens of thousands of years, the Bundjalung people," she says. "Byron Bay is the easternmost point of the Australian continent and is known as Cavenbah; it's where cultures have gathered for tens of thousands of years." The intersection of these two areas that fascinate her most—environment and equality—led her to identify as an ecofeminist. "Ecofeminism is about recognizing the pollution that is evident both in the environment and in culture as well," she says. "I'm interested in drawing parallels between the way we've historically treated the living world and the way we've treated women." For her, this means taking action, speaking out, and living an authentic life that reflects her beliefs and values.

Lauren's desire to live her truths—and to surf—is what led her to settle with her family in Byron. The area enjoys close proximity to reliable waves and what Lauren calls "the living world," pointing out the abundant wildlife, both on the land and in the waters. "A huge part of living here is getting to feel like you're connected to communities of other species as well," she says. "Our beaches are home to resident populations of dolphins, and we have whales that pass by each winter." The year-round uninterrupted swell allows her to connect to nature deeply through the waves, fulfilling a need; it's almost as enduring as a love affair. "Surfing is responsible for all of the most important things in my life," Lauren says. "My romance with the ocean, staying true to that, has really guided me."

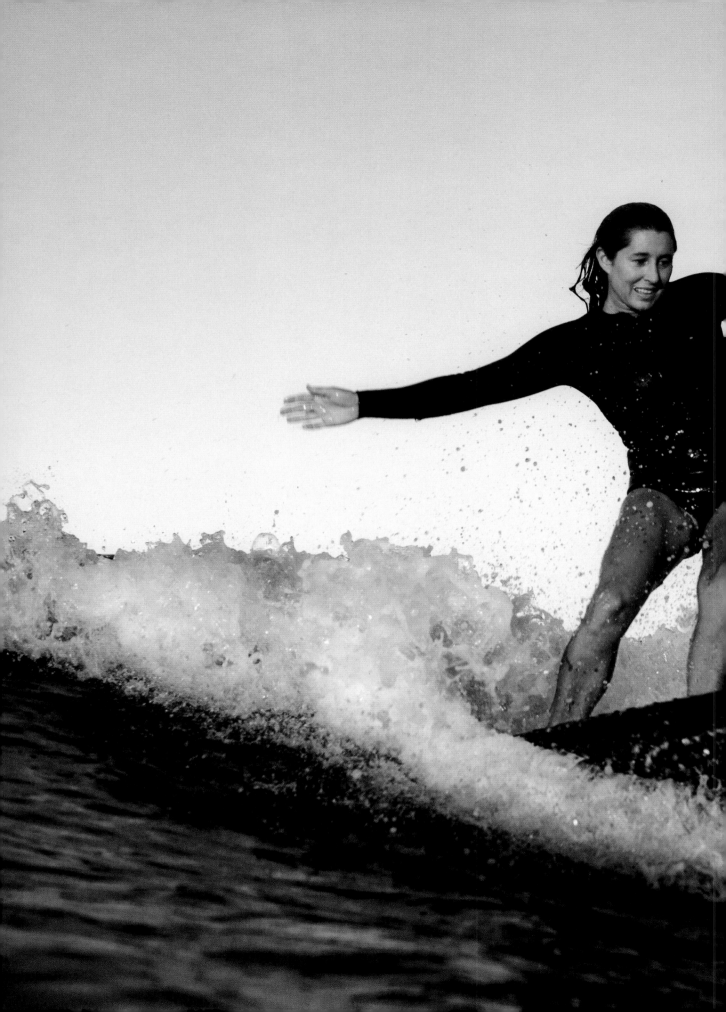

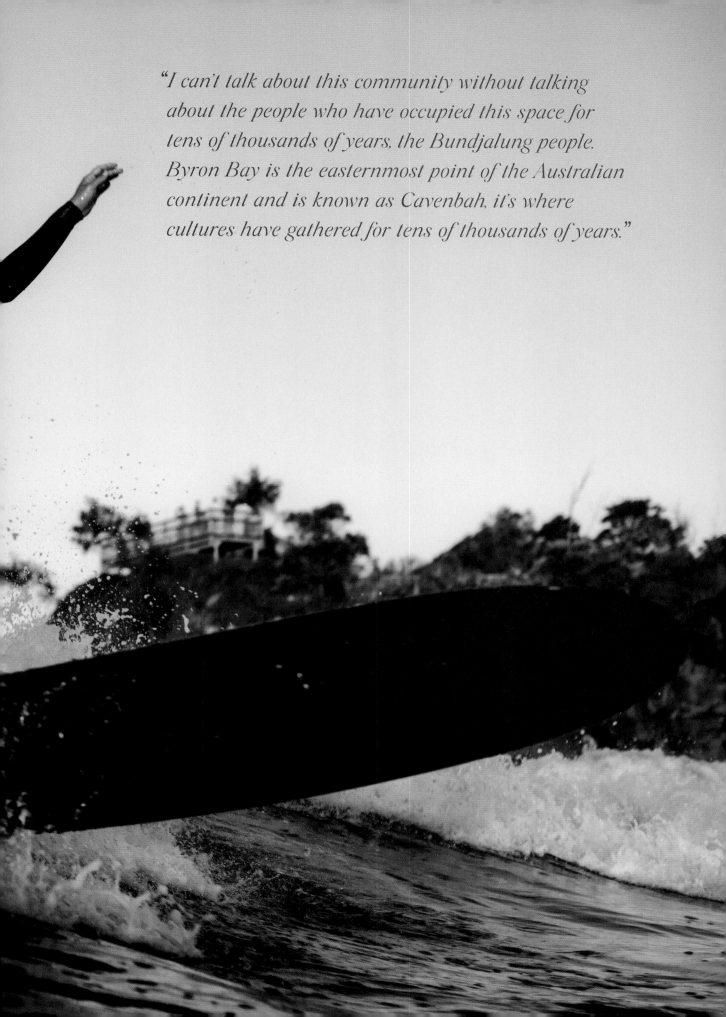

"*I can't talk about this community without talking about the people who have occupied this space for tens of thousands of years, the Bundjalung people. Byron Bay is the easternmost point of the Australian continent and is known as Cavenbah, it's where cultures have gathered for tens of thousands of years.*"

Sophie
HELLYER

Cornwall, United Kingdom

Nearly every morning off the dramatic, rugged coast of Cornwall, you'll find Sophie Hellyer immersed in the freezing ocean swells. "It's where I feel happiest and most comfortable," she says. "I leave all the worries on the shore." A former competitive surfer, Sophie still spends time on her board, but her love of the ocean has evolved. No matter the weather, she now has a daily ritual of cold-water swimming, which offers a way of coping with her battles with anxiety and depression.

For Sophie, the sea has always been a place of respite. Raised in a working-class family, Sophie was young when her parents split. Feeling limited by a less-than-rigorous education system and the stresses of a broken home, she took to the water as a means of escape. She swam, bodyboarded, and later surfed the icy waters of Westward Ho!, her tiny coastal community in Devon. Her father surfed as well as her older sister, Laura Hellyer, who became the youngest British surf champion at age fifteen. Eventually, Sophie followed suit. In 2003, also at the age of fifteen, Sophie won the British and English Junior Championships and earned a place on the European Junior team.

An outspoken, unapologetic advocate for diversity and equality in the surf world, Sophie was spurred into action by her own experiences on the competitive circuit. "I spent the next ten years sponsored by Roxy," she says. "But surfing wasn't a huge part of my surf career. I was never given any coaching. My experience as a surfer is hopefully different to what women are experiencing now. But then, it was very much part of the package that I would be a model as well as a surfer."

Sophie spent more time in front of the camera than on her board and frequently found herself forced to forgo competitions in order to travel for photo shoots. It became increasingly apparent that (for her sponsors at least) Sophie was a swimsuit model first, surfer second. "I went along with it even though at the time a lot of things that happened didn't feel right," she says. "But I didn't have the language to articulate it." She grew increasingly uncomfortable with the status quo. "I was about twenty-five when I actually started challenging it and asking, 'Why are we always modeling in bikinis when I only ever surf in a wetsuit?' and 'Why is it only the girls who look a certain way who are getting in the magazines and the marketing campaigns? What about all the other girls who aren't being represented?'"

As a result of this realization, Sophie began speaking out, part of a chorus of voices pushing the World Surf League into various policies that ensure fair treatment of women and negate opportunities for exploitation. She also uses social media to showcase real women surfers and to push for change within and beyond the surf industry. In part due to Sophie's efforts, the WSL eventually set various policies in place in regard to official surf photography, encouraging imagery "that actually shows women doing critical surfing instead of showing them being objectified and sexualized."

Sophie continues to write articles and grant interviews on the issue, but her stance has been on occasion misconstrued in a way that she says feels deliberately divisive. She was stunned by brutal backlash after one British newspaper quoted her out of context. "They'd made it out that I was attacking women who were wearing bikinis, which wasn't the issue at all," she says. "I have no problem with women who want to surf in bikinis. I have a problem with the culture that sexualizes women."

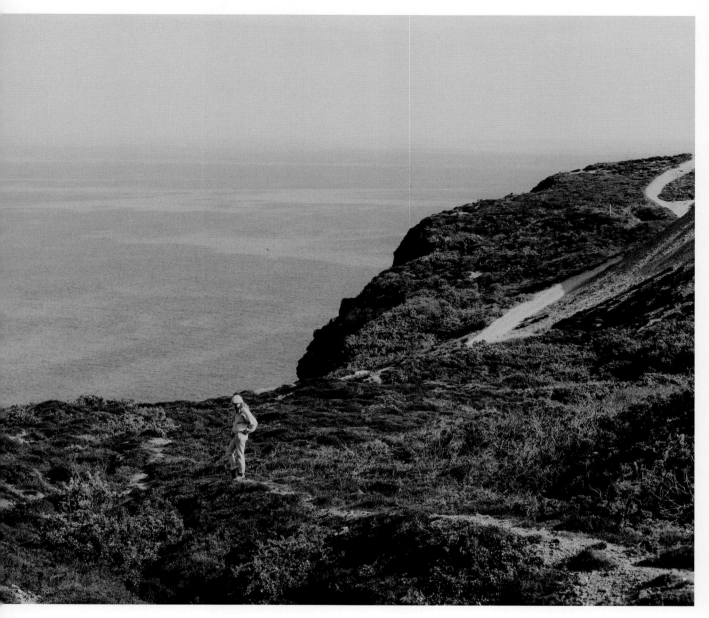

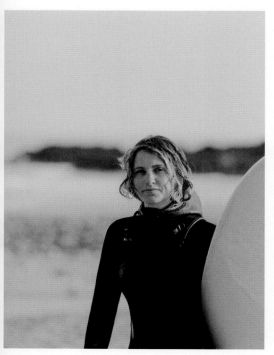

"'Why are we always modeling in bikinis when I only ever surf in a wetsuit?' and 'Why is it only the girls who look a certain way who are getting in the magazines and the marketing campaigns? What about all the other girls who aren't being represented?'"

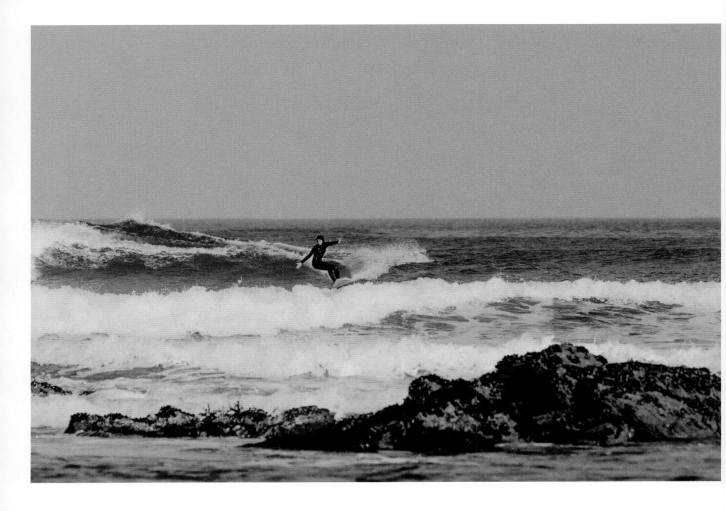

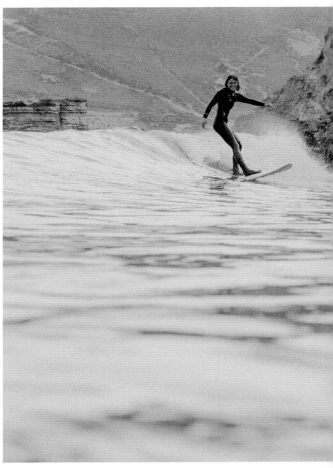

At first, Sophie was hesitant to respond to the wave of criticism that followed the now infamous article. "I did get really anxious and upset about it," she says. "But I actually just used that emotion. It fueled my fire." The comments, however, further soured Sophie on the complex politics of contemporary surf culture. Looking for ways to manage her anxiety while still engaging with the ocean, she took a cold-water swim with a friend and was immediately enthralled. "Surfing, even now, is a very male-dominated sport," she says. "That whole macho localism, it totally turns me off surfing. And in swimming, that doesn't exist. Everyone's welcome."

Inspired by that first swim, Sophie is now a volunteer lifeguard and has transformed her ritual immersions into a concept for collective retreats, inviting other women to join her for her Rise Fierce events. "We swim, do yoga, surf, and we also have environmental activities weaved in," she says. The restorative effect and the psychological benefits she gets from regular immersion in cold water recently inspired Sophie to lead group swims as research for the Royal Cornwall Hospital. Staff members who have experienced depression, anxiety, and PTSD due to the coronavirus pandemic take part, the results feeding into a much bigger study around the benefits of cold-water swimming.

Today, Sophie uses her podcast, *Two's Company*, to showcase female surfers and to push for change. She speaks out on environmental causes and organizes community gardens and ocean cleanup, and she advocates for GET OUT, a charity that strives to connect urban teens with the natural world. She also promotes City to Sea's Plastic-Free Periods campaign, which pushes for accountability in big-brand feminine products. Sophie's initial timidity has transformed into eloquent outspokenness. Her popular TED Talk championing sustainability has gone global, and she has created an ongoing photographic series highlighting local female surfers at her home break. And she still gathers together women of all kinds for her Rise Fierce retreats, where support and sisterhood are nurtured through the glacial thrill of a communal swim. "It just makes you feel very present, and in the moment and grounded," she says, smiling. "But it's useless trying to explain how it feels. You just have to get in and see for yourself."

What book should everyone read by age thirty?

How to Be a Woman
by Caitlin Moran

Hardest-won lesson you've learned about having a platform . . .

Not everyone is going to like you or what you have to say.

Your motto . . .

No such thing as bad weather.

When do you feel most powerful?

After a cold-water swim.

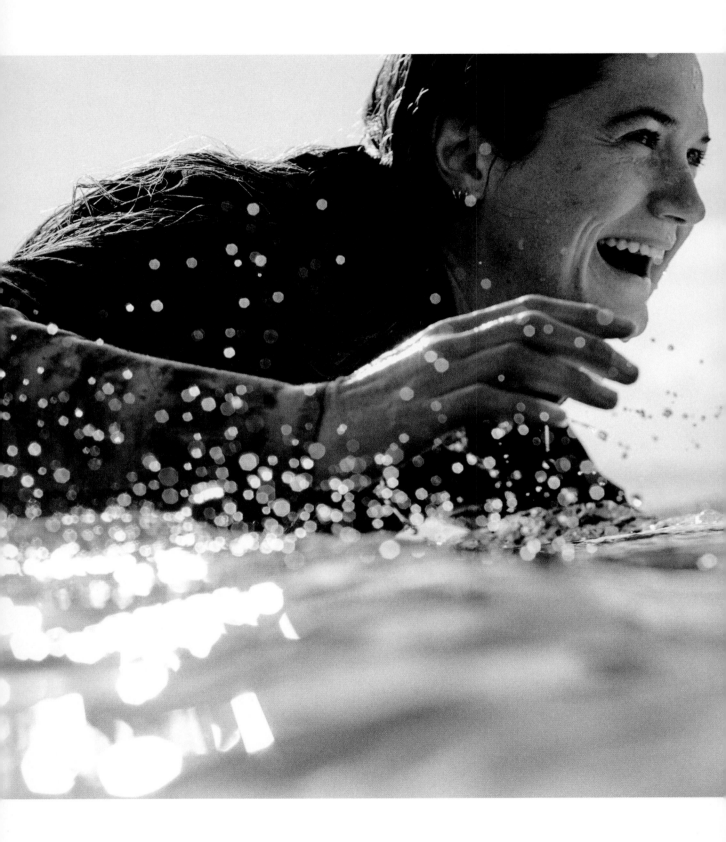

Bonnie *WRIGHT*

Santa Monica, United States

British actor Bonnie Wright moved from London to Los Angeles—with a quick stop in NYC—not for the film industry but for the surf. A decade of portraying Ginny Weasley in the Harry Potter film series made her a highly sought-after actor, famous on every continent. A move to Hollywood might have seemed like an obvious next step, but she says, "I didn't really move for any strategic career reason; I genuinely moved because I wanted to be by the coastline. I've always had an affinity with the water."

Raised in East London by artist-jeweler parents, Bonnie and her family decamped to East Sussex as often as possible and spent summer vacations in Australia, where her mother's family lived. "We'd always go to the beach, so I had this balance between this urban existence and being wild and free, playing in the sand, paddling," she says. Around the same time she went on her first audition, Bonnie went out for her first-ever surf. "I was about eight years old. I went with my dad and my brother down to Cornwall and just surfed every day and fell in love."

Low-key and humble, Bonnie literally grew up on a film set, watched by millions around the world. Her first Harry Potter appearance at the age of nine led unexpectedly to ten years of starring in the blockbuster film series, with Bonnie evolving right alongside her character. "I loved playing 'Ginny' because she had traits that I totally look up to," she says. "She was very unapologetically herself and didn't look for validation in anyone else. She was just a strong woman." These experiences on the set of one of the most popular film franchises ever opened up Bonnie's world, offering her opportunities, access, and a platform to engage with issues far beyond the film industry.

Deciding early on to use her fame and voice to raise awareness for global causes, Bonnie became a spokesperson for Oxfam, fighting poverty. "I saw the possibility of being able to communicate with people who maybe wouldn't have heard of these causes," she says. "People are listening because they were interested in what I was saying, because they were interested in who I was." Her first trip to Senegal in West Africa inspired a commitment to action that has only gained

momentum. She then went on to become an ambassador for Greenpeace, taking a trip on the Arctic Sunrise and becoming fully exposed to the plastics epidemic. "I came home and thought, 'I need to do this. I need to dedicate my entire life to this,'" she says. She recognizes the connection between social, racial, and environmental justice, firmly believing that the West needs to step away from its "colonial/savior mentality" and engage communities that have been largely ignored. "Until we center those people and put [them] into leadership roles," she says, "we're actually not going to be implementing the change that's actually needed by people."

As a spokesperson for Greenpeace, Bonnie focuses on raising awareness around ocean health and single-use plastics. She works closely with Rainforest Alliance on regenerative agricultural and forest initiatives. And she continues to strategically align with organizations to support initiatives around environmental issues and human rights—advocating and educating both on the ground and online.

After graduating with a BA in Film and Television from London College of Communication, Bonnie found herself shifting to a new position behind the camera—directing a number of short films and music videos. "When the Harry Potter films ended, it was challenging, because the films were so significant in my day-to-day life," she says. "Finishing them was this new chapter. Everything changed. I knew I would always be defined by that experience, but it was time to reconnect with myself." This reconnection has come about partly through her focus on activism but also through her relationship with nature, particularly with the ocean. "No wave is ever going to be the same," she says of surfing. "There's a lot of getting over yourself and being humbled by the water. Although the ocean deeply cares about us because we're part of it, the ocean doesn't really care what your agenda is."

In between filming and frequent surfing sessions at Malibu's storied First Point, Bonnie works in her garden growing food and takes hikes in the hills with her dog, Billy. She is now in the midst of developing her directorial feature film debut *and* has written a book on sustainability in the home. "It took a few years for me to have a kind of rebirth," she says. "But I'm now in a whole new chapter." The book is a culmination of Bonnie's research in finding

"I definitely believe in people's ability to change. I believe in our ability to come together and to imagine a new and better future for the world."

"There's a lot of getting over yourself and being humbled by the water. Although the ocean deeply cares about us because we're part of it, the ocean doesn't really care what your agenda is."

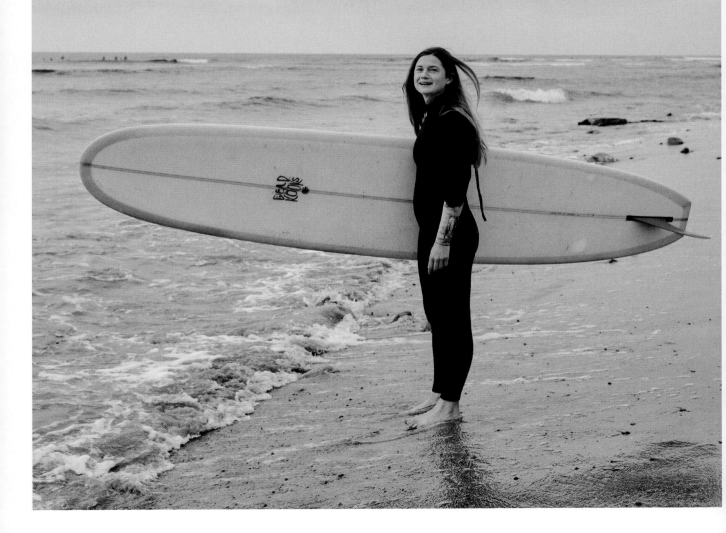

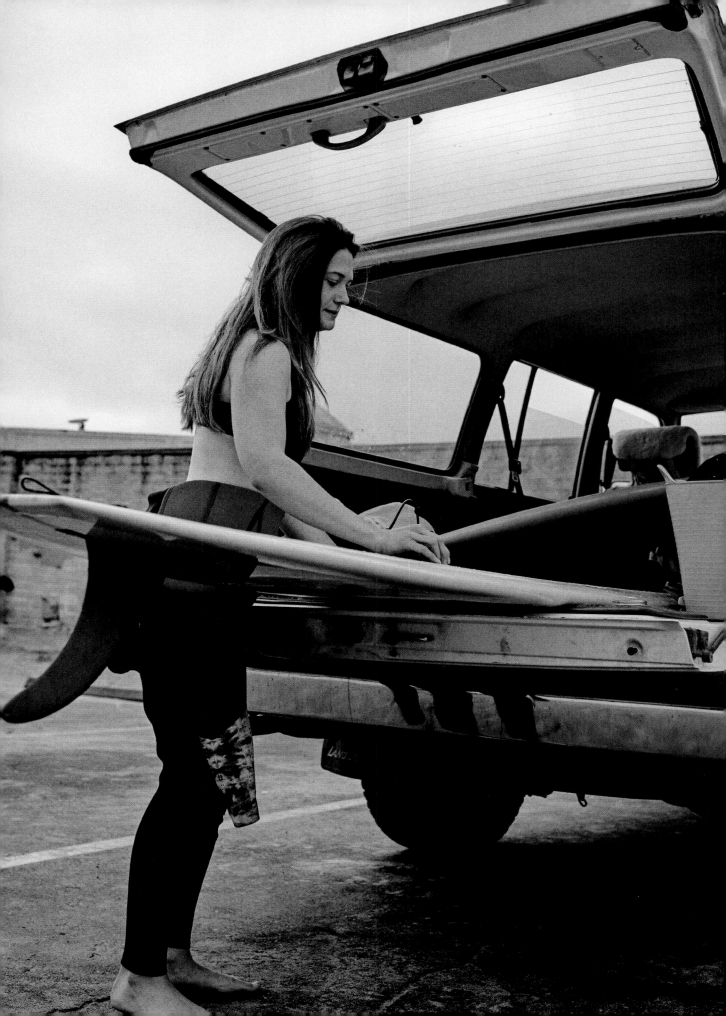

practical, sustainable solutions to environmental issues. "I felt pretty disempowered by the realities of plastic pollution," she says. "I had to reinvigorate my own hope. The book is essentially presenting a way to make changes in your daily life to have a closer relationship to your impact on the planet."

What has remained constant for Bonnie is her dedication not only to her surfing and creativity but also to activism, outreach, and engagement. "I try to show not just the issues that affect us but also offer solutions, how you can help, how you can contribute," she says. "Some issues are complex, but there are others where direct solutions exist." Although she uses her significant social media presence to communicate with her vast audience, she says, "Things need to exist offline. Our world is not changed by the way we engage online. I think it distracts us from actual action that needs to be done."

This practical mind-set is exactly what makes Bonnie and her messaging so engaging. Her approach to saving the world is both collaborative and communal, logical and positive. Her experiences on set, her intimacy with her audience, and her connection with the ocean have all informed the ways in which she leads. "I definitely believe in people's ability to change," she says. "I believe in our ability to come together and to imagine a new and better future for the world."

What book should everyone ready by age thirty?
On Earth We're Briefly Gorgeous *by Ocean Vuong.*

Post-surf rituals . . .
Drink lots of water, pump loud music on my way home, and write. I always feel inspired after a surf.

Your surf kit . . .
Kassia Surf wetsuits and wax, always. Raw Elements sunscreen and a $5 hat from the surplus store for the summer months (which I have yet to lose to the ocean). I hydrate my skin with Après surf hydrating face oil by Labbe. All my wet items go into a Red Guerrilla bucket post surf.

A quote to live by . . .
"There's no wrong way to do the right thing."—heard from Jayana Young

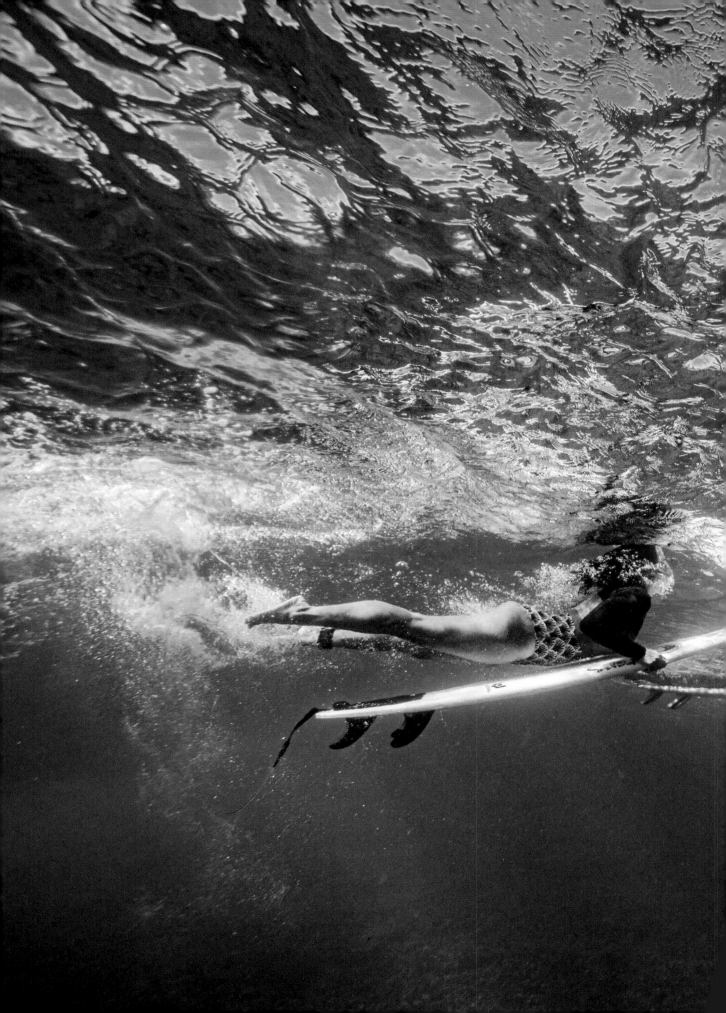

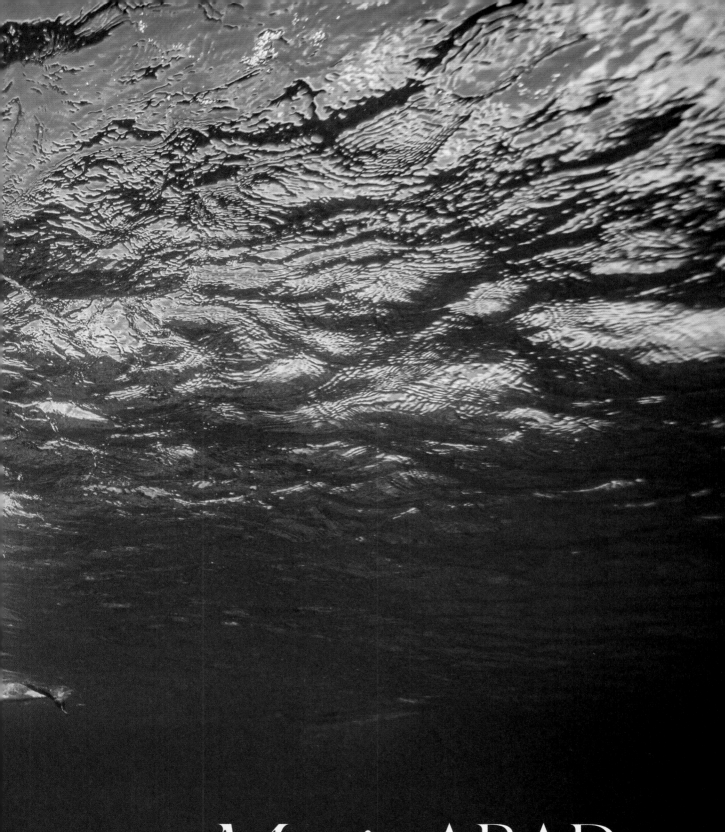

Marja ABAD

Siargao Island, Philippines

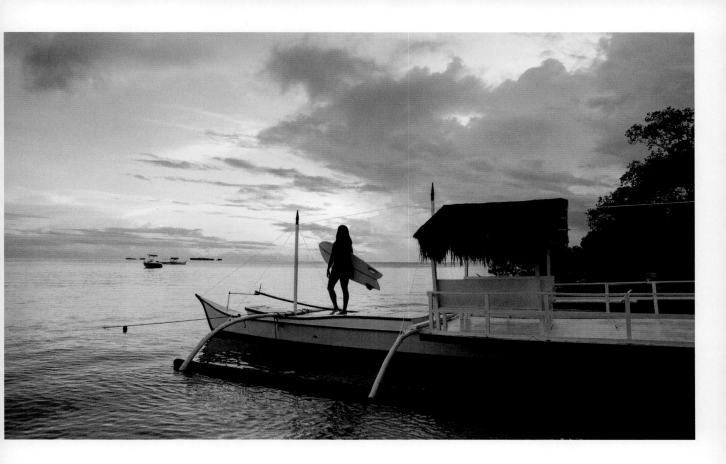

Some women are drawn to surf as a way to connect with nature, some to heal, some to get a sense of pleasure or empowerment. For Marja Abad, it was a combination of all of these. The first time she paddled out, she was recovering from a climbing injury. The immersion into the ocean worked on a profound emotional level, gently healing a deep grief and offering an unexpected new direction and purpose.

Raised in Davao City in the southern Philippines, Marja was young when her parents separated. Both left the country in search of greener pastures, leaving nine-year-old Marja and her younger brother in the care of various aunts and cousins. "It wasn't a happy childhood," she says. "I just really thought that I have to be strong to overcome this or it will break me. I made a conscious decision not to be a victim of the situation; to use it as a way to be stronger, wiser, and to just have a more colorful life." She studied hard; graduated college; and spent her free time with her mountaineering club, scaling crags and navigating boulders, just as she would continue to do off the mountain. Through rock climbing, she found a deep love for the environment, but it was her first time in the waves when something really shifted.

"I've always loved the outdoors, but with surfing it's more like being *connected* to the ocean," she says. "Ever since I got into surfing, my whole life just changed." Surfing and caring for the ocean quickly became central to her existence. She set out to create that "colorful

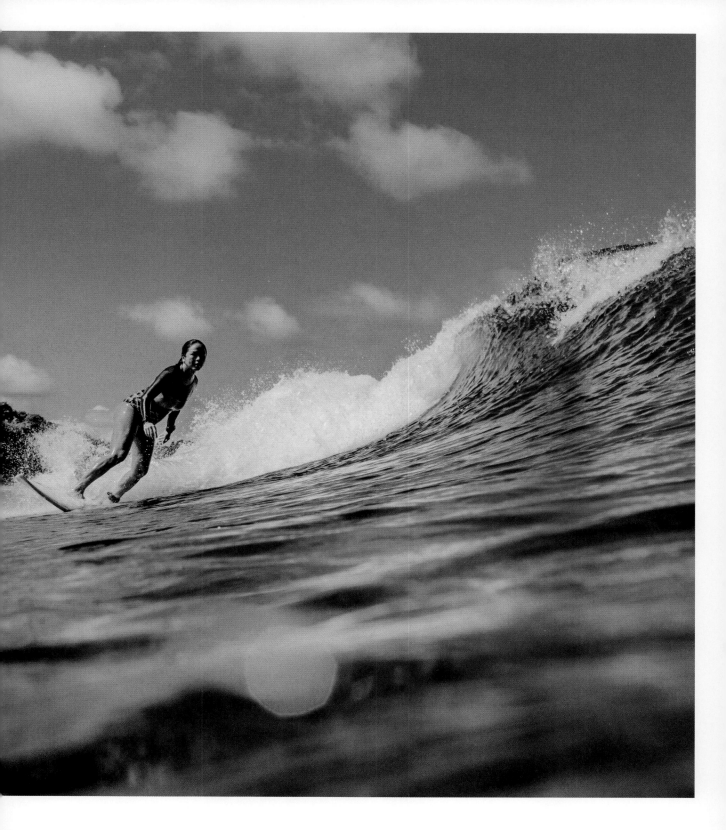

"*I learned to understand what was happening to me and ways that I could overcome it. And getting into sports allowed me to make friends with people who don't give up. You can keep setting goals and you can keep improving.*"

life" that she had envisioned as a child by moving to the island of Siargao, a place she considers to be the most beautiful in all of Asia. "The community here is amazing," she says, "and I think people are so in love with this place because the locals are so giving and so hospitable."

When Marja moved to the island, she immediately began to advocate for sustainability and community collaboration. "The first time I was here was 2006, and you really didn't see any trash on the beach back then," she says. "Fast forward to 2015, when I came back, and there was plastic everywhere." She initiated regular beach cleanups with the local kids. "People started to think, 'Oh, Marja can get things done; let's just throw things at her and she'll finish it,'" she says.

Five years later, they had been proven right. Marja is the cofounder and dynamic vocal champion of the SEA (Siargao Environmental Awareness) Movement, working alongside the Indigenous communities on the island to spearhead environmental and sustainability initiatives. Through community mobilization, Marja has closed down businesses that weren't conforming to environmental regulations and stopped construction on a water park that would threaten a fish sanctuary. She also facilitated the ban on single-use plastics that was passed through the SEA Movement's initiative.

On the inspiration for the Movement organization, Marja explains, "I just thought, 'I'm having a great life here. I need to give back.'" SEA supports community cleanups and recycling centers. They raise funds for food and education for the island community—trading bags of rice for bags of used plastic bottles. As a result of Marja's efforts, Siargao has become one of the country's leaders in sustainable tourism, working with both the Philippines Surf League and the World Surf League to create plastic-free surf events on the island.

Marja's early education instilled in her a sense of collective responsibility and service that has only grown stronger as she's gotten older. "I went to a Catholic high school and we had retreats," she says. "They really forced us to reflect on life. It made me decide in college to study social work and nursing." Her degree serves her environmental objectives, working for change on a national level and engaging like-minded brands to invest in the island's sustainable future. Education also helped Marja overcome her own chaotic childhood. "I learned to understand what was happening to me and ways that I could overcome it," she says. "And getting into sports allowed me to make friends with people who don't give up. You can keep setting goals and you can keep improving."

"I've always loved the outdoors, but with surfing it's more like being connected to the ocean. Ever since I got into surfing, my whole life just changed."

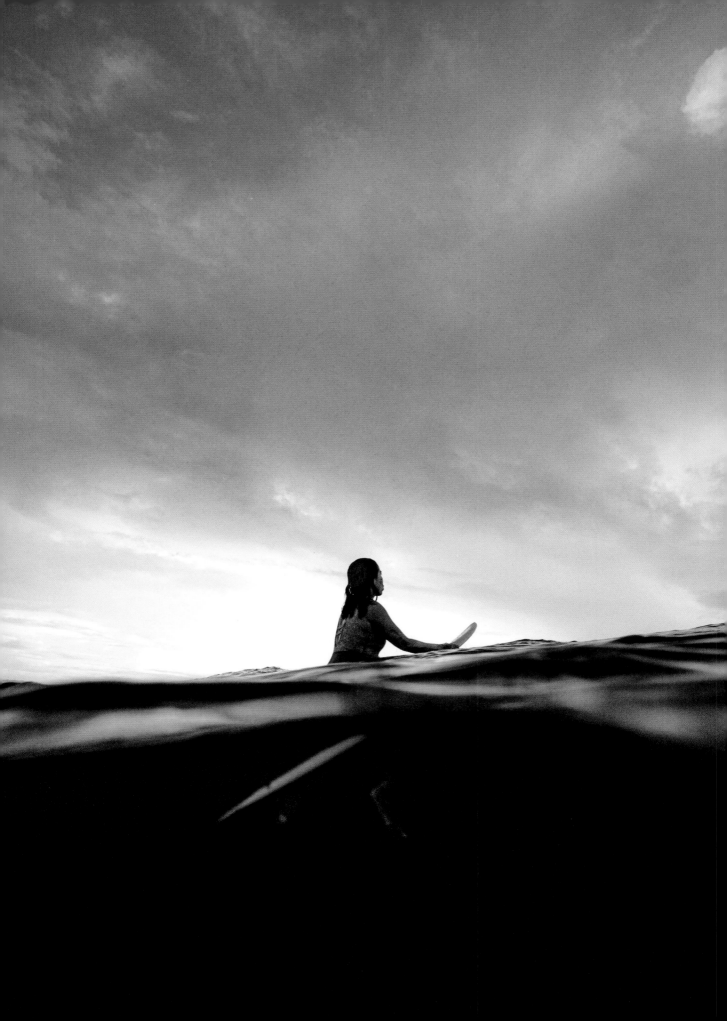

Marja's drive and determination enable her to face the odds with unwavering, gritty optimism. She doesn't complain, she doesn't look back—instead she simply gets things done. "I'm never content with one thing," she says with a smile. "If I accomplish something, then I'm on to the next, and I never stop. I work, I do community work, and I surf."

Alongside her nonprofit efforts, Marja created the Greenhouse, an eco-resort and restaurant on the island that attracts surfers from all over the world. She is also building a sustainable clothing and hardware brand, Kudo Surf. "In everything we do, we still always practice our environmental principles and try to educate the surfers that it's our duty as watermen and waterwomen, as surfers, as ocean lovers to respect the environment," she says. "To me, all brands should have this eco-consciousness. Surfing brands should market a product and a principle that will not only help their business grow but also preserve what made their business in the first place—the ocean."

On a personal level, surfing has given Marja an intimacy with nature and an empowered inner self. "I owe Mother Nature my epic life," she says. Looking ahead, she envisions a world where "sustainability will be a norm, a moral value that the human race will live by. And the planet will finally be prioritized over profit." Marja's hope is that by creating a better future in Siargao, she'll ultimately be part of manifesting a better future for us all.

Advice for tourists visiting Siargao . . .

Siargao is a state-declared protected area. Bring your own reusable bottle, and support local, environmentally conscious businesses.

When you feel overwhelmed trying to save the world . . .

I take a break from it, reevaluate the project, and tweak it so it's more fun to do. When I feel recharged, I start work again.

The woman you most admire . . .

Anna Oposa, chief mermaid of Save Philippine Seas. She's an incredibly smart and charismatic leader, ocean lover, and diver. Her dedication to her work is inspiring. From her I learned most of what I know about heading up S.E.A Movement.

Most significant challenge facing women in the Philippines today . . .

Poverty. When a woman lives below the poverty line, she is faced with many challenges that can cripple her whole womanhood—including poor access to reproductive and maternal healthcare. She's also more likely to be a victim of domestic violence.

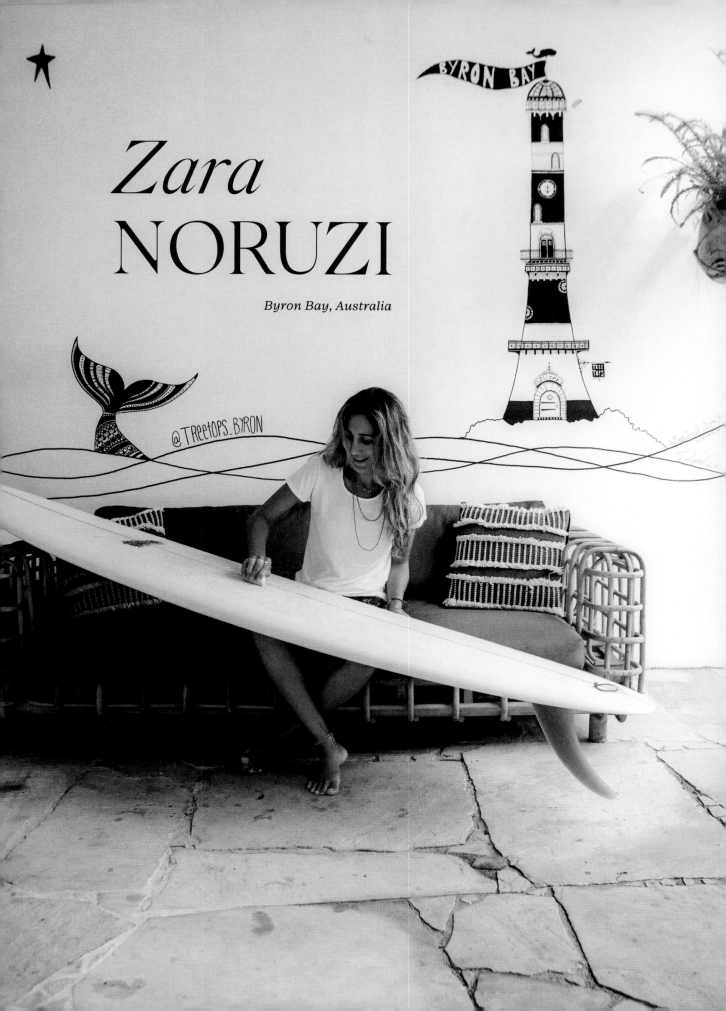

Zara
NORUZI

Byron Bay, Australia

@TReeTOPS_BYRON

BYRON BAY

TREE TOPS

Zara Noruzi is a survivor. Fierce and resilient, she's been through hell and come out the other side—outspoken and unapologetic. Born in Iran, Zara was raised in a family of intellectuals, a line of powerful women. She came of age in the midst of the country's long war with Iraq. "I grew up with a family full of activists," she says, "with the instinct that if you don't stand up for what you believe in, then you won't be here the next day." As a child, she saw firsthand both the danger and the power of speaking out. "My dad's cousin was taken by the police and no one ever saw her again," she says. "When I found out about that as a kid, I realized that one person's thoughts and ideas could be so powerful—they could frighten an entire government."

Instead of being frightened herself, Zara was inspired to follow in her relatives' footsteps. She wrote articles on women's rights and participated in protests. Then, while at a demonstration at her university, she was arrested and imprisoned by the government, enduring more than a month of torture and isolation before finally being released. Today, when Zara speaks of this harrowing episode, it becomes clear she would have done nothing differently, despite what she suffered at the hands of the state. "If you have strong conviction, if you're fighting the right fight, that is incredibly powerful," she says. "To choose to ignore it and not to do anything about it, to me—it's just not even an option."

On her release, Zara, then only nineteen, quickly left the country as an exile, finding safe haven in Australia, her home for the past two decades. It was there, still reeling from the intense emotional and physical ordeal of her imprisonment, that she was embraced by a community of young surfers who encouraged her to take to the waves. "Once I found the ocean community, I found passion and purpose. Everything changed," she says.

The water offered both refuge and community. Shocked by the racism she experienced when she first arrived in Australia, Zara found a sense of belonging on the waves. Despite the prejudices, she persisted, finding her voice again through surfing. She began to heal from the traumatic events of the past and adapt to her new environment. Zara redefined and rebuilt her life, settling with her young family in Byron Bay. She fell in love, got married, had a family, and wrote an award-winning memoir about her

Byron Bay, home of the Bundjalung people. The Aboriginal flag was painted over a "Locals Only" sign.

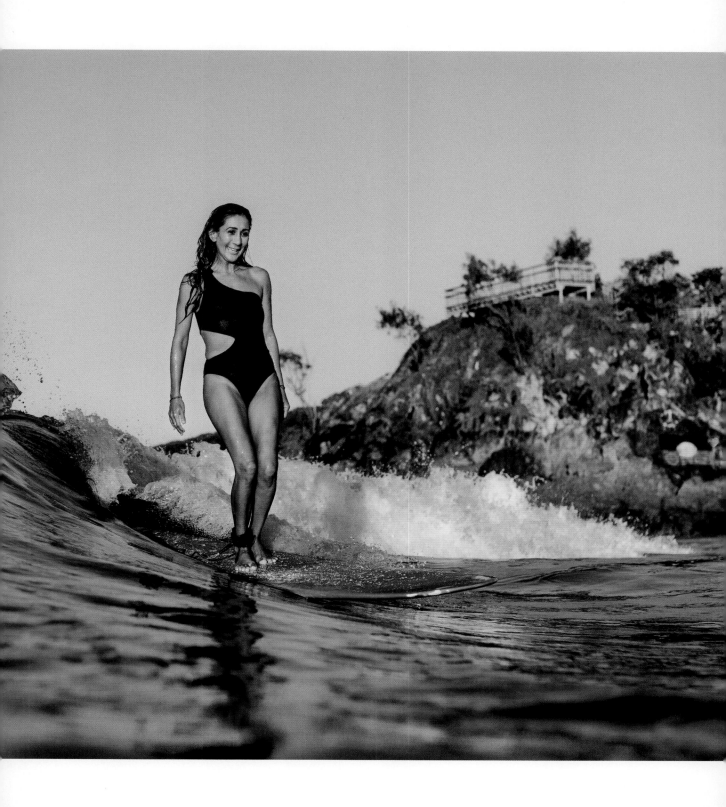

"Race and environmental issues are hand in hand. We've lost compassion for each other and the planet."

imprisonment, *My Life as a Traitor*. The book offered Zara an opportunity to share with people the Iran she loved, one that Western media failed to portray. "When I first got here," she says, "I was asked where I was from, and the guy said, 'Oh, you're not a terrorist, are you?!' By writing my book, I wanted to show my culture and humanize us."

Still, her trials were not over. In 2017, Zara was in a horrific boating accident. Her leg was nearly severed, and she was told she would likely never walk again. For the past four years, she has fought to regain her physical health, giving little thought to the odds set against her. With the help of doctors, countless hours of rehab, and the support of her family and community, Zara has brought her body back.

Not only is she walking, she is back on the board. Surfing is an integral part of her recovery. The practice has once again offered her psychological healing, and this time it has brought about physical healing as well. "It's a miracle really, and I'm grateful," she says. "But I do have quite a lot of pain, so I have to be calculated and mindful." She has found that movement is key, and surfing is essential. A self-proclaimed "surf rat," she now heads to the water every day "frothing," seeking out waves with an obsessive dedication.

Beyond family, surfing has become the most important thing in Zara's life. What she gets from the ocean is arguably more than most. It brings release—from trauma and from physical and psychic pain. It also offers her the stamina she needs to fuel her continued commitment to activism. On land she remains utterly fearless and as dynamic as she is in the water. Outspoken and unapologetically opinionated, Zara is a woman who sets her sights and doesn't get sidetracked. She's founded and supports numerous initiatives that fight for human and environmental rights.

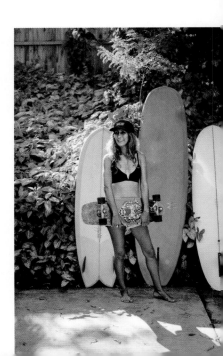

"Race and environmental issues are hand in hand," she says. "We've lost compassion for each other and the planet." Hers is a key voice pushing for change around sustainable agriculture practices, pollution, environmental policies, immigration reform, and universal health care. "If my one idea can change yours, and you can change the next person, that is the most powerful tool that a person could have," she says. This concept of starting small and gradually bringing people in one at a time was part of the inspiration for cofounding

the Radical Hope Club. Ignited by needs directly within her community, Zara works together with like-minded locals and Aboriginal leaders to educate people on land use, sustainability, and conversations around race and policy. "We're going to start a community garden," she says. "People will come and speak on issues of race and environment. We'll teach, plant, feed the homeless. We'll educate on what we can do to sustain our land."

In addition to her ongoing list of charities and activist work, Zara also cofounded the popular Byron Bay Comedy Festival, recently pushing to make the event plastic-free and carbon-neutral. Surfing and activism are central to her existence; along with her family, they are perhaps the reason for it. Despite the traumas of the past and the pain of the present, Zara is relentless in her commitment to a better future—for herself, her family, and for the world. "If we have the time and the space to dream something better, then comes the question, 'What do you stand for? What kind of world do you want to live in? What kind of world do you want to leave behind for your children?' And then you let the work begin and not be afraid of the result. Sometimes you lose, but that's not a good enough reason not to fight."

The
CHAMPIONS

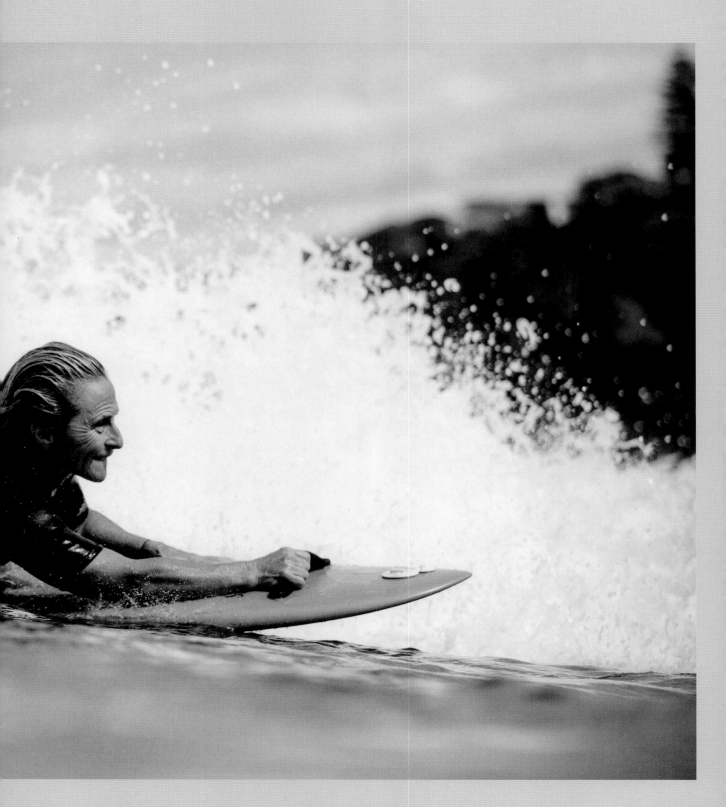

Stephanie *GILMORE*

Duranbah, Australia

W hat would Stephanie Gilmore do if she wasn't busy being the most influential female surfer in the world? "I'd love to be a rock star," she says, with a smile. "Maybe when I retire from surfing, I'll become an old, washed-up rock star. That could work!" The fact is, Stephanie is already a star, playing to an adoring audience of millions with her phenomenal performances on the waves.

Stephanie surfs like no one else on the planet, fierce but feminine, uncompromisingly competitive but possessed with a humility that has allowed her to continually evolve. "You can be a world champ a million times over, but no one's ever really going to be perfect in the ocean," she says. "You can constantly learn how to surf stronger and better or funky or however it is that you want to surf. For me, there is an endless pursuit of learning and evolution. That's what keeps me coming back."

Raised in northern New South Wales, she grew up surfing the beaches at Kingscliff (Main Beach, Bowls Club, and Cudgen Reef) and just over the Queensland border at Snapper Rocks and

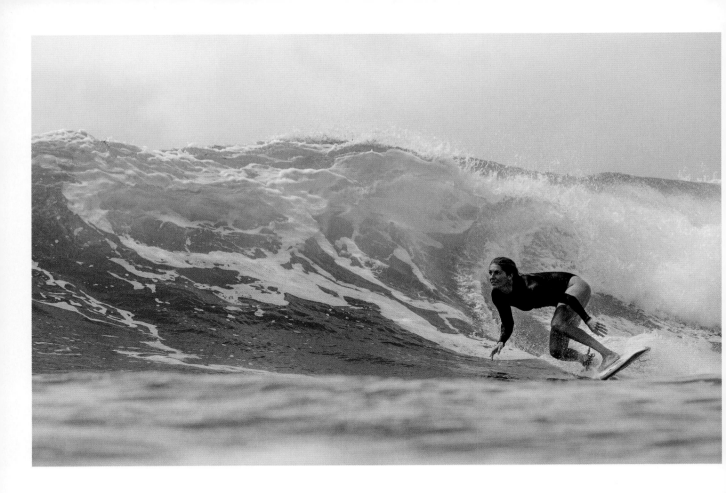

"For me, there is an endless
pursuit of learning and
evolution. That's what
keeps me coming back."

Rainbow Bay. She won her first world title as a rookie in 2005 to this day the first surfer, male or female, ever to do so. That win, she says, "was a definitive moment in not only my career but my life, because it really made me understand the power of visualization and manifesting things in your life, of having a dream of something and chasing after it and making it happen, but also thinking, 'Okay, I achieved that, what can I do next?'"

Now vying for her eighth world title win, Stephanie is likely to become one of the most decorated surfers in history. She is also unquestionably the most successful woman in Australian sport, chosen to lead her national surf team into the sport's very first Olympic competition. Despite the endless accolades, however, it is her humble, easygoing attitude that allows her to continually embrace the challenges as they present themselves. "I try to keep a balanced approach the whole way along, which is how I've approached everything in my life," she says. "I love the challenge of rising to the occasion when it comes, but not being overwhelmed, and also enjoying the process along the way."

Both in and out of the water, Stephanie is regarded as an indomitable force. She doesn't miss an opportunity to use her fame to educate and inspire and engender serious change. Her fierce engagement has been supported in large part by her collaborations with her sister and manager, Whitney. "She has been hugely

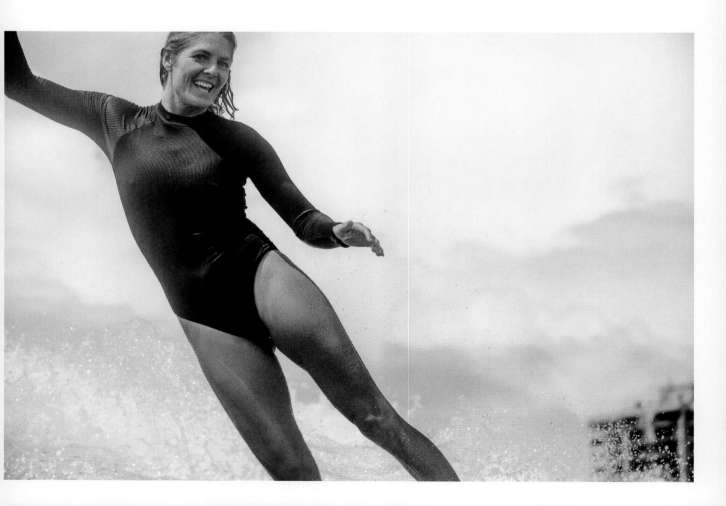

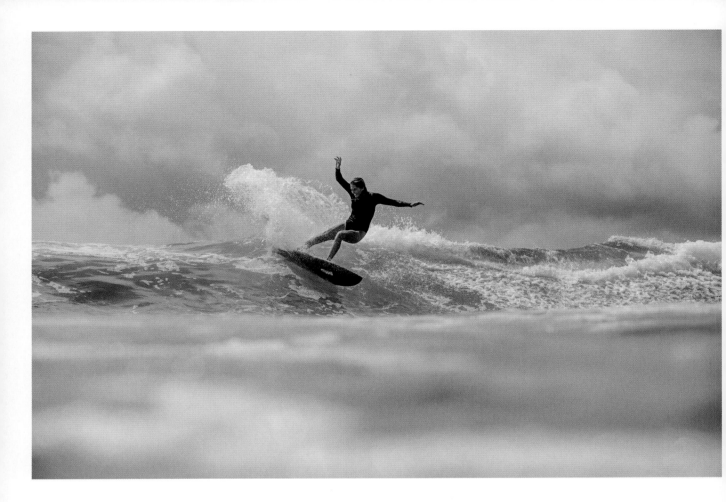

influential," Stephanie says. "I think about how my career might have been without her, and it would've looked very different. I'd say my surfing achievements would have been the same but in terms of my brand—I know that all of that has come from Whitney's vision of what she can do with my personality and my surfing style."

The two have worked in tandem to define and focus Stephanie's messaging and image, bringing on partnerships and sponsorships that are truly reflective of their mutual ethos and beliefs. "Whitney has taught me so much," Stephanie says. "Just be able to have great conversations and tell stories, and keep them engaged with what you're saying. It's been a great relationship for the both of us. And we haven't killed each other yet! She's very much more of the control system, and I'm just going along for the ride."

There from the beginning of Stephanie's career, Whitney has become the curator of the Stephanie Gilmore global brand. With her sister's support, Stephanie has focused her attention on the issues that mean the most to her: ocean awareness and conservation, sustainability, and inclusion. "I use my voice to show that the power of surfing is not about world titles but having a relationship with the ocean," she says. "It is so important in so many ways, for mental health, for adding value to our lives. I think telling those stories is a part of my duty as a surfer."

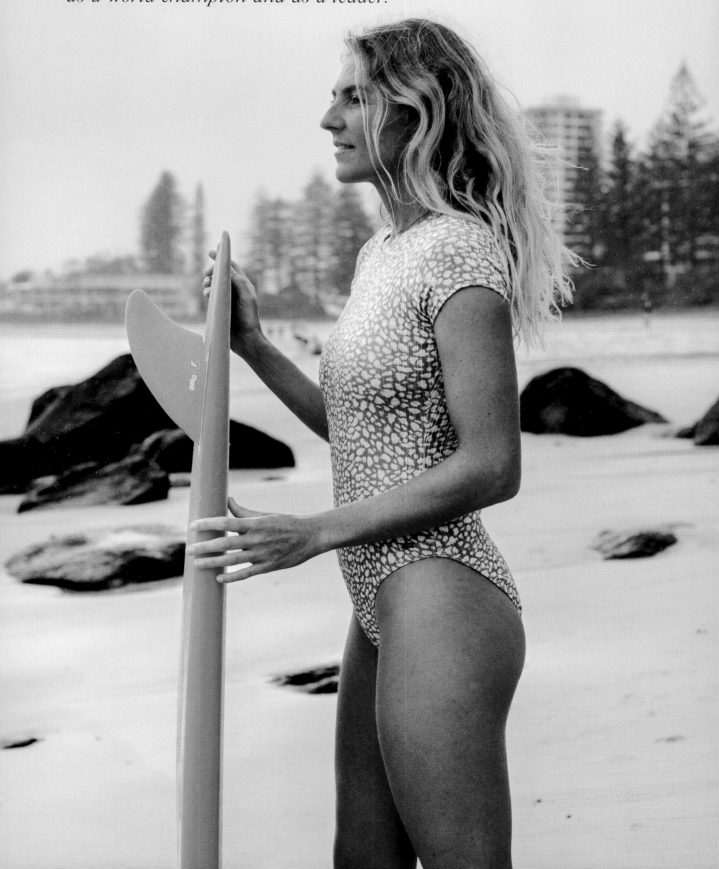

"I really needed to stop and think more on the bigger picture as to what I can achieve as a world champion and as a leader."

Together, the sisters have taken on and called out inequity. It was Whitney who pushed Stephanie (and the women around her) to not only talk more about the pay gap in women's pro surfing but to take action. "Look, it's 2021," Stephanie says. "The fact that we're even still having these conversations is ridiculous. If women's surfing had had the same support from the very beginning, maybe we would be at the same level as the men. We're trying to make sure that women are respected on their sporting platforms as much as their male counterparts. And striving to make those changes within our sport has been really important." As a result of their campaigning, the World Surf League now awards equal winnings in both the men's and women's championships. "If you can't make a change in your own industry," Stephanie says, "then where can you make a change? I really needed to stop and think more on the bigger picture as to what I can achieve as a world champion and as a leader. And I'm so proud that I'm a surfer and we could make these changes and show people that this is how it should be."

This revaluation is one of the pivotal moments in Stephanie's life and career. Another occurred in 2010, when, in the midst of her meteoric rise in the surf world, she was brutally attacked in her home by an unknown assailant. She was just twenty-two years old. "That was a moment in time that changed my perspective on the fact that life's not all rainbows and world title trophies," she says. "A lot of shit happens, and people go through gnarly stuff every day. It took me a couple years to find my feet again and find that strong, intuitive, competitive nature that I had." Suffering from the trauma, Stephanie found it difficult to focus on training. "There were definitely moments where I thought, 'Oh, maybe I'm done,'" she says. "And there were a lot of people saying the same. But I used it as fuel. I turned it around on itself and said, 'I'm not done. I've got so much more in the tank.'"

Three favorite surf breaks . . .

Greenmount Beach, Australia;
Lance's Right, Sumatra; and
Rocky Point, Hawaii.

Most important challenge
facing women today . . .

Loving ourselves for who we truly
are, in all our imperfect ways.

Music you surf to . . .

Hawaiian slack key guitar.

A quote to live by . . .

"You don't have to be great
to start, but you have to
start to be great."—Zig Ziglar

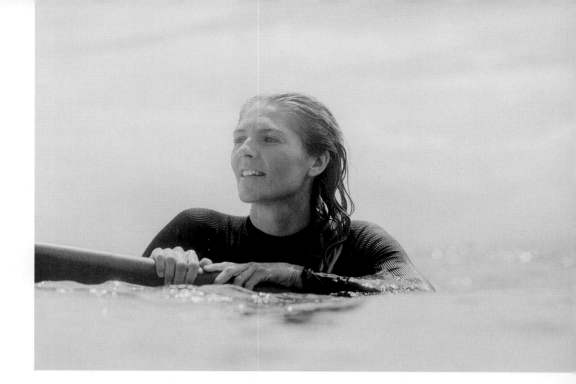

For Stephanie, surfing has always been both about embracing the pleasure and not shying away from the pressure. "It's really important to remind yourself that challenges in life are a great way to see what you're actually capable of," she says. "The most magical moments are when you realize what you can do when you're pushed out of your comfort zone. I get nervous. But nerves are great. Nerves remind you that you're excited to be there, that you're in the right place."

Stephanie definitely seems in the right place—surfing (and living) with complete commitment, unreserved passion, and inimitable style. She's become the rock star she wanted to be in every sense, and fans love it. "Never underestimate yourself" is the advice she offers. "Don't define who you are based on what you do. And push yourself, work hard, don't be afraid of challenges. They're just opportunities that have been presented for you to see just how deep you can go and how great you can be."

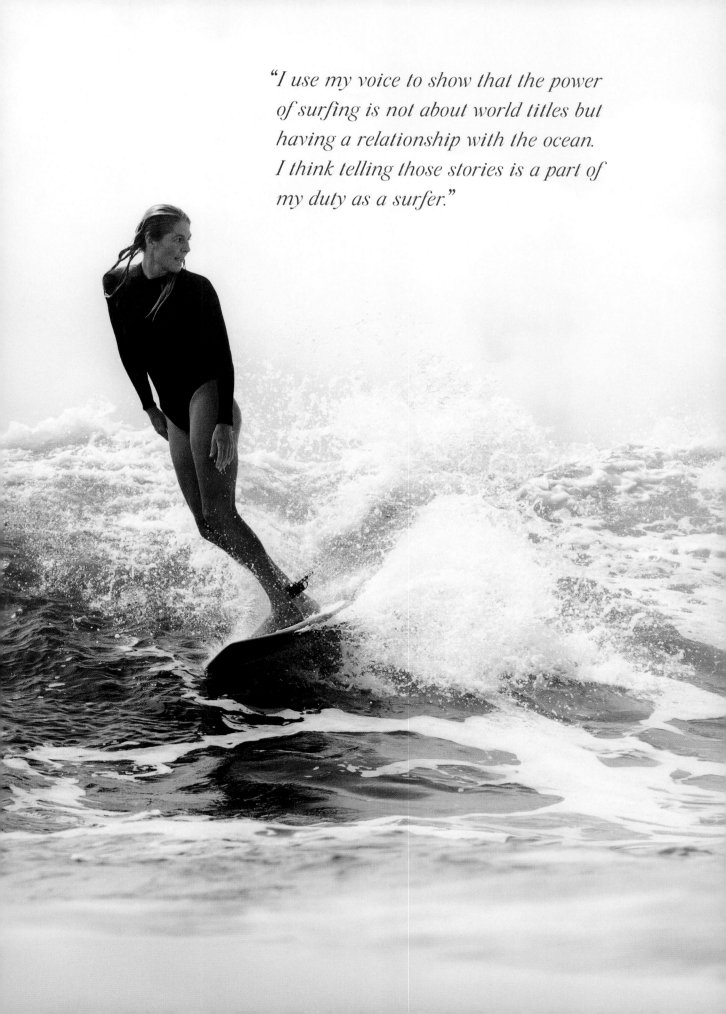

"I use my voice to show that the power of surfing is not about world titles but having a relationship with the ocean. I think telling those stories is a part of my duty as a surfer."

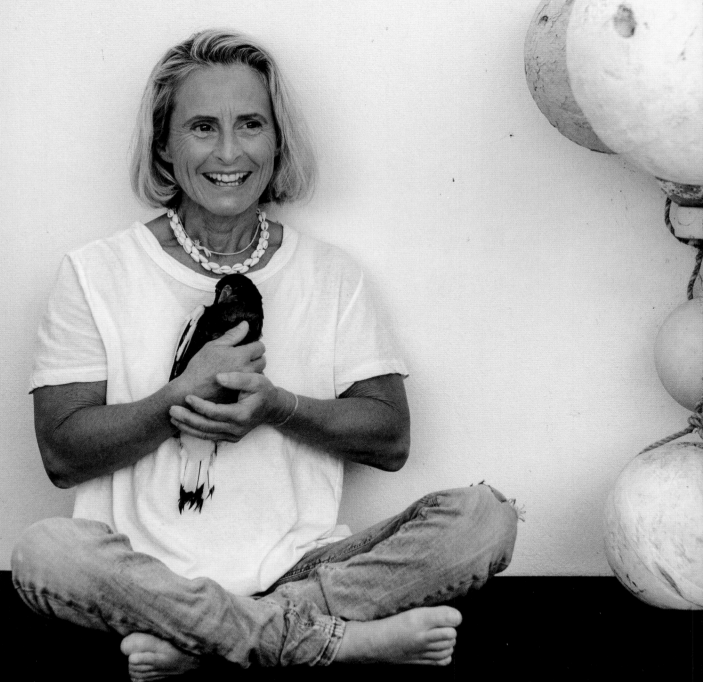

Sam
BLOOM

Newport, Australia

"If you experience what I have, you need hope to find something that you love doing, whether it be a sport, art, or something you care about. Creating purpose will eventually lead you to happiness."

For Sam Bloom, life is divided into two distinct parts—before the accident and after. Before, there was her identity: fiercely independent, a natural athlete, and enthusiastic world traveler. And then there was the tragic fall off a hotel rooftop that broke her body and, for a while at least, her spirit. By now, many are familiar with her story—paralyzed from the chest down by the terrible accident in Thailand while on vacation with her husband and three young sons. Others are familiar with her redemption as well, saved from a depression that threatened to engulf her by an unlikely connection with an injured magpie Sam named Penguin. This part of her life is now the subject of two books as well as a feature film, *Penguin Bloom*, starring Naomi Watts.

There are many threads that run through all parts of Sam's life, not least her independent spirit and her competitive nature. In the narrative arc of her story, she is embarking on a third chapter, one of renewal. Now is the phase of Sam the activist and athlete, author

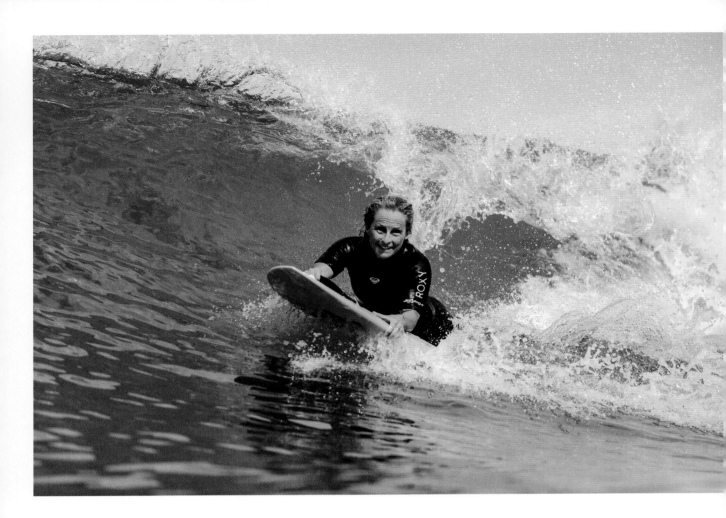

and public speaker, international kayaker, and a two-time world Para Surf champion. In footage of her first victory in 2018, we watch her glide on waves, in her element, her face alight with pure rapture. She comes to the shore and realizes she's won.

Recalling that moment, Sam lights up. "It was just unreal," she says. "I didn't know I was winning. And then, that's when the team rushed down, shouting, 'You won, you won!!' I was so stoked." In the footage, shot by her husband, Cam, Sam is swept up by family and friends and carried across the sand to chants of "Aussie! Aussie! Aussie!" "It's awesome representing your country," she says. "I was proud of that, but I was also really proud that I won for Cam and the kids, because they were there. They were like, 'Damn! Look how far you've come?!'"

After the fall, Sam was in the hospital for seven months, but it was the period that followed that almost overwhelmed her entirely. Anger, isolation, grief, guilt, and a feeling of helplessness gave way to a deep depression. She mourned the loss of her old self—happy, carefree Sam, surfing the waves of Sydney's North Bilgola Beach, running the hillsides by her hometown, climbing the jagged rocks

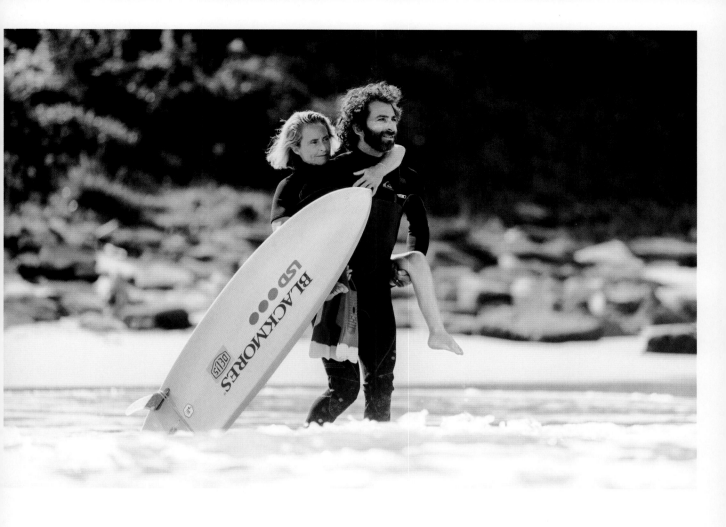

Hardest-won lesson you've learned about being a mother . . .

Accepting that the natural role of parent and child has been so cruelly reversed since my accident. Seeing my boys' compassion and love for me is something I'll always be thankful for.

A quote to live by . . .

Don't put your dreams on hold. Make them happen today, not tomorrow.

Things people don't know about you . . .

I decided to become a nurse when I was six years old. I finished an exam at university so I could race into the city to see Nelson Mandela.

When feeling like we've lost our strength, how do we regain it?

Remember that we are all stronger and more courageous than we think we are. Even though it can be hard at times, have faith in your ability to overcome the challenges you are facing.

that form headlands overlooking the sea. "I'm not religious, but there is a spot in North Bilgola, just off the rocks where I'd go surfing, that was almost like my church," she says. "It's where I spent my childhood, wandering, looking for octopus. And every day after school, we'd be surrounded by nature and hang out down at the beach. It was just beautiful."

In between travels and her work as a neurosurgical nurse, Sam would wander solo into the spectacular natural world that shaped her. "I used to go up to the National Park, and I'd sit on this particular rock and watch the sea. That was my happy place. I miss that so much now. I'd do anything to get back to my rock." Sam's recovery is an ongoing journey, and she has overcome myriad physical obstacles to engage fully in her life, but the dark thoughts still lurk. "There was also a lot of guilt, guilt that I'm not the same person," she says. "I hated it so much because I couldn't do anything on my own. I couldn't be the person I was."

Sam relies on movement—exercise and sports—as a way to push through pain and stave off the emotional demons. Immersion in the natural world also helped. The story of Sam's adoption of the injured magpie "Penguin" is well documented in the press, as well as in books and a feature film. The baby bird became both a part of the family and an inspiration for Sam to carry on. But it was the first time she got back in her kayak that Sam says she felt a bigger

"It made me feel a bit like my old self again. That is what surfing brings to my life."

shift occur. "Kayaking was so good for my head. I was on the water again and surrounded by nature. I could be on my own. That was so pivotal for my mental health." The kayaking led to boxing, which led to weight training, and finally, finally back to her surfboard. "It made me feel a bit like my old self again. That is what surfing brings to my life."

At first she was resistant. The para surfing techniques didn't feel right, and she felt that what she was doing wasn't surfing. But encouraged by her husband and sons, as well as an inspiring letter from Nola Wilson, mother to Australian surf pro Julian Wilson, Sam finally acquiesced. "My son would have a board under his arm and he'd look at me and say, 'Oh, sorry, Mom, I know you'd really love to go for a surf,'" she says. "He felt guilty, and that made me feel even worse. So when I finally got back out on my board, it was awesome because we both caught a wave together; we just had so much fun."

Sam is now looking ahead to more World Para Surf competition victories. Surfing has shaped her new life in many ways. She has redefined herself as an athlete, resurrected herself as a mother and wife, and is a fierce advocate and public speaker. Sam today is perhaps even more powerful than before. "I am ridiculously patient now because I always have to wait," she laughs. "And it's made me come out of my shell. Public speaking wouldn't have happened before the accident. I feel more confident talking to people now than before the accident. And of course representing Australia for kayaking and surfing, that would never have happened before. Also, two books and a movie—so yes, many good things have happened, and I'm proud of that."

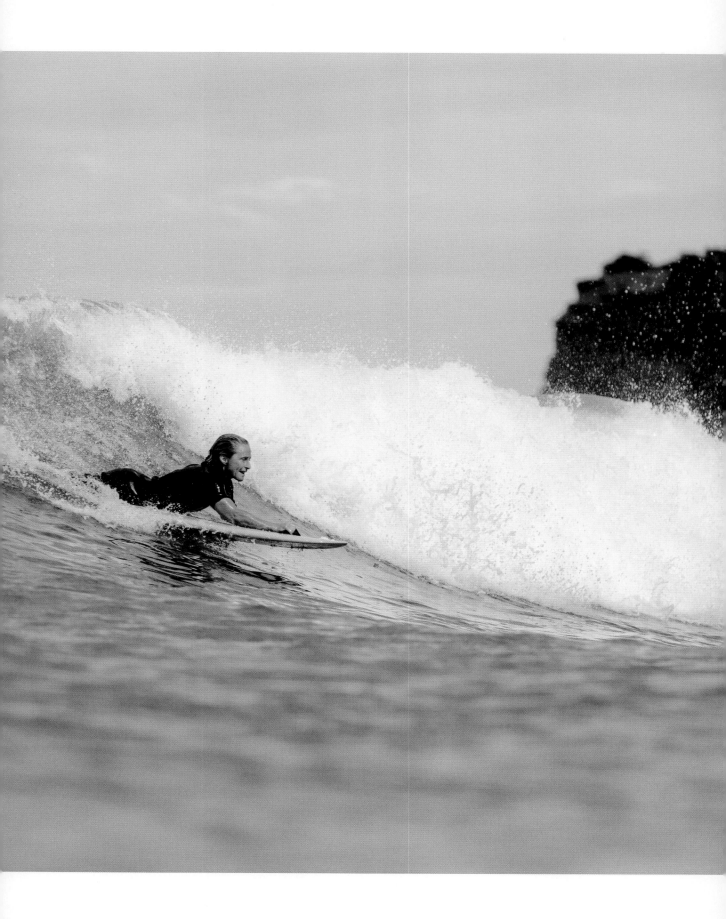

"If you want to do something, then do it because you never know what will happen."

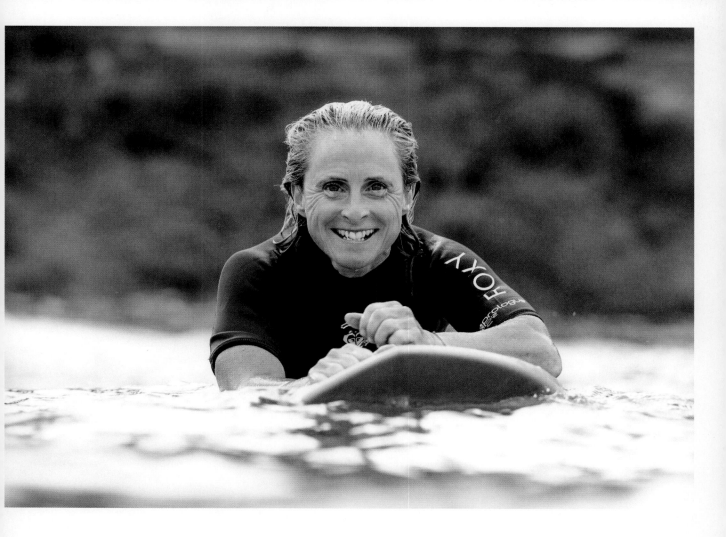

Sam acknowledges that the outpouring of messages she's received from those inspired by her story to tackle their own struggles has offered much solace. "The stories I hear are so sad, but it's all totally worth it if I can help a few people," she says. "I used to be a nurse, so I feel like I'm sort of helping people again, which is really rewarding." That is not to say she'll ever be accepting of what happened. "I'll never be okay with it," she says quietly, but she *will* keep moving, raising funds and awareness for spinal cord injury research, pushing herself back into the light. The accident has taken away so much, but it has offered her something invaluable—perspective.

"If you want to do something," she says, "then do it, because you never know what will happen." Sam has found her own way forward through surfing, nature, her family, and her own unexpected resilience. "If you experience what I have, you need hope to find something that you love doing, whether it be a sport, art, or something you care about. Creating purpose will eventually lead you to happiness." It is a different happiness to the carefree existence before the accident, but the moments of joy are more profound, more resonant. She certainly isn't taking her future for granted.

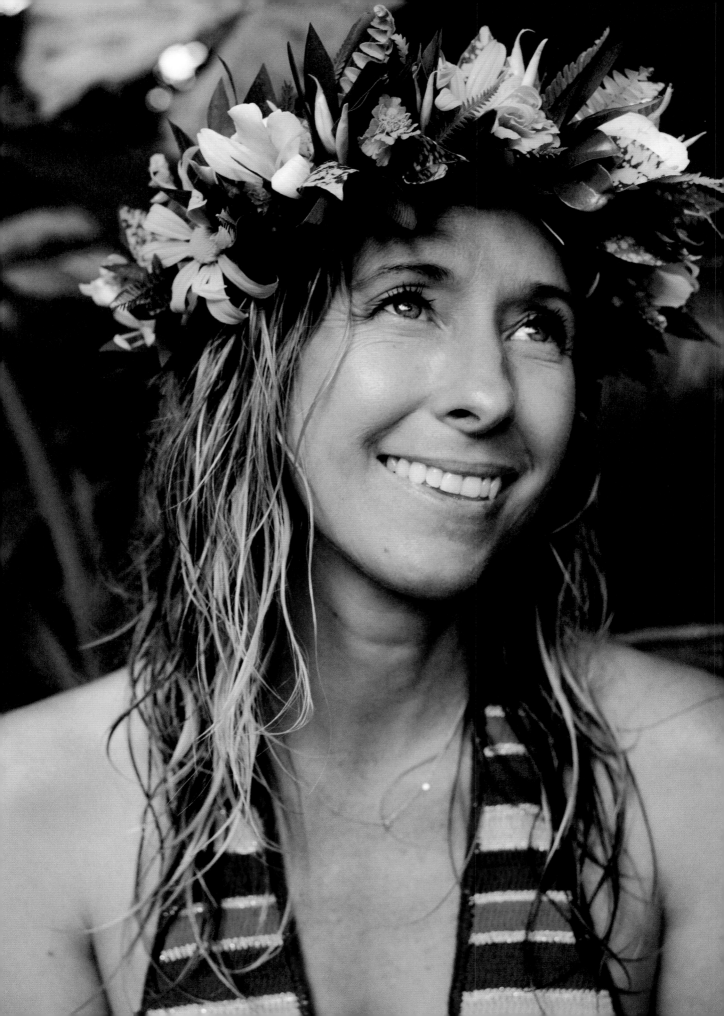

Daize Shayne GOODWIN

Kauai, United States

Daize Shayne Goodwin surfed her way out of a dysfunctional childhood and into the envied position of two-time longboarding world champion (1999 and 2004), altering the face of women's surfing along the way with her rebellious, unapologetically radical presence. She then transformed herself—from pro surfer to artist, writing music, making albums, and playing concerts in Madison Square Garden. She traveled the world for more than a year with her young family as the focus of a documentary film. But it was only when she slowed herself down that Daize discovered a sense of peace and ease that had always eluded her. On returning to her home in Kauai, where she now lives with her husband and three children, Daize finally found a long-sought-after equilibrium.

The Goodwin compound sits amid fruit groves and lush flowerbeds, the hundred-year-old cottage and scattered outbuildings settled into the deep, mineral-rich soil of Kauai as if they have always been here. It is a place where kids run barefoot, following overgrown

141

trails to secret waterfalls, and where the towering volcanic green-ridged coastline dives down into the sea. Daize first arrived here a lifetime ago, as a sixteen-year-old tomboy escaping a fractured family life with few boundaries, which left her feeling lost and rootless. "I didn't really fit in. I didn't really know what I wanted to do in life," she says. "But I knew surfing was my main passion because it gave me a place where humility and boundaries were essential and also a kind of spirituality that I didn't have growing up, that I think we all want as kids."

Looking for a foundation, Daize focused on her studies and graduated early from high school. As soon as she got her diploma, she was off. "I went to Kauai and I surfed. And that's really what turned my whole head to the professional aspect—I could make a living from surfing." This realization set the course for her life and career, taking her far from the shores of Hanalei Bay—and ultimately back again.

Daize went pro, becoming the quintessential It Girl for '90s surf culture, beautiful but on her own terms, feminine but undeniably tough. Sponsored by Quiksilver and Roxy, Daize offered a drastically different vision of the woman surfer. "When I first started learning, the guys would drop in on me," she says. "They would laugh at me. But I knew that I was going to give them a run for their money." These "guys" included legendary surfers like the late Andy Irons and his brother Bruce, Roy Powers, and Reef McIntosh. "I could see their faces when I would catch a wave," she says. "They were kind of shocked. They saw my dedication and they saw my persistence."

Despite her success, Daize continually rejected the excesses of the pro world; her fear of losing it all kept her focused on her health, rest, and surfing itself. "That was my biggest fear," she says. "I didn't want to fail." Surfing gave her purpose and a community. "It was not only my way out, but it also connected me with the few girlfriends I had, who also had traumatic things happen to them. We teamed up. We didn't care that there were no girls in the lineup. We were unstoppable." Daize and her friends created and then defied the stereotypes, ultimately redefining female surf culture. "We wore men's board shorts and we cut them," she says. "We were our own thing. And it was saving us and holding us together. Now, women's surfing is taking off. There's thousands of women surfers. But when we started—there was zilch."

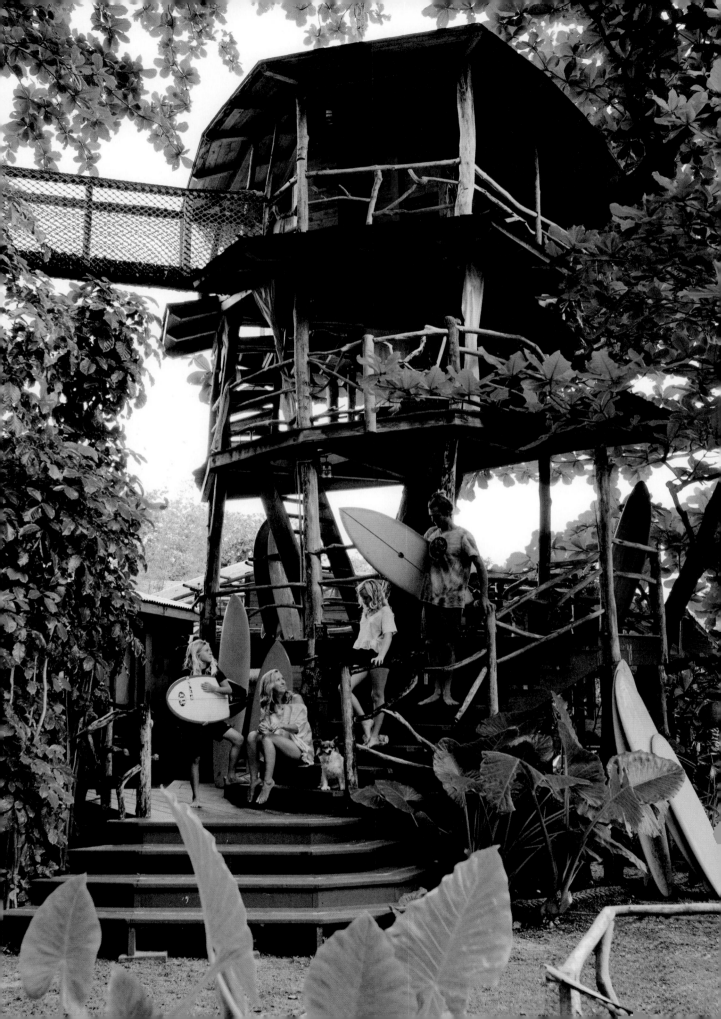

Riding waves back then, Daize was confident and self-assertive, but on shore she remained ill at ease. "You go surf and then you come in and you're still dealing with the same struggles," she says. Looking for other outlets for self-expression, Daize began to play guitar and write music. It wasn't long before she had a manager, a label, and an offer to move to Los Angeles to record. "That was one of my favorite times of my life," she says. "It was an incredible period of self-expression." Daize surfed each morning and headed to her rehearsal space at night to play music.

She married her longtime friend and fellow surfer Aamion Goodwin, and together they surfed the pro tour as Daize's music career also took off. Eventually, she grew increasingly uncomfortable with the direction that both her record label and her surf sponsors were pushing her. "At night I'm doing gigs with a short leather skirt, boots up to my knees," she says. "I can see what the guys in the audience are looking at. They're not looking at my heart. They're looking at my legs. It was the same with surfing, that a lot of it was our image, how we were pretty—instead of what we could do."

Just as she was questioning her identity as both surfer and creative, Daize found out she was pregnant with their first child. Motherhood, she says, "cracked open this part of me that I didn't even know existed. I just wanted to be a mom. I wanted to be able to give my kids a different life than I had. We were just going to have this amazing family." But early in their life together with their new baby (whom they named Given), the financial crisis hit. "The economy crashed, and we basically lost a lot of sponsors, my husband and I. We tried to open a small business. We failed miserably, then I was in survival mode of clocking in, clocking out.

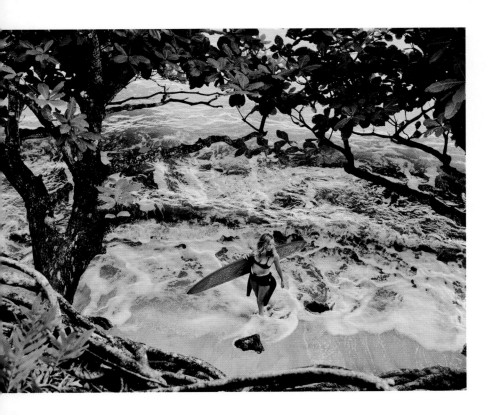

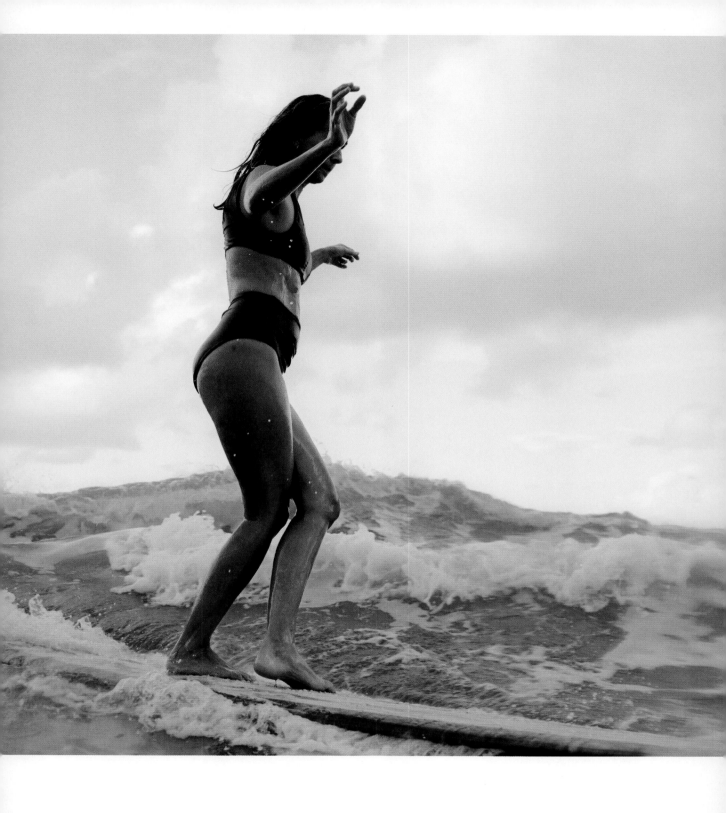

"That was my biggest fear. I didn't want to fail."

I had waitressing jobs. I was cleaning houses. I just really missed the freedom of being a pro athlete." Daize was desperate to escape.

During this period, the Goodwins were approached by director Jesse Bianchi with an opportunity to travel around the world as subjects for a documentary film. "We immediately said yes, 'Please! Let's just get out of here!'" Daize says. The resulting film, *Given*, follows the family on a cathartic yearlong adventure through more than fifteen countries—an incredible document of a young family seeking to raise their children as global citizens.

At the end of production, the Goodwins moved back to Kauai to begin yet another new life in the place they had always felt most at home. These days, Daize, with her children, Given, True, and Shyne, works from the family's compound, counseling clients on health and wellness. She also helps run the family's shaved ice shack, the Wishing Well, in nearby Hanalei. Along with her husband, she founded Slow Yourself Down, their signature ethical and sustainable apparel brand. The latter was inspired by the filming of *Given*. "We were doing an interview for the film, and my husband said, 'If you slow yourself down, you'll see so much more.' And it became not just a slogan but a way of life," she says.

The most important lesson you teach your daughter . . .

Be kind and compassionate, but as fierce as a blazing fire. Learn how to work hard and play harder, and remember life is quick, so move each day like it's your last.

A quote to live by . . .

"There are only two days in the year that nothing can be done. One is called Yesterday and the other is called Tomorrow. So today is the right day to Love, Believe, Do, and mostly Live."—Dalai Lama

When do you feel most free?

When I'm dancing with loud music playing, surfing waves—high waves—playing guitar with three or four other musicians, or alone in a quiet space.

Favorite surf film of all time . . .

Litmus

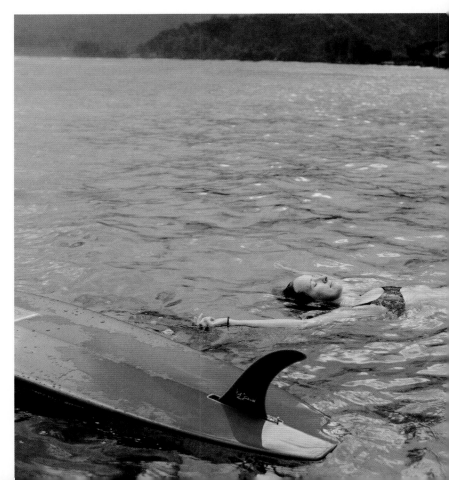

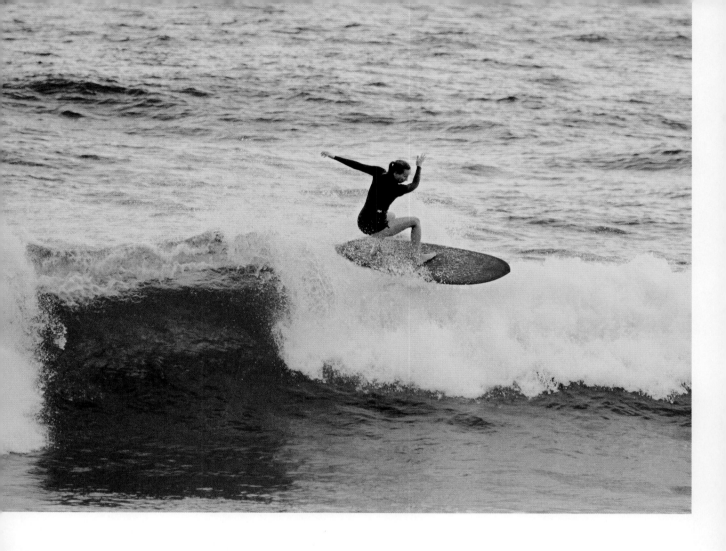

"Surfing was my main passion because it gave me a place where humility and boundaries were essential and also a kind of spirituality that I didn't have growing up, that I think we all want as kids."

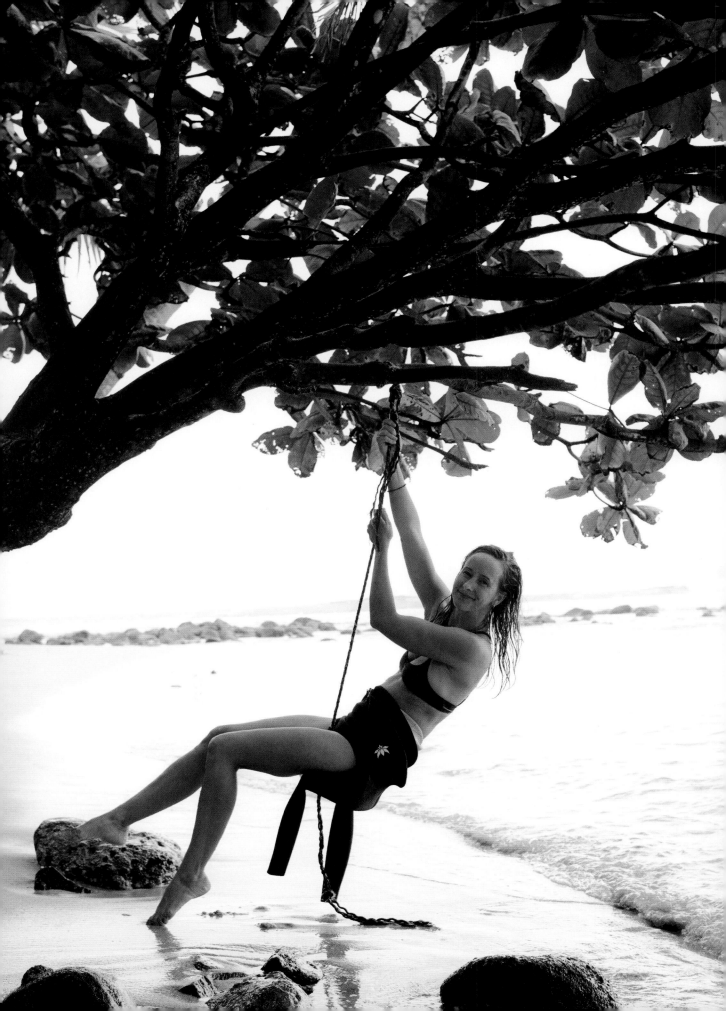

It is the way Daize and her family live now; after all the moving around on surf tours, concert gigs, and global documentary filming, she recognizes that moving too fast may mean missing out on the things that really matter—community, family, nature, service, and the freedom found in being still and in engaging intimately with life. "I really feel like we want to do these big things and we want to change the world," she says, "but what I've learned is that you can create change right where you are."

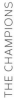

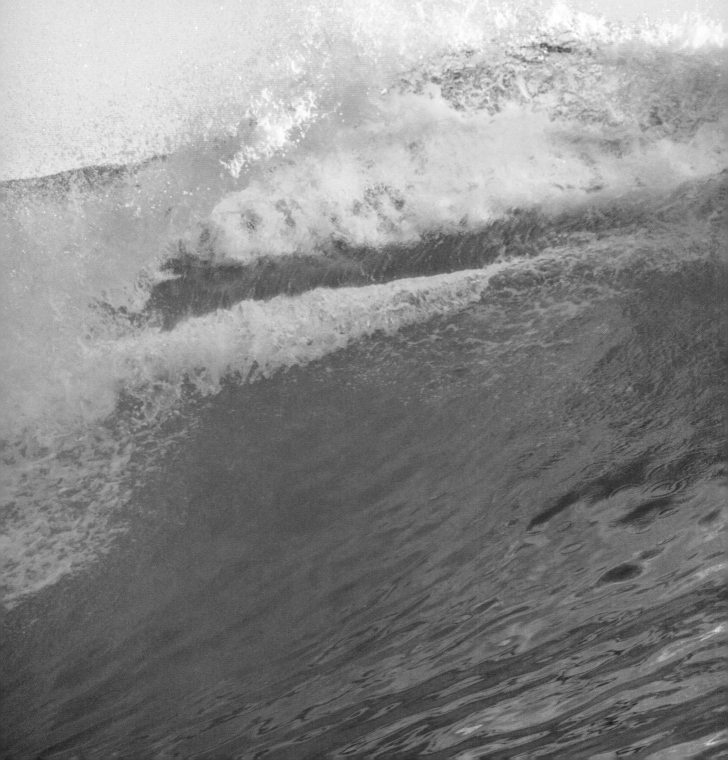

Maya
GABEIRA

Nazaré, Portugal

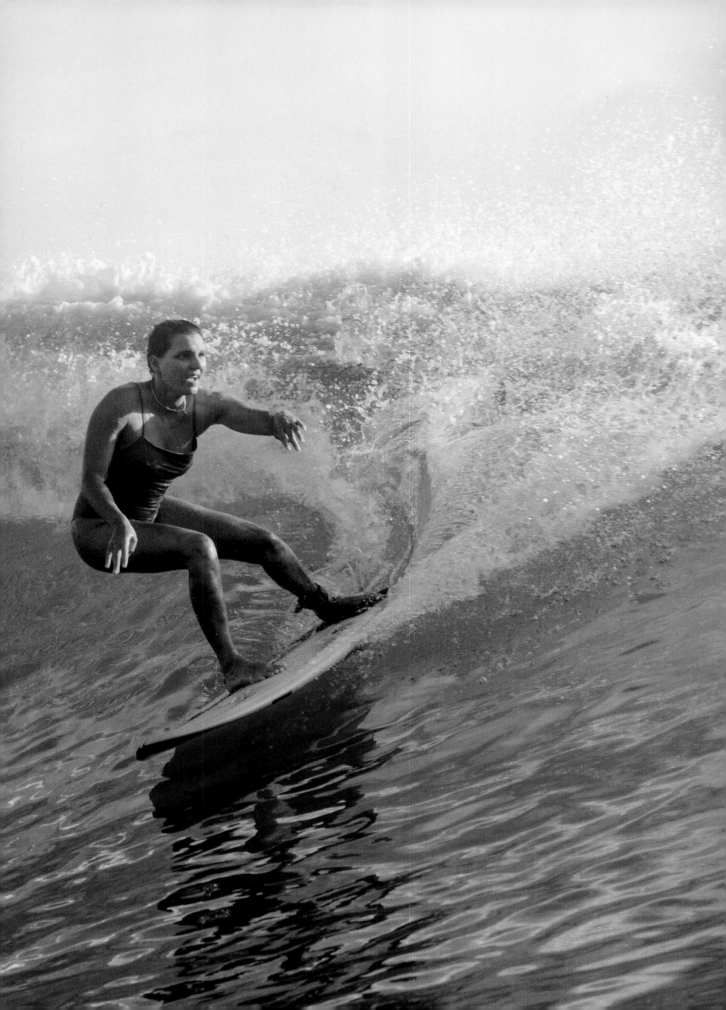

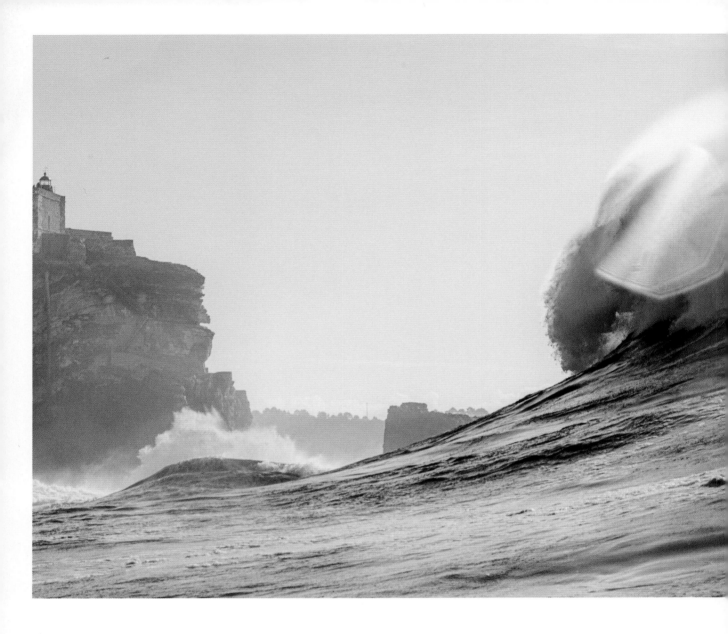

On a winter's morning in 2020, just off the coast of Portugal, Maya Gabeira surfed one of the largest waves in the world. At 73.5 feet, it was the biggest swell that anyone—male or female—had ridden that year. The scale, the sheer vastness of the wall of water that forms at the infamous break at Nazaré each season, is almost impossible to comprehend; but the footage offers a glimpse of the minute speck that was Maya, the enormous break falling behind her, like a mountain crashing down, gigantic white teeth snapping at her tiny frame.

The feat landed her a world record, although she readily admits that she wasn't the favorite to win and that her slim victory should not diminish the accomplishments of her female peers. Maya seems to be fueled by the same unrelenting force that compels all the great explorers—the desire to do what no one else has ever done, go where no one else has ever been. She likes to explore uncharted

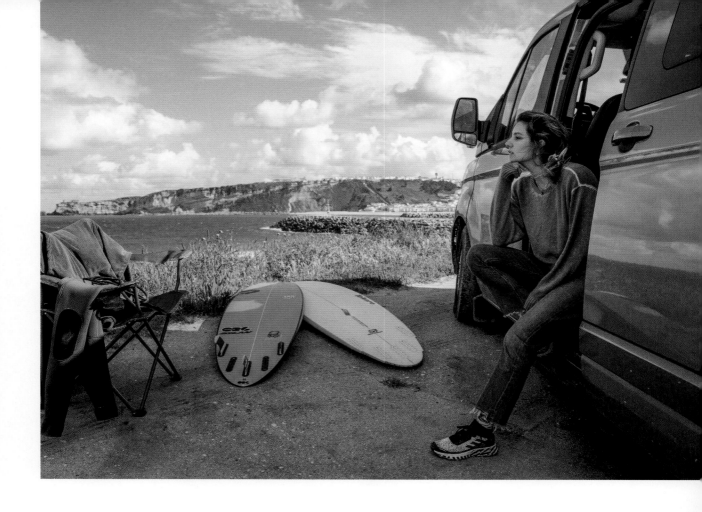

Boards you ride . . .

*Twin fin shaped by Org Surfboards,
5'7" and 5'9".
Gun shaped by Tokoro, 9'8" and 10'4"
thruster and quad setup.*

How do you embrace the fear?

*I understand all the great things
you can do with it.*

A quote to live by . . .

Never give up on your dream.

Something people may not
know about you . . .

I am an introvert at heart.

The weirdest thing you've
heard in the lineup . . .

*That even a grandmother could
tow into the waves that I do.*

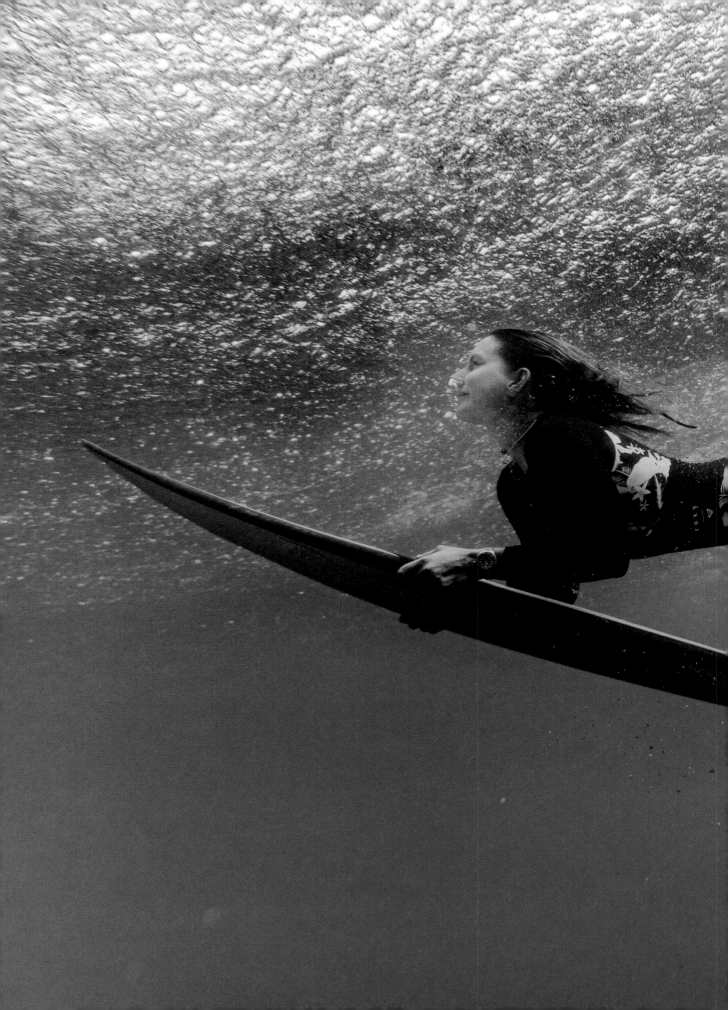

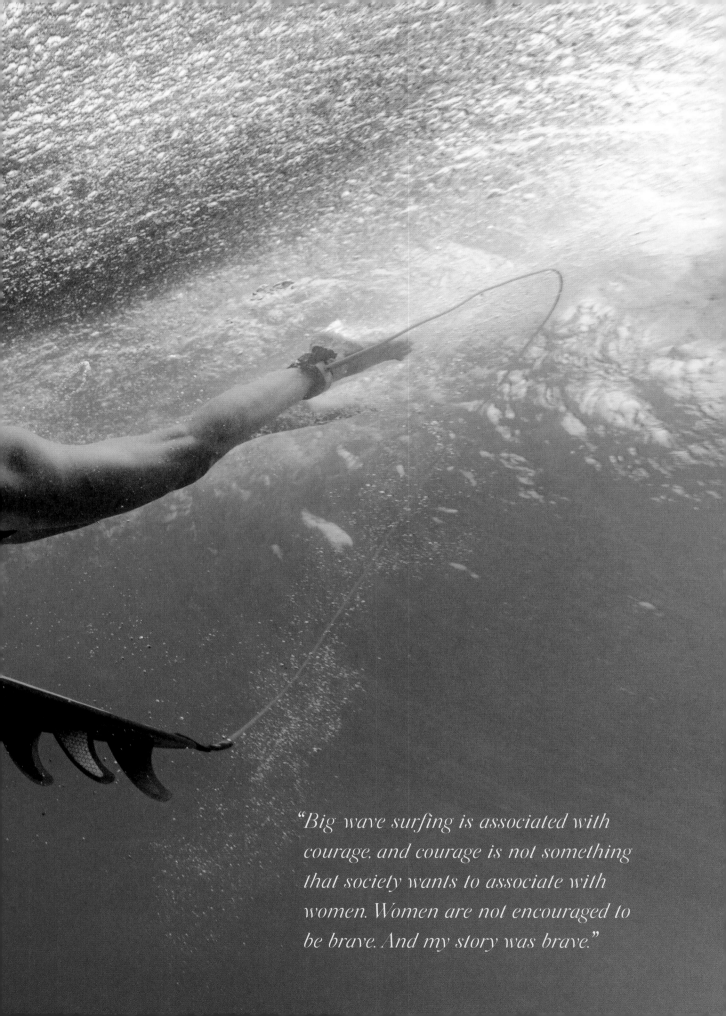

"Big-wave surfing is associated with courage, and courage is not something that society wants to associate with women. Women are not encouraged to be brave. And my story was brave."

territory in physical terms as well as in the mind. "I always found it much easier to work being pushed by nature rather than by people," she says. "From the beginning, there was a desire to prove myself for myself, to prove that a woman could be in that environment. There was passion for the ocean, passion for adrenaline, intensity, speed. And there was the will to overcome my fear, to overcome the challenges, to be pushed—always."

The first time Maya surfed in Nazaré, in 2013, the same wave that would later win her a world record nearly killed her. She had conquered Mavericks and Waimea. She had surfed massive peaks in the Alaskan Sea and the shark-infested waters of South Africa's notorious "Dungeons." But her near-death experience on the Portuguese wave—something that might have kept almost anyone else out of the water and that break in particular—seemed only to have deepened Maya's desire to return to it. "I just kept asking myself, 'Do I really want this? Should I keep doing this? Am I good enough?'" The answer was always: "YES."

Born into a family of Brazilian intellectuals, Maya first turned to surfing as a way to manage her childhood asthma, after advice from medical professionals. "My family was not really a sports family," she says. "We used to rarely even go to the beach." As a teen, she began surfing on the beaches of Rio. "I was not a natural," she says, "and I was very afraid of the ocean because I didn't grow up swimming. It was so scary, so foreign, and so unknown. I wanted to explore it." The curiosity, the overcoming of fear in favor of exploration, pushed her forward. "I was not very good, but I took it very seriously. That's all I wanted to do. It was my life's purpose."

At fifteen, Maya convinced her family to let her leave Brazil, following the waves to Australia's Gold Coast and later, when she was seventeen, to Hawaii. "Hawaii is where I first saw big waves, at Blue Crush and Pipeline," she says. "I already had a lot of fantasies about big waves." There were very few women at the time in those lineups, a fact that only fueled Maya's determination. "I was already understanding that if I was ever able to succeed," she says, "it would not be on the conventional path." That revelation set Maya on the path to big-wave surfing. She started the transition slowly, borrowing boards, asking older, more experienced riders to take her out on larger and larger breaks. "I loved the intensity," she says. "I loved everything about it."

When Maya first began breaking records on big waves, she unexpectedly found herself the subject of criticism. "It was harsh at times because big-wave surfing is associated with courage, and courage is not something that society wants to associate with women," she says. "Women are not encouraged to be brave. And my story was brave. My [male] peers were being celebrated for bravery, and I was being criticized for bravery." After her traumatic experience at Nazaré, Maya faced international backlash and

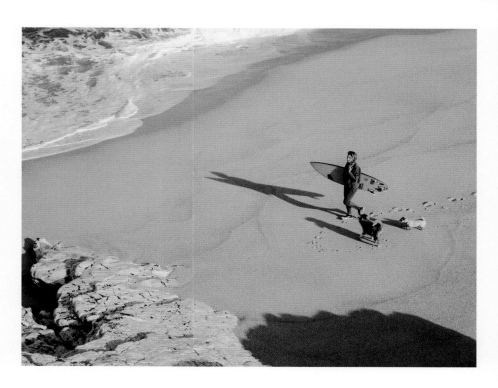

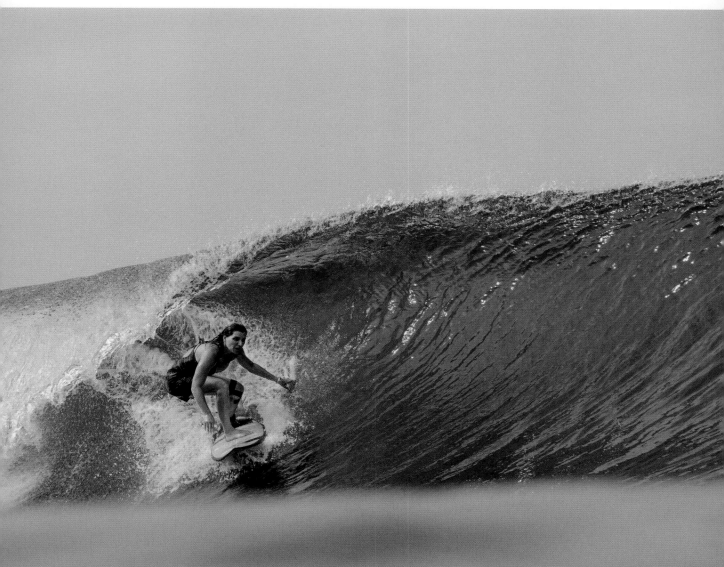

criticism, but again this adversity only fueled her. It took four years of physical rehab, therapy, and intense training to manage her debilitating anxiety. When she finally returned to Nazaré in 2018, she was utterly terrified. "All the insecurities, all the doubts, all the questions, all the things that people hammered in my mind," she says, "it was pulling me down. And the trauma itself, understanding that I was going back to perform in conditions that had almost killed me."

When Maya succeeded in breaking the world record in 2018, she proved to herself that she was indeed worthy of the wave. "I don't know who I am if I'm not doing that," she says. "It's a big part of my identity, and I struggled with that a lot when it was taken from me for so many years when I was rehabbing. It was like I wasn't sure who I was, and it was very difficult to understand who I was and how I could contribute to the world."

Now a two-time Guinness World Record holder and one of the most famous women in the sport, Maya has made contributions that go beyond her achievements in the water. On the board of directors of Oceana, Maya studies research findings on ocean health and votes on future science-based policy campaigns. Her work with UNESCO as global ambassador involves raising awareness around climate change, overfishing, and pollution. And because of her big-wave triumphs, Maya earned respect not only for herself but for other up-and-coming women big-wave riders. "The women now, they're well respected within the community and by their peers as great surfers," she says. "There has been a massive shift from maybe six years to now; society has really emphasized equality and has really stopped allowing men to harshly criticize women in the working environment."

Maya also writes children's books—epic tales of young girls overcoming big odds and dreaming big dreams. "When I was younger, I had massive dreams," she says. "I imagined one day I would surf the tallest waves. It was difficult to feel welcomed in that environment. But I never forgot my dream. There's nothing big I have achieved that I didn't dream first."

Turning dreams into reality, desire into manifestation, pushing aside fear and facing death to achieve the unimaginable, this is Maya's legacy. For her, there will always be more to accomplish and a bigger wave just up ahead, but her desires and goals have evolved. "I'm not going to tell you all I do is hope for a third world record, because that's not true," she says. "If it happens, it's a result of me being a better athlete, more mature, and deserving of that bigger wave. I put my life on the line for this. And it used to be that I would do anything for this, but not anymore. I want to experience life. I want to be here. I want to live."

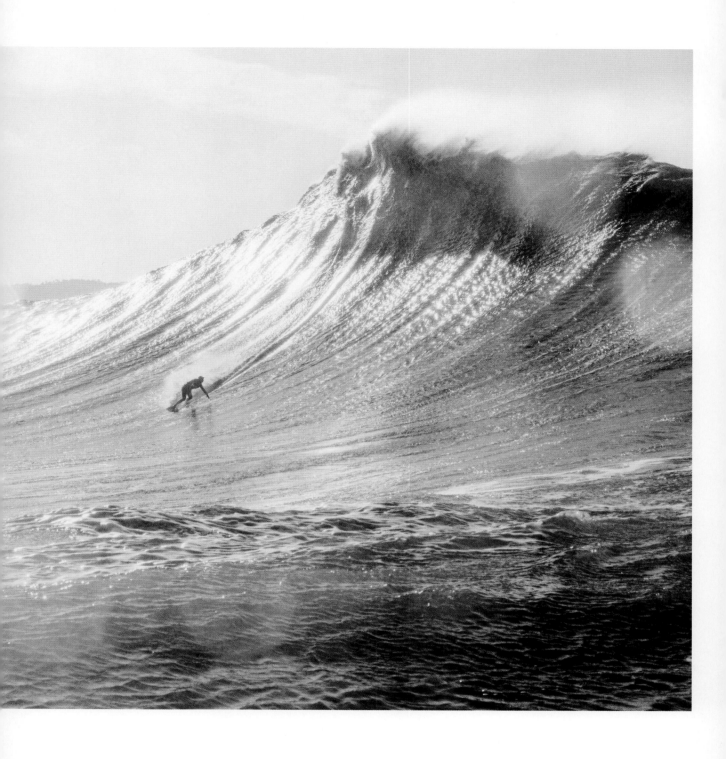

"*I imagined one day I would surf the tallest waves. It was difficult to feel welcomed in that environment. But I never forgot my dream. There's nothing big I have achieved that I didn't dream first.*"

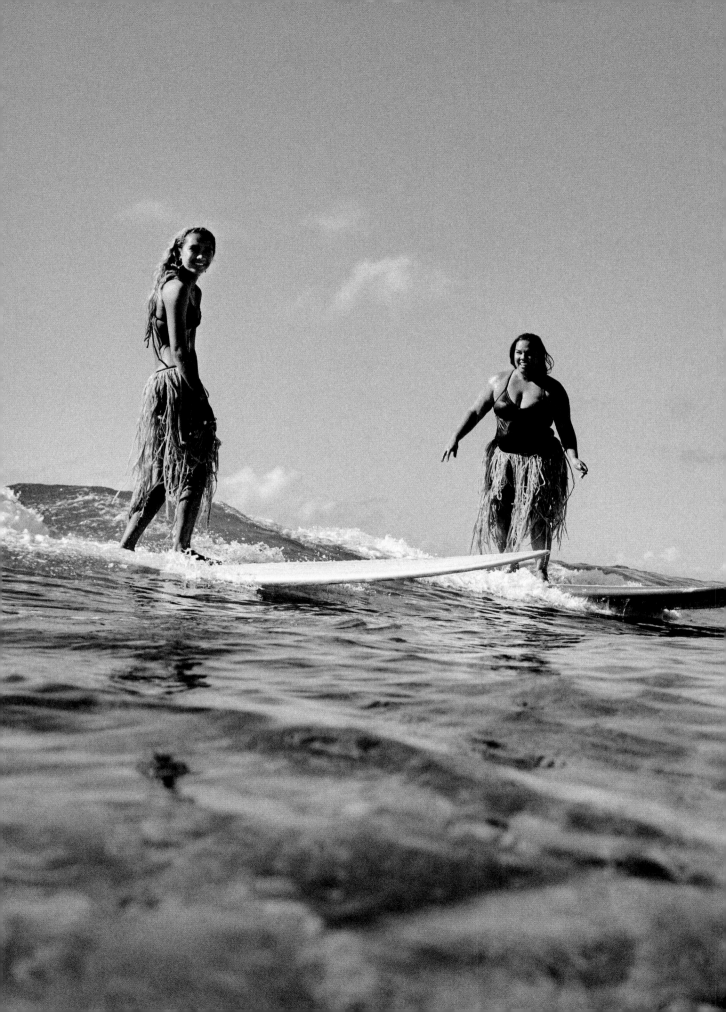

Kelis and Malia
KALEOPA'A

Honolulu, United States

Waikiki is postcard Hawaii. The slow curve of Queen's Beach, a spot that has seduced millions with a sunset-tinged vision of luaus and leis, hula skirts and ukuleles, and of course, the enduring allure of Oahu surf culture. Today the city is a vast sweep of high-rise hotels peddling this dream to flocks of tourists who gather in droves for a taste of shaved ice and sunshine. There are many more layers to this town, though—a rich history, a deep culture, and a strong community who has called this place home for centuries.

Considered the birthplace of modern surfing, Queen's Beach and the practice of surfing have been integral parts of both the cultural and spiritual life of these islands since as far back as the fourth century. *He'e nalu*—meaning "wave sliding"—was enjoyed by all, men, women, royalty, and villagers alike. The stretch of Queen's Beach, in fact, is named in honor of Hawaii's last sovereign monarch, Queen Liliuokalani, whose niece, Princess Kaiulani, was celebrated as an

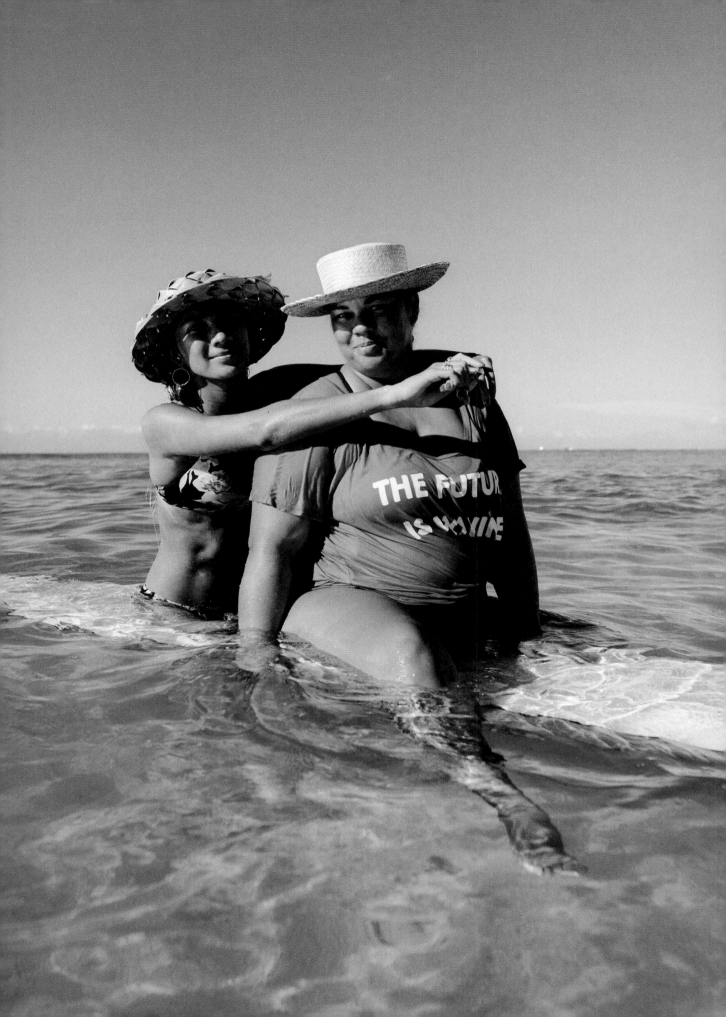

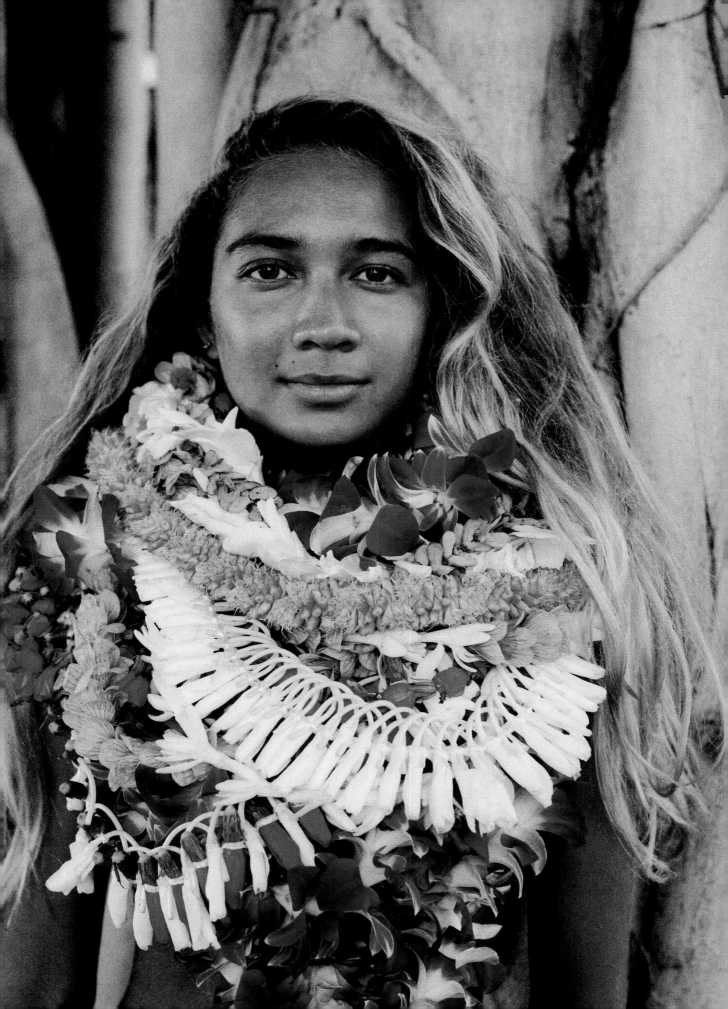

avid and skilled surfer. After the annexation of the islands to the United States in 1898, the princess became an outspoken advocate for surf culture, pushing to keep the religious and spiritual traditions of her homeland intact and thriving.

Today, it is here at Queen's where you'll most likely find Native Hawaiian Kelis Malia Lei Kaleopa'a, gliding alongside her friends on a dusky blue Kai Sallas single fin. Watching Kelis, it is hard not to veer into cliché to describe her grace on the water. She seems a part of the wave, anticipating its movement and making it her own, long limbs tiptoeing up and down her board reminiscent of a prima ballerina moving across the stage. When asked to define her impeccable surf style, Kelis humbly credits both her upbringing and her hometown. "We were raised to learn the ways of the waters," she says.

Her mother, Malia, expands on this. "We like to think of surfing as a dance on the ocean and so the wave is your partner," Malia says, speaking about her daughter, herself, and the generations of Hawaiian surfers before them. "The way that Kelis navigates the wave, it's like the wave is leading and she's responding. The way that we've been raised here in Hawaii, the wave is in charge, the wave is the leader in the dance, and you're just there to make it look beautiful."

Growing up on Waikiki, Kelis spent her childhood in sand and sea, surrounded by aunties, uncles, cousins—a circle of longtime locals who still watch over each other with loyalty and tenderness that recall a time when this place was just another village in paradise. Kelis was homeschooled by Malia to make her schedule more flexible, allowing for time on the waves. Now sixteen, Kelis realizes that what she has is rare in a world that moves fast and furiously. "I'm grateful for the life that I live," she says. "It is very different from most lives. And to be raised with my friends, we all have very similar upbringings, and that's something that I get to share with them for the rest of my life. I don't think a lot of people can say that."

A huge part of that shared upbringing is, of course, surfing. Kelis comes from a long line of dedicated surfers. Malia surfed competitively as a teen but decided to retire and focus on motherhood when she had Kelis at nineteen. She now coaches her daughter with a seasoned wisdom gained from her own career. "That's a hard role to navigate," Malia says about being both mother and coach. "I don't want to hurt her from a mom point of view, but I want to teach her from a coach's point of view, and so we've worked on that. We've worked year after year, and I feel like each year, she made a little bit of a bigger step."

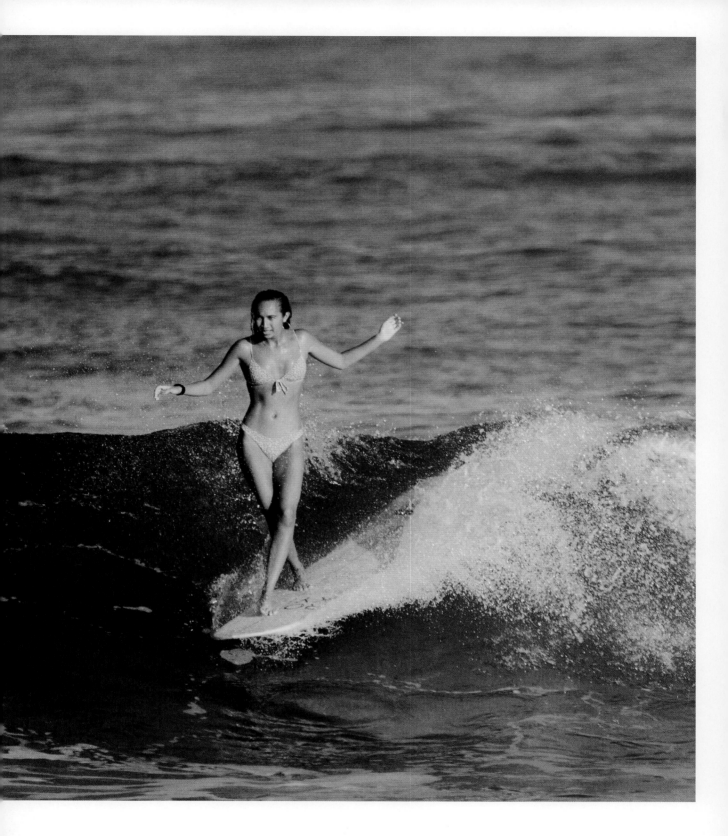

"It's like the wave is leading and she's responding. The way
that we've been raised here in Hawaii, the wave is in charge,
the wave is the leader in the dance, and you're just there to
make it look beautiful."

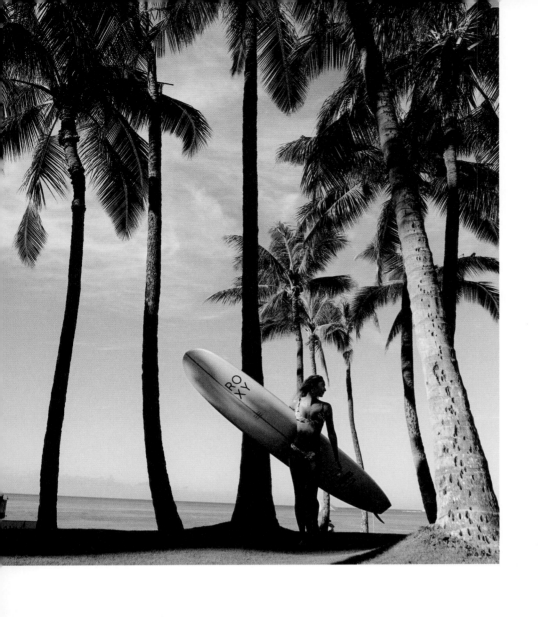

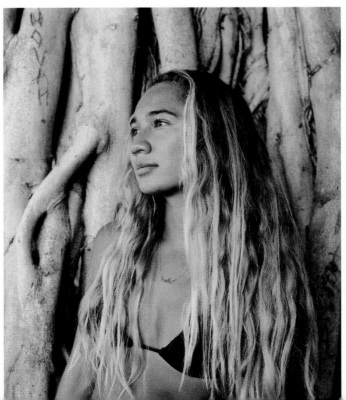

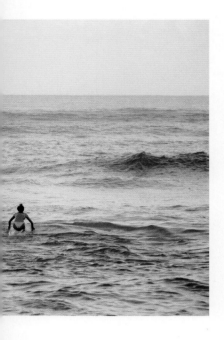

Kelis agrees. "I lucked out very much in the relationship that I have with my mother," she says. "A part of it is that she had me at a very young age, so I feel like she understands most of the situations that I get put into surfing-wise. It's very open communication between us. She trusts me, I trust her. She's hard on me but for the right reasons, and I've got to accept that."

That rigor has certainly paid off. In 2019, at the age of only fifteen, Kelis became one of the youngest surfers ever to become the women's world number-one longboarder. The victory was a culmination of wins that began with Kelis placing first at the Van's Duct Tape Invitational the preceding year (where she was also the competition's youngest winner ever at fourteen).

Even though she's on track to become the youngest surfer to be crowned world champion, titles are never the first thing Kelis mentions. The fact that she is the world's number-one longboarder doesn't even warrant a callout in her Instagram bio. Instead it states simply: "Hawaiian Surfer. Waikiki born and raised." Not that Kelis isn't proud of her accomplishments. "It's been a dream and goal since I was little to be the youngest world champion," she says, "and that was kind of the only goal that I've ever set in my life. I'm just grateful and lucky that I have the opportunity to be in the running for one."

Kelis's incredible progression as a surfer can be credited to her innate skill, her mother's intensive coaching, and in large part to the support and encouragement of her close friends, who include fellow pros Sophia Culhane, Keani Canullo, and Honolua Blomfield as well as Kelis's cousin Kaniela Stewart. Among them, there is a camaraderie that runs deep; the group are kindred spirits in their dedication to the waves. "We surf with each other every day, and none of us thinks we are better than each other," Kelis says. "There's always going to be that competitive mind-set, but not super

What do women bring to the lineup?

A sense of fun and grace. You can always count on good vibes, a fun surf session, and some beautifully surfed waves.

What are you hopeful for?

Malia: That the world opens back up and we can have some face-to-face conversations and laughter with people we love and miss!
Kelis: The next generation of Waikiki groms are really showing

us how to live aloha. That makes me hopeful for Waikiki.

What makes you feel powerful?

Malia: Just waking up each day with a smile on my face.
Kelis: I'm still finding my power! Learning life lessons on the daily and just embracing the fun of it all.

The women you most admire . . .

We admire women who live life. They do the things that spark passion in them, they don't take no for an answer, and they always come from a place of love.

hardcore like, 'I'm going to beat you.' We're still friends in and out of the water. We learn from each other every single time we're out in the ocean. We are each other's futures, in a way."

And those futures look bright. Calling themselves the Waikiki Grom Squad, Kelis and her crew have won competitions all over the world—from Portugal to Australia, England to California. When Kelis claimed her world championship in Noosa, Australia, it was the Grom Squad who met her on the sand to celebrate the victory. "My favorite moment was getting cheered on at the beach by my best friend, and all my family and friends around me," she says. "That was a very special moment."

Kelis and her Queen's Beach community have come to exemplify the island's new generation of powerful young waterwomen. Along with her mother and her friends, Kelis carries Hawaii's storied surfing legacy just as Princess Kaiulani did more than a hundred years ago—by dancing with the ocean, moving gracefully, as lightly as foam across the waves.

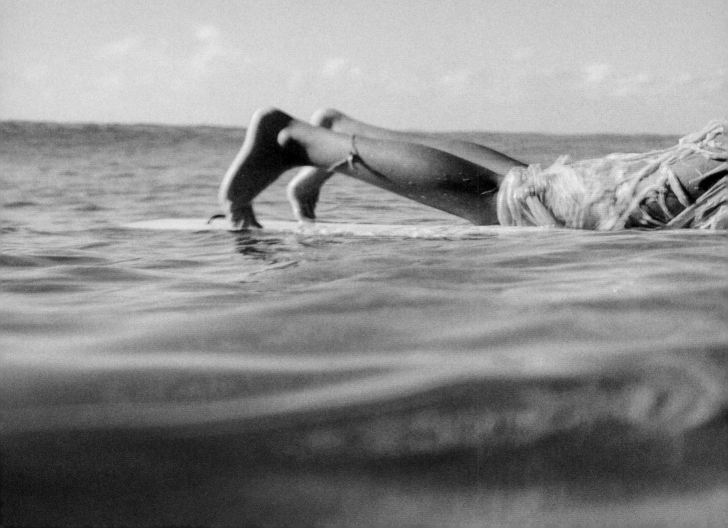

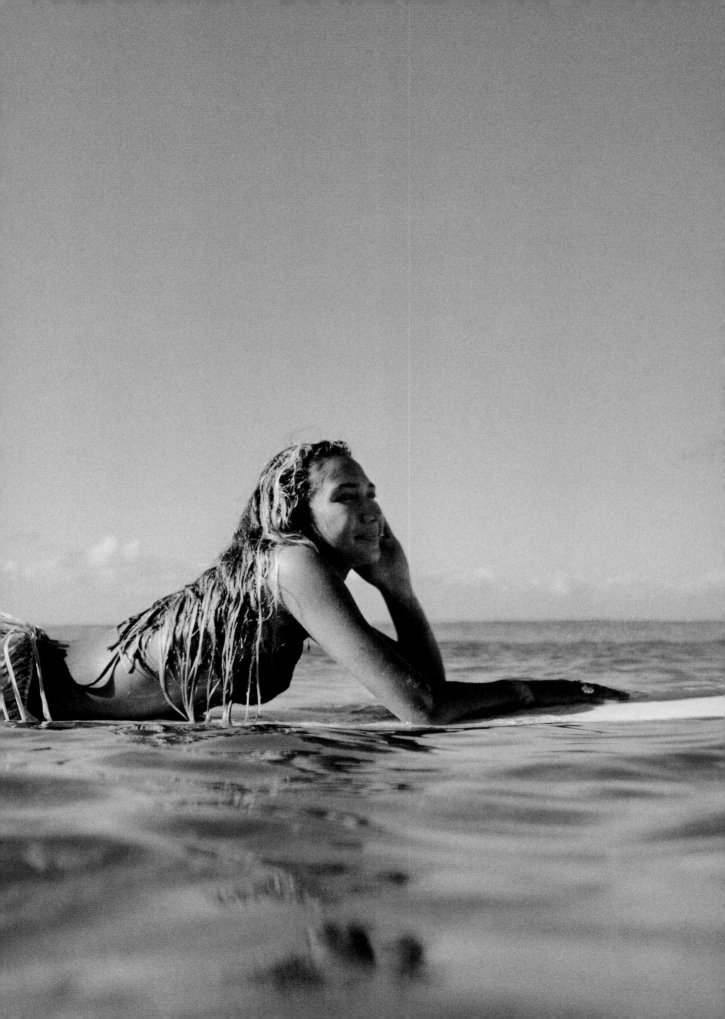

The CULTURE SHAPERS

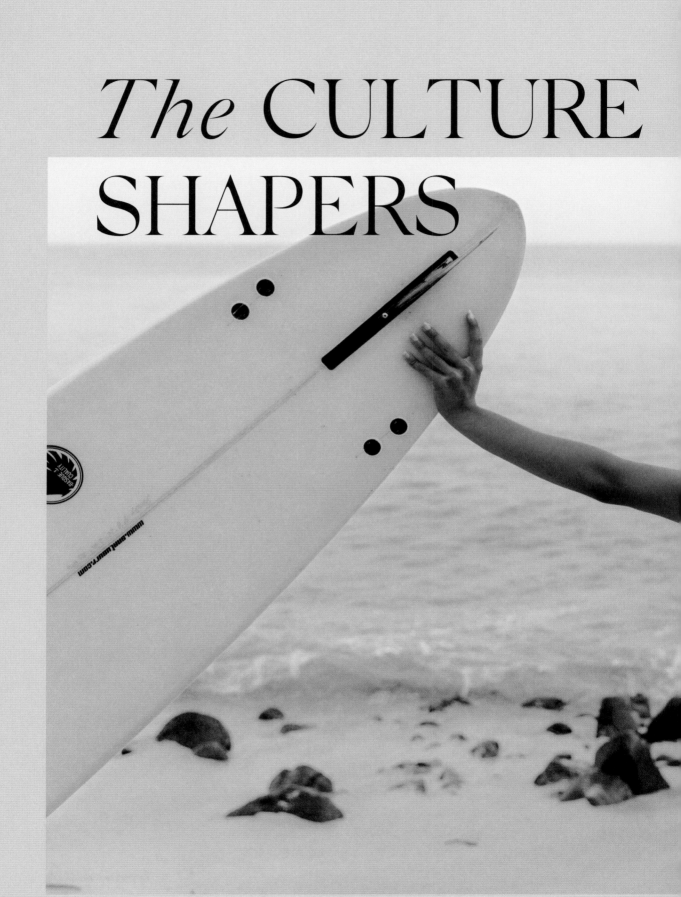

Ha'a
KEAULANA

Mākaha, United States

H a'a Keaulana grew up steps away from the blue shores of Mākaha Beach—wild, rugged, and defiantly untamed. "Mākaha means 'fierce' or 'savage,'" explains Ha'a, "and I think that definitely fits the whole vibe of what this place is. It's very beautiful, but it can be very fierce. The people can be fierce; the ocean can be savage if you just don't respect it. But if you appreciate it, it can be a fierce beauty in its own way." Asked to describe her town in one word, Ha'a says, "Raw. Raw beauty and raw people. You just get the real deal. People here are unfiltered; they are not putting on any fronts."

This is also true of Ha'a, who at twenty-eight has a grounded composure and a measured calm that seems beyond her years. Of Native Hawaiian descent, she has been indelibly marked by this place, Mākaha, her family's home for generations. Her lineage boasts a host of legendary watermen and waterwomen, the Keaulana name woven inextricably into the history of Hawaii itself, including King Kamehameha, a great conqueror and first ruler of the kingdom of Hawaii. Her father is the stuntman and big-wave legend Brian Keaulana, her grandfather the trailblazing surfer known simply as Buffalo, or the Mayor of Mākaha. Alongside Duke Kahanamoku, Buffalo Keaulana was one of the Waikiki Beach Boys (as Hawaii's early surf pioneers are known), and he played an integral role in introducing Hawaiian wave culture to the world.

Ha'a, like everyone else in the family, was raised not just near but *in* the ocean. "A normal person would say, 'I grew up with my parents taking me to a park or a jungle gym,' but for us, we had Mākaha Beach," she says. Ha'a grew up around her grandfather's legendary surf competition known as Buffalo's Big Board Surfing Classic. The best surfers in the world would come to this special place to vie for the coveted title of "Waterman" and "Waterwoman." The unique event features canoe surfing, body surfing, boogie boarding, tandem bully boarding, SUP surfing, SUPSQUATCH, and longboard surfing.

Ha'a's dad, Brian Keaulana, now the event director, is also part of the remarkable safety team along with Hawaiian Water Patrol. He was one of the pioneers of jet ski water safety and is the go-to guy for stunts in Hawaii. She still occasionally joins her dad on Hollywood sets for stunt work. "I've done stunts on *Soul Surfer, Battleship, Godzilla, Hawaii 5-0*," she says. "I've done falls, tackles, I've thrown Molotov cocktails, ran from fire explosions, and done a lot of running."

The women in Ha'a's family have been equally influential, helping to foster in her a formidable inner confidence and resolute determination. "My mother, my grandmother, they taught me to never be submissive to men," she says, "and I really thank my boy

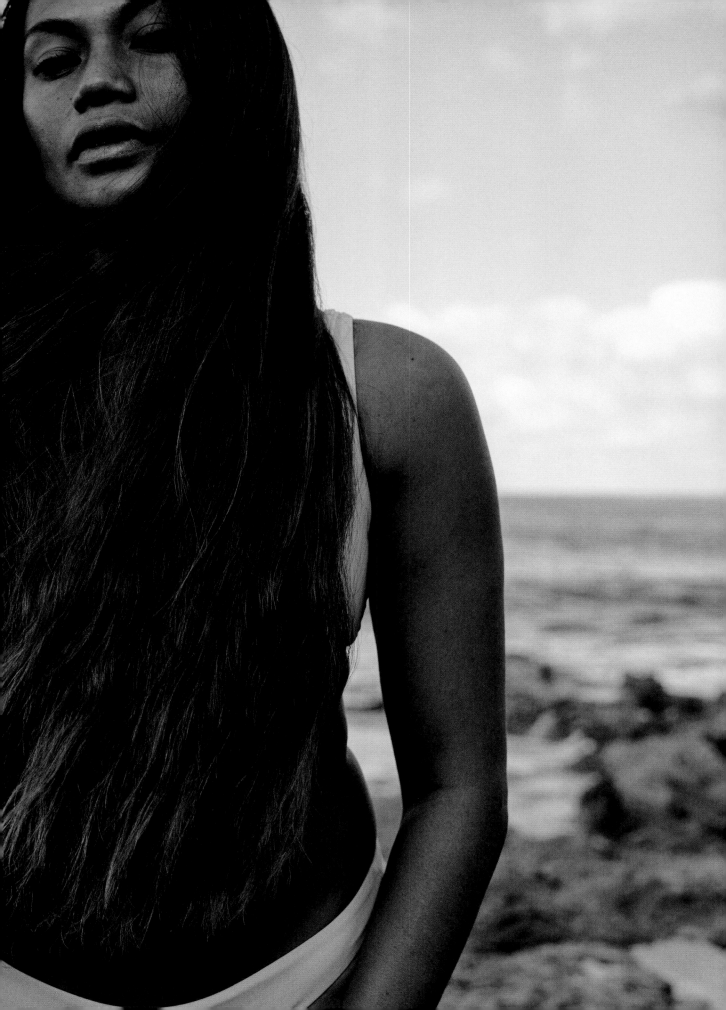

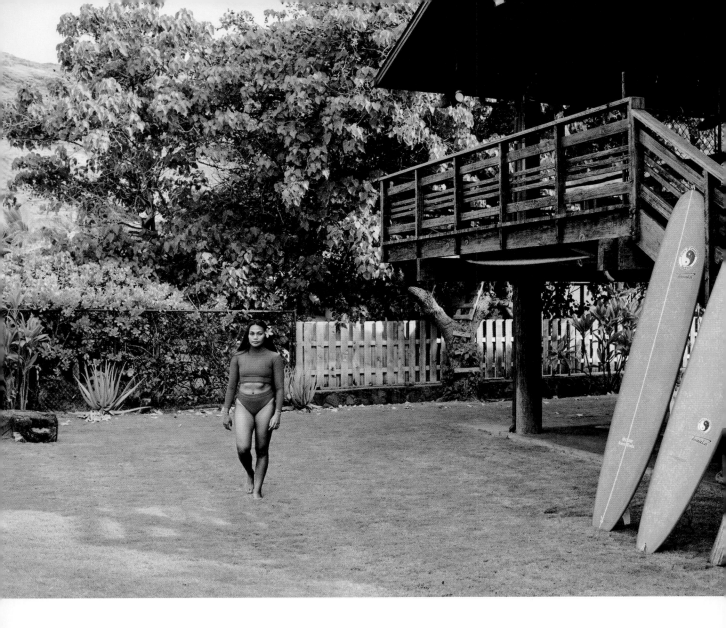

"*That woke up some generational trauma that I didn't know was there. Mauna Kea is sacred because all the land is connected. The land is what makes us healthy, but only if we keep the land healthy.*"

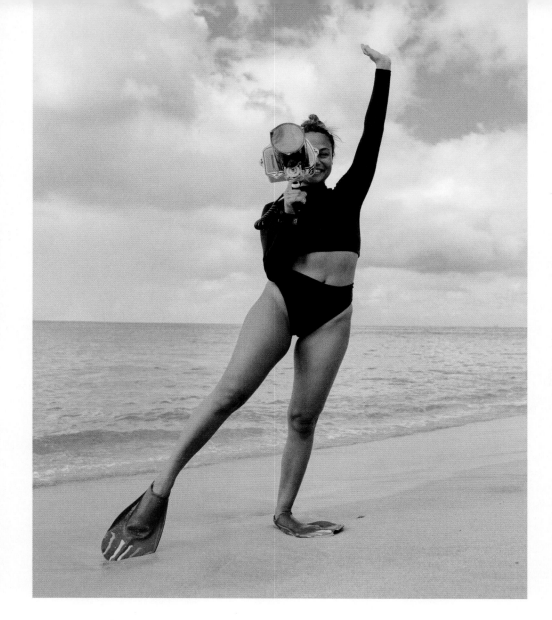

cousins for never treating me like a girl, because I think that's what made me who I am today." As role models, Ha'a also credits the late surf pioneer Rell Sunn (known as the Queen of Mākaha) and local surfer Aunty Pua. "They were both legendary waterwomen," Ha'a says. "Rell Sunn was a world champion surfer. They did a lot for kids in this community. Especially out here, kids don't really come from much and they can't afford their own surfboards. So, Aunty Rell and Aunty Pua would go out of their way to try and make that happen for them. I was lucky to have them as a part of my life."

For Ha'a, this focus on community and Native Hawaiian culture has become the inspiration for her own work in surf and underwater photography (she calls herself a "surftographer") and a key focus of her social media presence. Ha'a strives to use her platform to educate fans on the history of the place she loves. "When people come to Hawaii, they think everything's a luau show," she says. "I really try to ask my followers to research about where we actually

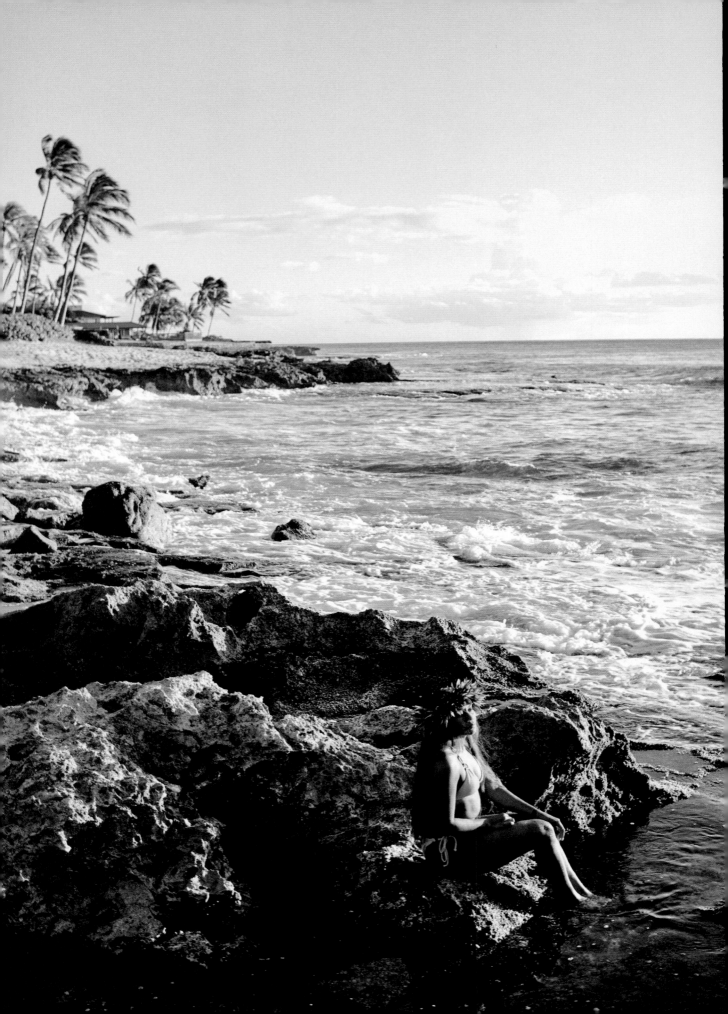

come from." Hawaii Nei still resonates with a brutal history of colonization—the overthrow of the Indigenous monarchy and the erasure of much of its Native traditions.

"We were told we couldn't speak our language," Ha'a says "It's not taught in schools. My grandfather doesn't know his own native tongue, but when he's in the ocean and doing what he loves— whether it be saving lives, sailing, surfing, fishing, diving—that's him portraying our Hawaiian culture. And he raised his children and his children raised us, the grandbabies, with the same values that he was raised on. And he taught us to really embrace and perpetuate our culture in any way that we know how. I feel like when I'm surfing, I'm perpetuating my culture. When I'm swimming, diving, taking my photos, I'm perpetuating my culture."

Ha'a's grandfather Buffalo, truly a legend, made history in the mid-1970s as part of a team selected by researchers to traverse the Pacific by *Hokulea*, a traditional Polynesian voyaging canoe. Using only the stars as guidance, Buffalo and the rest of the crew sailed all the way to Tahiti, disproving the dominant narrative historians had perpetuated and confirming that the Polynesians had indeed used celestial navigation. "It was such a huge renaissance and celebration for all Polynesians, because they proved a lot of scientists and historians wrong," says Ha'a proudly. "Our whole family history just starts with my grandfather and everything that he's done for not only surf culture but Polynesian and Hawaiian culture. He connected to his culture through the ocean."

Following in his footsteps, Ha'a has also become an outspoken activist for Native Hawaiian rights. In 2019 she was involved in the Protect Mauna Kea Movement, protesting the construction of a telescope on Mauna Kea, considered the most sacred mountain in all of Hawaii. "That woke up some generational trauma that I didn't know was there," she says. "Mauna Kea is sacred because all the land is connected. The land is what makes us healthy, but only if we keep the land healthy." This realization awakened Ha'a. She recognized that, like her grandfather and father before her, she could use her influence to not only share her culture but help to save it. "It was a huge shift," she says. "I thought, 'I can do something about this. I can use my platform to show the world what's going on.'"

Ha'a continues to document her life in Hawaii, photographing friends, family, and the rough and robust splendor of Mākaha. In doing so, she connects more deeply to the place and helps her followers to become more aware, too. "Every time I'm doing what I love or just seeing the beauty of my home or my nieces and nephews growing up with that same appreciation and joy for the ocean—that's when I feel the closest, the most connected, to my ancestors," she says.

A break you most want to surf . . .
My favorite surf break is Makaha. It's my teacher, church, playground, and home.

What are you hopeful for?
I'm hopeful for Native Hawaiians to get their land and rights back.

A quote to live by . . .
Don't ever expect anything. Be grateful for what you have, not what you think you need.

Renee
LABBE

Los Angeles, United States

The ocean has saved Renee Labbe not once but twice. The first time, salvation came on the heels of a separation with her husband. "The breakup was a devastating experience for me," she says. "I didn't know how to process it. It felt like if you were on a ladder and someone just kicked it out from under you and now you're upside down in the bushes; and it's painful; you're broken, embarrassed, and everything's a mess."

In need of escape, Renee booked a solo trip to the Virgin Islands and—although she had never spent real time in the ocean before this—took in as much of the warm Caribbean Sea as possible, spending her days more often wet than dry. On her last night, she found herself in the ocean one final time. "I realized that I felt truly at peace, but in a way that I didn't anticipate," she says. "It wasn't just regarding the state of my marriage. It was like I had made peace with life and with everything that I felt had wronged me in some way." Renee returned to L.A. and asked for a divorce. Having recently quit her corporate job and started her own business, she

"I feel like almost every woman that I've watched become a surfer takes a new control of what they want their life to look like, in a way that they weren't doing before. I think the world will be a better place when more women get to do that."

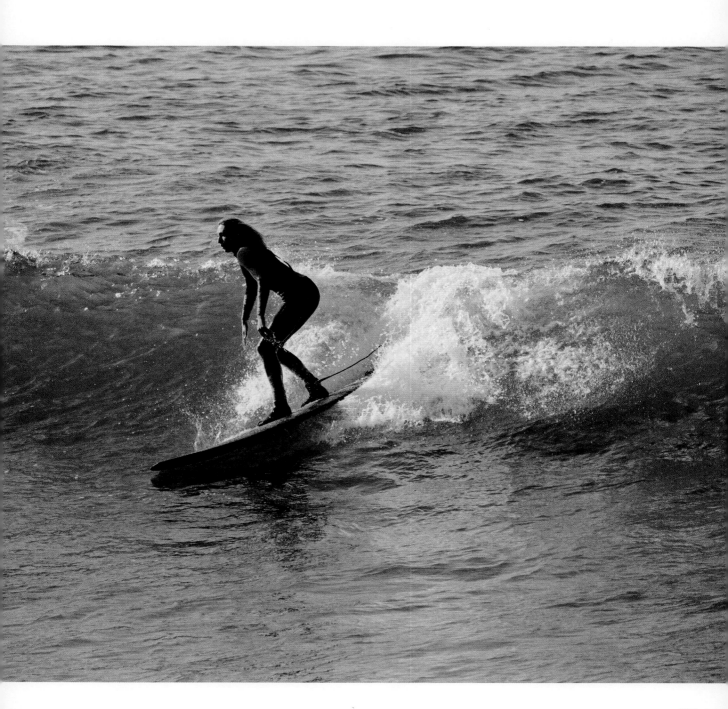

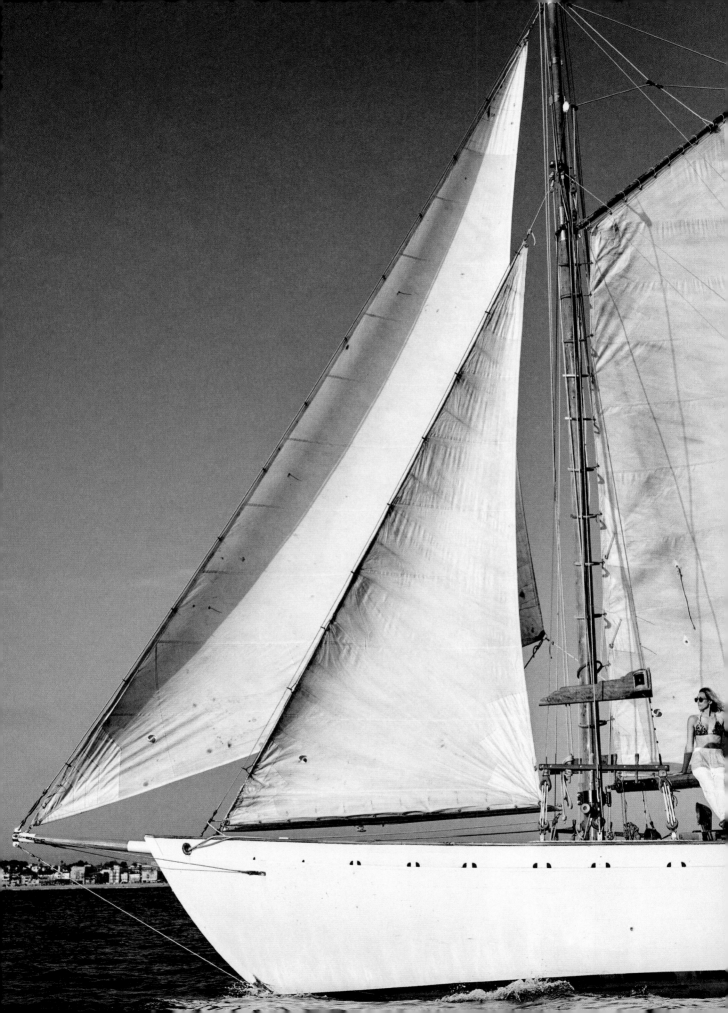

moved to the beach. "I think I had felt dead after the breakup, and now I realized how much the ocean really brought me back to life."

Renee felt challenged again a few years later, when she suffered a miscarriage. "I thought the sadness would swallow me whole," she says of the experience, "and I knew I needed to get in the ocean." Searching desperately for something that would keep her emotional state afloat, she decided to take a surf lesson in the unpredictable Pacific Ocean despite not being a strong swimmer. "It was March," she says. "It was freezing, but I found a surf instructor and I got on a wave." Renee talks about this moment with an awed reverence: "I caught that first wave and rode it all the way to the beach, and I remember feeling all of that pain, all that negativity go for a couple of brief moments. It was a wonder. Every time I surfed again, the pain was less and less and the fascination was more and more. It put me back together." This newfound enchantment offered Renee an unexpected transformation that has become the cornerstone of her life.

Biggest challenge faced as a professional woman in your career . . .

Believing in myself. Once I got through that—game changer.

Hardest-won lesson you've learned about starting your own business . . .

That the hardest-won anything needs to be won again tomorrow.

What book should everyone read by age thirty?

Where the Sidewalk Ends by Shel Silverstein to help you stay a bit of a kid.

A break you most want to surf . . .

Lohis, Maldives—because, Maldives. And it's a left.

Today Renee lives with the ocean at her door. She spends as much time on or near the water as she can—surfing, sailing, and walking the Venice Beach streets with her dog, Fender. At work, she's a veteran trend forecaster, sought after by companies around the world for her insights and predictions. She goes with her gut, making decisions with a sensitivity and foresight that she has relied on for as long as she can remember. Although her personal life came with some unexpected hurdles, it was this intuition that first drew Renee to the water and gave her faith in its ability to heal.

Inspired by her love for surfing, Renee has developed LABBE, a plant-based skincare line specifically created for use postsurf. She hopes the brand will support those who carve out regular time with the ocean. "I feel like almost every woman that I've watched become a surfer takes a new control of what they want their life to look like, in a way that they weren't doing before. The world will be a better place when more women get to do that."

Her relationship with the sea has not only saved her, it has brought her a second career and a fresh perspective. "As soon as my bare feet are on the boardwalk and I can feel the wood, the noise of the city fades away to the sound of the ocean crashing," she says. "The world goes quiet. There really is magic in our relationship with the ocean."

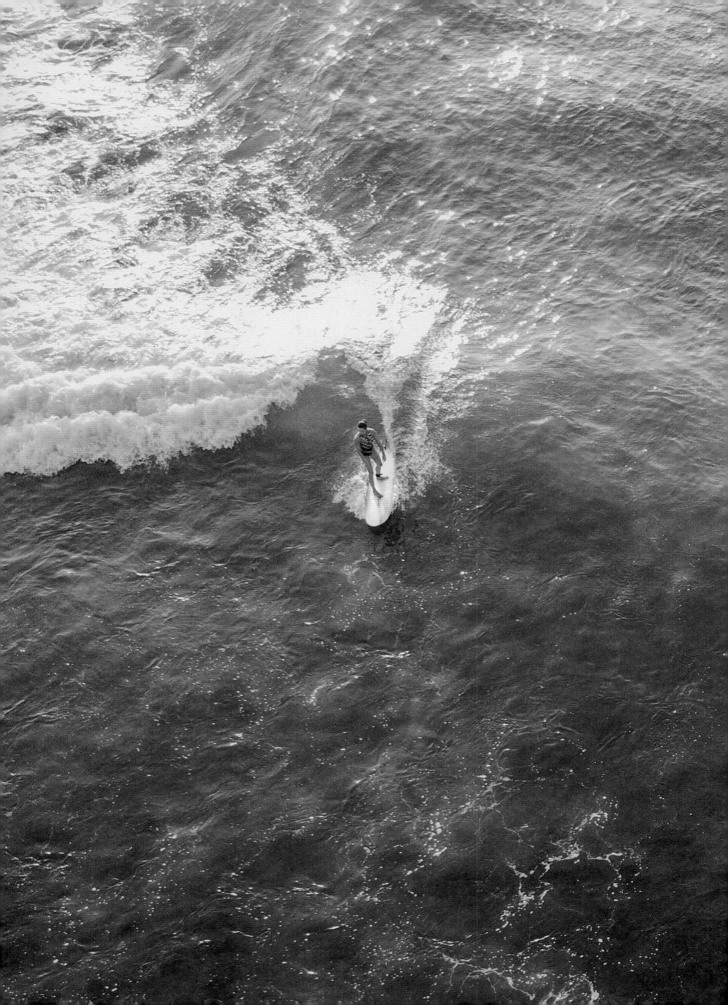

Emma
WOOD

Wales, United Kingdom

E
mma Wood has swagger. On and off the water, the British artist and surfer is full of bawdy charm and a sunny, dismissive disdain for authority. Descended from a line of Cornish pirates and Irish *bons viveurs*, she describes her family as being possessed of "a general Celtic wildness." In the 1960s, while her father was motor-racing in Formula 3, her mother had a stall at London's Kensington Market selling vintage clothes at the height of the city's swinging, countercultural scene. "It was where you got all the cool fashion, music, everything was going on there," she says. "Her stall was next to Freddie Mercury. He was selling platform boots, and she was making her own clothes."

The family spent summers in Ireland's wild outpost—the Kingdom of Kerry—renting a caravan and camping along the beaches of the southwest coast. "I'm the third generation of our family who has made this part of Ireland a home away from home," she says. Although Emma spent her childhood wandering this wild windblown landscape, it wasn't until her early thirties that

she realized surfing was a possibility there, as surfing had been nonexistent in Ireland until then. "I pitched up one summer and ran into my cousin, and she was like, 'Guess what I've been doing?'" Emma remembers. "I'm like, 'What?' 'Surfing!' 'Where?' And she said—'HERE.'"

Despite the bitterly cold water and fickle weather—bright sun to hailstorms in minutes—Emma threw herself in. "I booked a lesson there and then and went surfing on the beach that I'd grown up on. And that was it—life changed," she says. The laid-back, "no rules" mentality of this part of Ireland is every surfer's dream and one that Emma and her family have fully embraced. "After a surf, you go into the pub with your wetsuit on, dripping wet, ask for a hot toddy, and no one gives a monkey's!" she says. "It's such a great community; everyone looks after each other. You wake in the morning to find some dude has put a bunch of mackerel in your fridge!"

Emma has looked at every opportunity as a chance for the next adventure. In her early twenties, while still a student at Manchester University, Emma took a yearlong trip to Mexico as part of a study-abroad program. "I got to Mexico City," she says, "had the most ridiculously fun weekend, and I called up my parents and said, 'I think I want to stay.' And they were like, 'Well, why wouldn't you?'" Despite not knowing anyone in the city, Emma's parents encouraged her. "I was supposed to be getting a flight to Brazil, but I ditched the

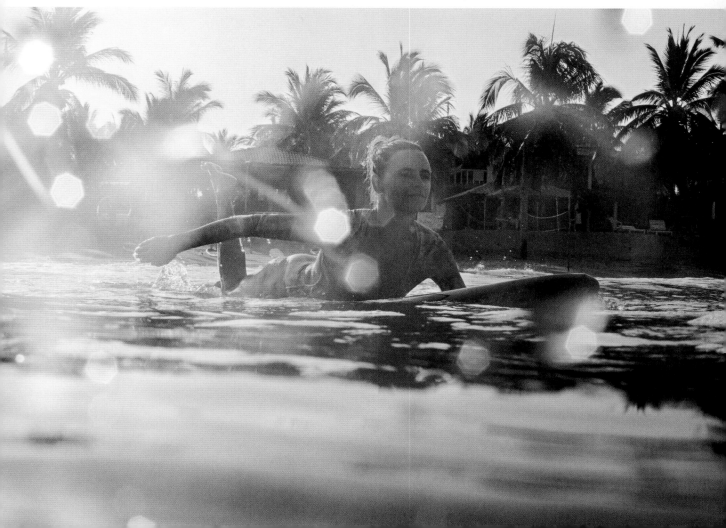

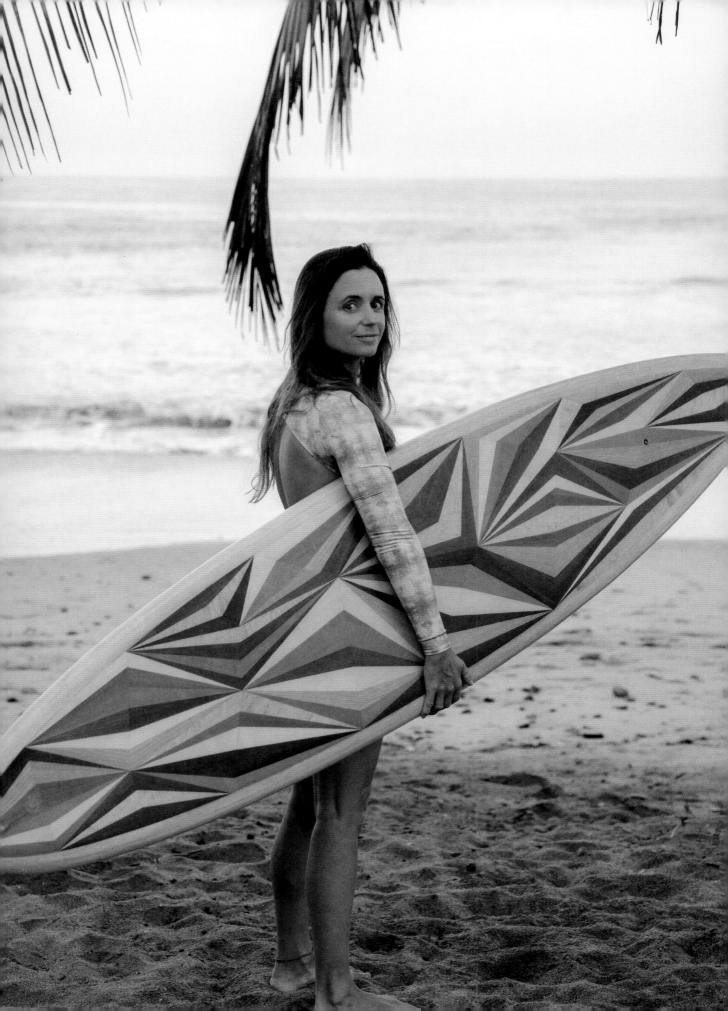

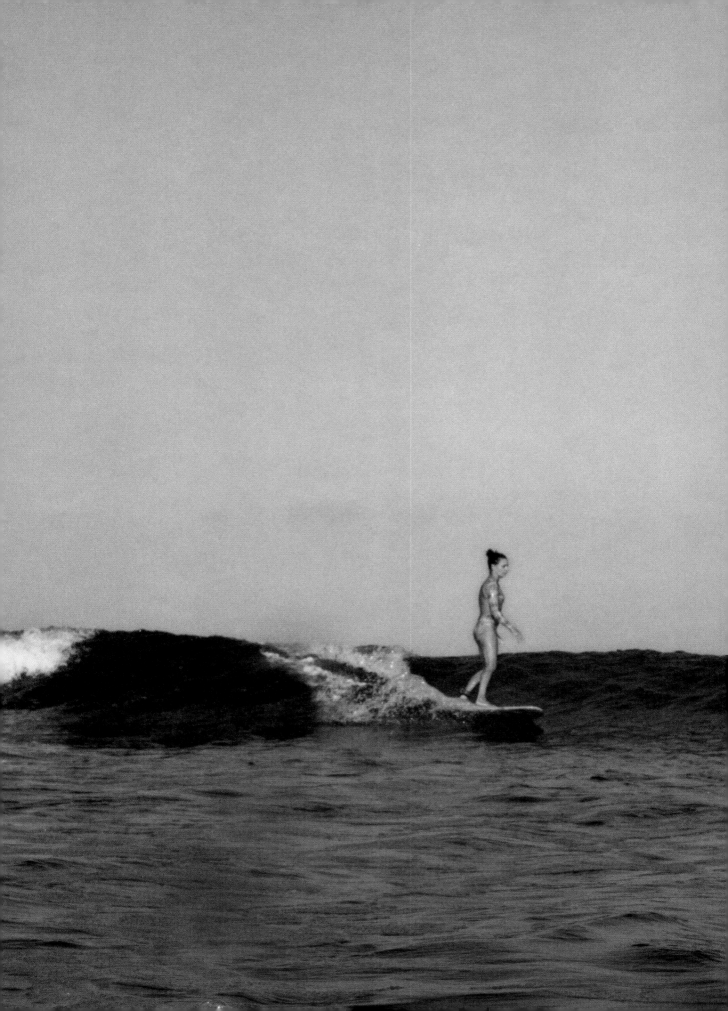

flight and made Mexico my home for the next four years," she says. "It was (and still is) such a magical place. Living there was incredibly empowering and I think galvanized my life philosophy of 'go with your gut, and don't be scared to live the life you want to lead.'"

Although her main home and workshop are now in Wales, Emma spends a lot of time in Mexico City, working and collaborating with different local artists and artisans, whose skill leaves her humbled. "None of them has had formal training," she says. "They're just so good with their hands. It's always an incredible experience working in Mexico." She also travels to the coast of Mexico each year with her young family, visiting old friends and hitting the warm water swells.

It was a close friend and cabinetmaker who suggested Emma try her hand at marquetry, an ancient and meticulous craft of carved geometric patterns out of wood veneer. She had been making objects, lamps, and furniture and selling them at weekend markets while working an artist development job in the music industry. Still, she decided to give it a try. "At first, I had imposter syndrome because I'd never studied art or design," she says. "But as soon as I started, I knew I had finally found what I wanted to do." Emma began working mainly on furniture, creating complex, beautifully intricate pattern work. "Marquetry is a very old-fashioned craft, but I wanted to present it in a more contemporary context," she says. "I'm kind of a weirdo with math, sacred geometry, the way the same repeating mathematical ratios appear in architecture, art, nature. I'm absolutely fascinated by that, which I think informs my aesthetic."

On a surf trip to Ireland, Emma spotted a woman surfing a wood board and inspiration struck. "I started obsessing about the idea of putting marquetry on a surfboard," she says. The result was a surf-inspired mix of detailed art and wild imagination. Working alongside a talented shaper, her stunning boards take months to create. "All the boards are made completely environmentally friendly," she says. "The timber we use is from sustainably managed forests. We use bioresins instead of any harmful epoxies. We don't use plastic fittings; everything is as sustainable as it can possibly be." A percentage from the sale of each board goes to Surfers Against Sewage, a British nonprofit that tackles sewage pollution in the UK. The craftsmanship is remarkable; the boards are elegantly intricate yet functional, equally at home on the wall or on the waves. "So far they've all ended up on a wall, but I'm dying to see one surfed!" Emma says, smiling.

A quote to live by . . .

Dance, grow things, try not to be a dick. Always put off until tomorrow the things you should be doing today.

What woman do you admire most?

Mother Nature. She's resilient, powerful, and should be treated with the utmost respect. Ancient cultures revered the natural world and knew how to live sustainably and in harmony with their surroundings. We seem to have replaced this knowledge, acquired over millennia, with greed and short-term thinking.

Postsurf ritual . . .

The pub with a hot port (large port with hot water, lemon, and cloves) and a crab sandwich.

When do you feel most powerful?

Getting barreled at Jaws—only joking. Staying on a four-foot wave without incident makes me feel pretty powerful!

Regardless, her surfboards are signifiers of her journey, a confluence of her experiences and passions, her willingness to embrace change and keep learning and exploring. "I've always grown up with the notion that I was capable of doing whatever I wanted to do as long as I put my mind to it, worked hard, and focused and just got shit done," she says. "You have to go out there and make your mark and just not be put off by societal norms or anyone getting in your face." This ethos is simply a part of Emma, a philosophy that has only been magnified by her ever-evolving surf practice. "Surfing has changed the way I live my life in terms of where I go, what I do, and how I do it," she says, adding that her end goal is "to create good, responsible art. Look after the planet. Don't piss people off. Be good to my family and friends. And have a good time while I'm doing it."

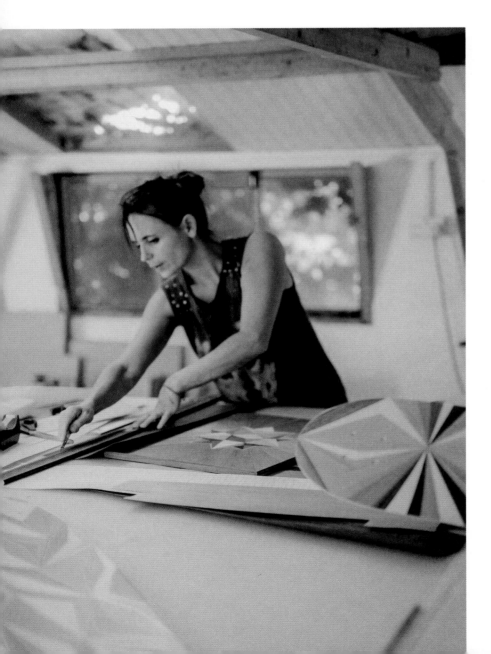

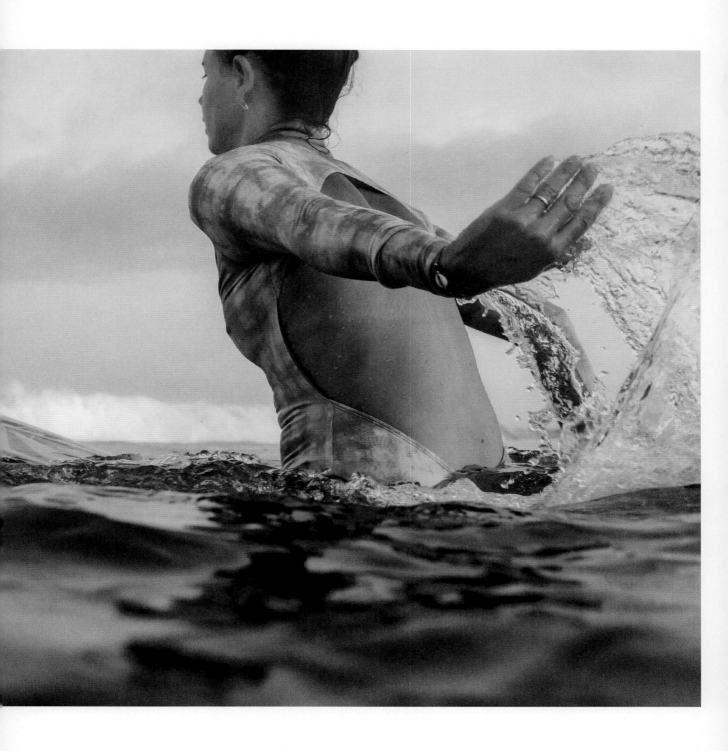

"I've always grown up with the notion that I was capable
of doing whatever I wanted to do as long as I put my mind
to it, worked hard, and focused and just got shit done. You
have to go out there and make your mark and just not be
put off by societal norms or anyone getting in your face."

Whitney
GILMORE

Malibu, United States

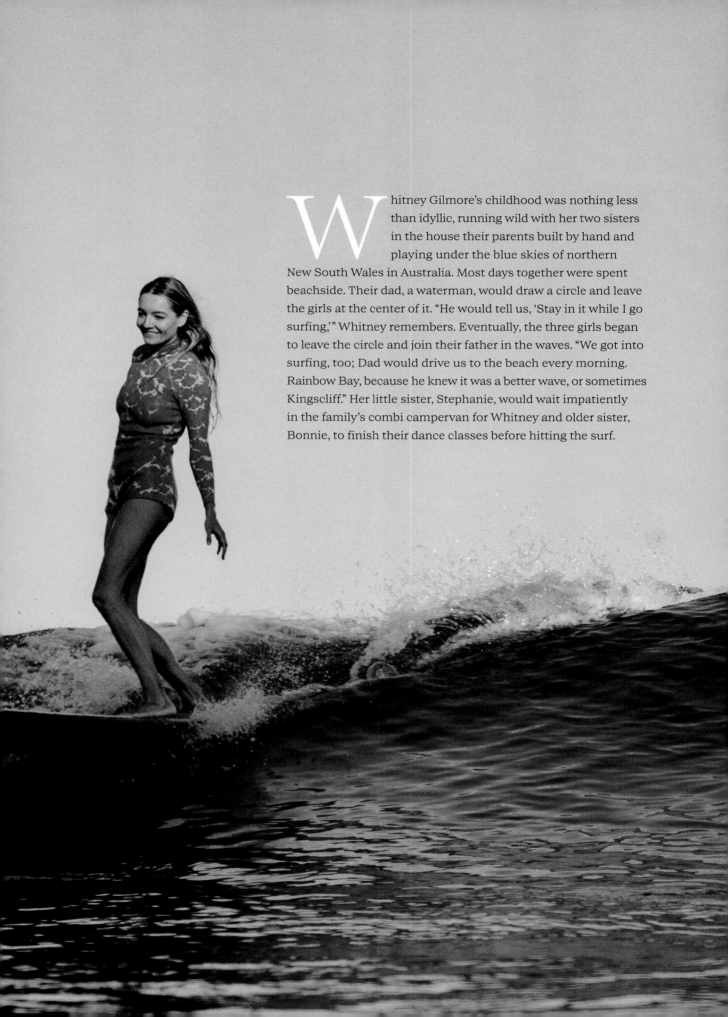

W hitney Gilmore's childhood was nothing less than idyllic, running wild with her two sisters in the house their parents built by hand and playing under the blue skies of northern New South Wales in Australia. Most days together were spent beachside. Their dad, a waterman, would draw a circle and leave the girls at the center of it. "He would tell us, 'Stay in it while I go surfing,'" Whitney remembers. Eventually, the three girls began to leave the circle and join their father in the waves. "We got into surfing, too; Dad would drive us to the beach every morning. Rainbow Bay, because he knew it was a better wave, or sometimes Kingscliff." Her little sister, Stephanie, would wait impatiently in the family's combi campervan for Whitney and older sister, Bonnie, to finish their dance classes before hitting the surf.

"Steph would always say, 'I can't believe I have to wait for them to get out of ballet before I can get to the water!'" Whitney recalls. Steph, of course, is Stephanie Gilmore, seven-time world champion and perhaps the most famous female surfer in the world. The role that Whitney played in elevating her sister from a World Surf League title holder to a global icon should not be underestimated, something Stephanie readily acknowledges. As her manager, it was Whitney who first set the foundation of the Gilmore brand, encouraging her sister to use her voice to advocate hard for herself and for women within the industry. The two watch over each other with a fierce protectiveness. When they were young, the pair played on sports teams alongside each other, which cemented a bond beyond sisterhood. "We were always pretty tight," Whitney says. "When you're on the same team with the common goal of winning, you learn to play together in a different way."

Having completed a degree in business and marketing, Whitney began her career with Billabong just as Stephanie's pro surf career started to explode. Before too long, she became Stephanie's manager. Whitney was only twenty-two, but she had an instinctive understanding of the importance of protecting Stephanie's "brand," especially at such a pivotal moment. "She won her first world title and the press was like, *Happy Gilmore* [the Adam Sandler comedy]," Whitney says. "I remember thinking, 'Oh, that's *so* tacky and that's not Steph. She's so cool.'" Whitney quit her job at Billabong and stepped in. "I don't think she even understood how she wanted to be seen," Whitney says. "I always had an eye for looking outside of the surf world and into the fashion world and looking at broader campaigns."

Your surf kit . . .

Shade 50+ zinc stick. Ripcurl 3/2 E-Bomb (the minimal seams on this wetsuit are so flattering). Roxy Japan flower print surf bucket hat and a Surf Ranch broad-brimmed hat (I hide from the sun at all costs). Gimaguas striped beach bag. Lucy Folk postsurf beach robe. Kassia palo santo wax. Know Wave Radio towel. 88 yellow 7ft softie. Some change for a postsurf Frostie Fruit (Aussie icey-pole). Fun friends to surf with.

Your most conspicuous personality trait . . .

Generally happy-go-lucky—well that's the main feed, and then I get spicy when I'm passionate.

What do you miss most about Australia when you're traveling?

I miss the drive from Rainbow Bay to Byron Bay. It's so beautiful with green rolling hills and grounding. And the Mullumbimby farmers' market.

Do you consider yourself a feminist?

I believe true equality is to not think one gender has more power than another—and I believe we will get there. I believe the current state needs women and LGBTQ communities to find strength, use their voices, and fight for their rights. If that means the pendulum needs to swing toward the other direction before it swings back to balance, then so be it.

"I was seeking justice for Steph in this male-dominated industry. Steph, she's star quality. She walks into a room and people are in awe of her."

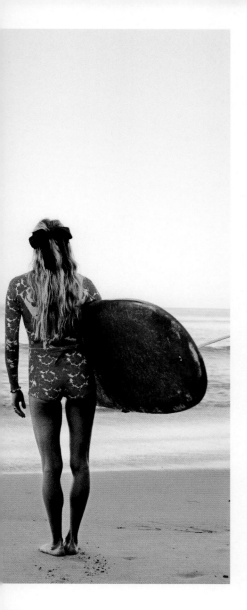

The sisters sat down together to map out the new direction for what would become a hugely influential global brand. "I remember doing a brand analysis with her. 'What brands do you want to work with? What brands do you like? What companies inspire you?'" says Whitney. "And I was probably writing down the ones that inspired me not her, which is how the relationship really went. I would say, 'This is what you need. And if anyone asks, you want this.'" Whitney is quick to recognize that they also found some incredible mentors along the way, and at a moment when the industry was floundering, together the two sisters almost instantly became a barometer of what was cool. "It was just Steph and I, a little bit in the wild west of doing things."

Despite this commercial success and a fourth world title for Stephanie, when it came time to renegotiate contracts with her then sponsor, she was offered a fraction of what was on the table for the male surfers who were enjoying far less success. Whitney recalls sitting in the room with (mostly) men who told her sister she wasn't worth anything more to them until she won seven world titles like Layne Beachley had. As Stephanie's manager, Whitney immediately turned the offer down. "I was seeking justice for Steph in this male-dominated industry," she says. "Steph, she's star quality. She walks into a room and people are in awe of her. They just couldn't see it."

The two women positioned themselves at the forefront of the push for equal pay within the surf industry. Whitney recalls telling her sister: "Steph, this is bullshit. Until the first place title gets the exact same pay as the first place on the men's side, you have come far . . . but it's not equal yet." After pressure from the Gilmores and other determined women surfers, the WSL finally announced equal award prize money for title winners in 2019, one of the few US-based sports to do so.

The Gilmore sisters have inspired not only equity in the sport itself, but they've also influenced how female surf wear brands market to their audience. When Stephanie first started out, there was a wide divide between how competitive female surfers and "lifestyle" surfers were branded. "Lifestyle" usually meant women surfers who were not on the pro circuit yet exemplified a fashionable beach culture. Female pro surfers were usually marketed in an entirely different way—less feminine and fashionable. But with Whitney by her side, Stephanie gracefully straddles both worlds, balancing champion athleticism, with laid-back, easygoing surfer cool. "There is much more harmony now, and I would like to say that Stephanie's image has really helped that," Whitney says. "She's completely the lifestyle, fun girl who's got other things going on, but then she's also this fierce competitor."

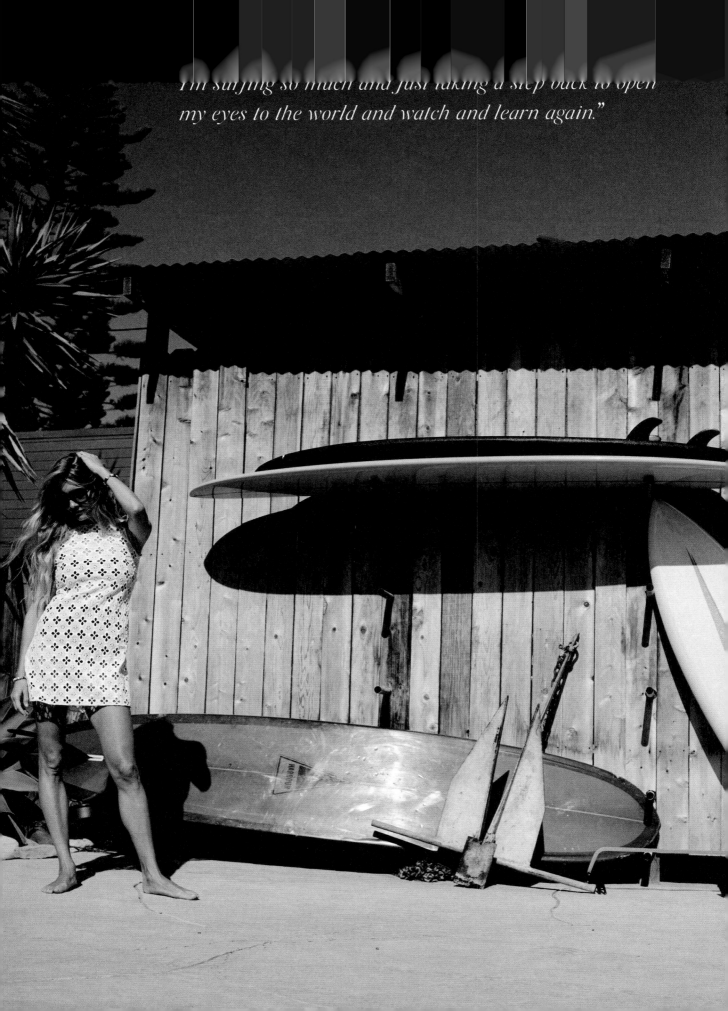

I'm surfing so much and just taking a step back to open my eyes to the world and watch and learn again."

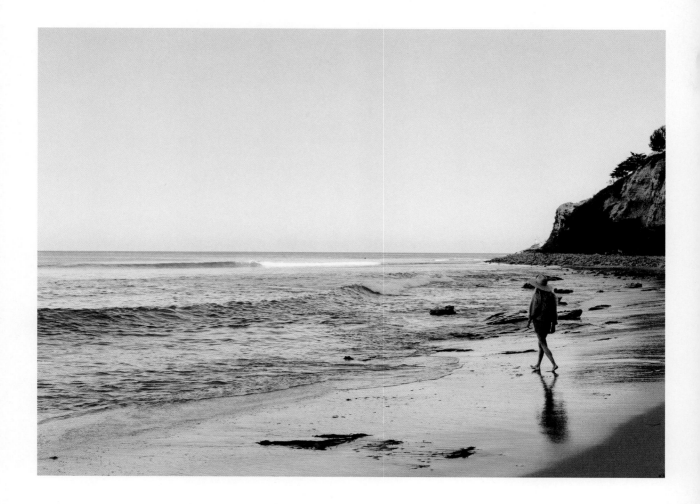

Whitney now lives in Malibu, close to the breaks at Point Dume, Zuma, and County Line. After nearly a decade as Stephanie's manager, she is taking a sabbatical to reflect on her next move. "I've always wanted to do something of my own," she says. "I don't really want to be my sister's keeper forever. I started working with her because I wanted to fight for her. I wanted to get in there and make sure she was seen. I also knew it was what women's surfing needed—having grown up around it and understanding that world. Surfing needed Stephanie. She is the gem of the equation. I just wanted to make sure that she could *be* that."

Now that her sister has reached the top, Whitney wants to focus on finding her own path. She's surfing regularly again after a long hiatus, encouraged by Stephanie to get back in the water. "I just fell back in love with it," she says. "I'm surfing so much and just taking a step back to open my eyes to the world and watch and learn again."

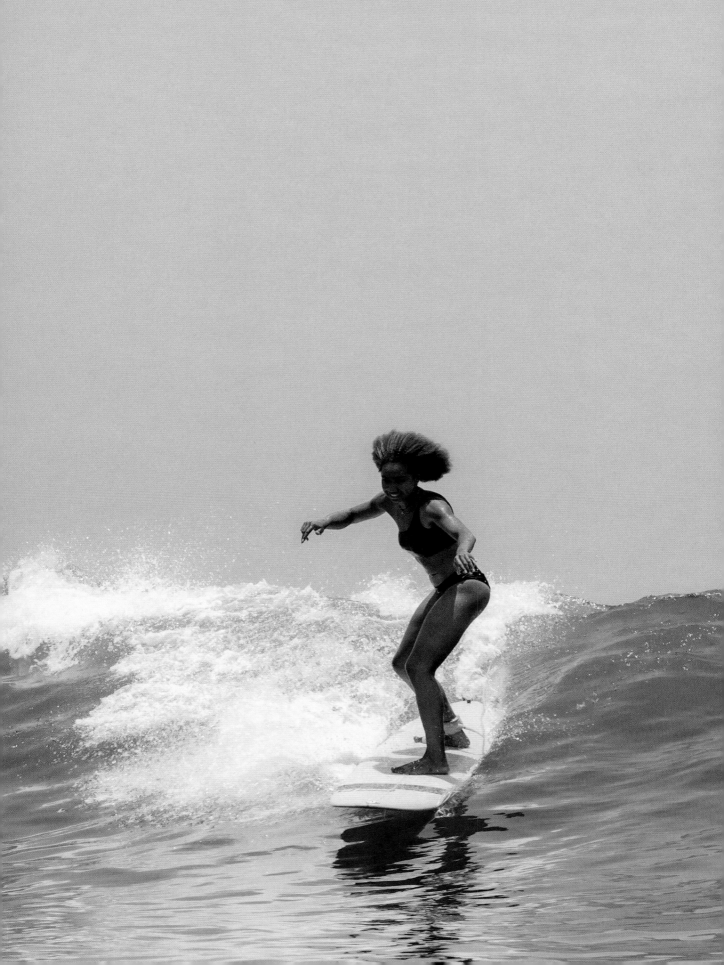

Imane SIGNATE

I mane Signate came of age alongside a country in transition and in a nascent African surf culture where, somewhat ironically, Black surfers are rare, and Black *female* surfers are very much an anomaly. Senegal's incredible breaks, first immortalized in Bruce Brown's 1966 documentary *Endless Summer*, have been gaining in popularity among expat surfers from around the globe, but few from the country itself. "There is not a long history of surfing here," she says. "There are many different ethnicities, and each has their own relationship with the ocean."

Raised in Dakar and surfing since the age of thirteen, Imane acknowledges she is very much the exception, but she is intent on changing that. "The fact is, for many of the women here, they're not really supposed to do sports at all," she says. She sees a gradual shift happening. "One of the coaches of the national [surf] team is giving surfing classes to local girls," she says. "It's a great initiative because if these young girls keep surfing, they will be the future of female surfing in Senegal." For now, hopes are firmly focused

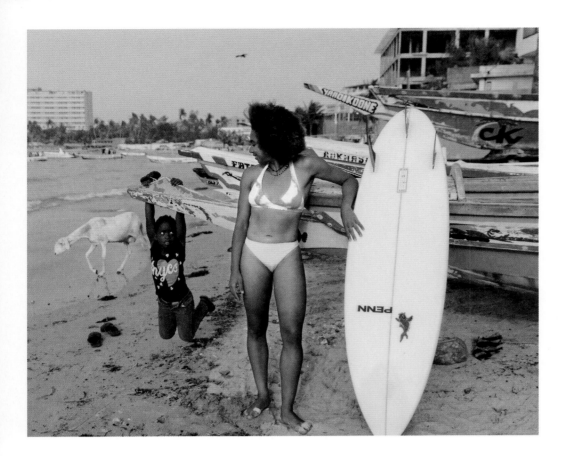

on Imane. At twenty-two, she's surfed competitively for the past few years; and in 2021, she was vying for a position on the Senegal national team for their debut at the Olympic Games.

French and Senegalese, Imane is one of the privileged few in the country who have been able to go abroad for their education. She's been to schools in Sweden, Portugal, and France and done internships in Scotland and Australia as part of her European Business Program (EBP). She's since returned to Senegal to finish her master's degree in business and is keen to promote the evolving surf culture in Senegal and also surf internationally. Imane is well aware of the advantages she's had, and her goal is to use her privilege and position to encourage other Senegalese female surfers and promote Senegal's tourism, which she feels is key to helping develop communities in Dakar and beyond.

Word of Dakar's waves is quietly spreading. Over the past few years, while surfing her local breaks, Imane has noticed that most surfers sharing the waves with her were predominately tourists. "They are always so surprised to see someone who is not white surfing, even though they are in Senegal!" she says, smiling. "But it is good to have tourists here. Good for Dakar. There are waves all year, it's

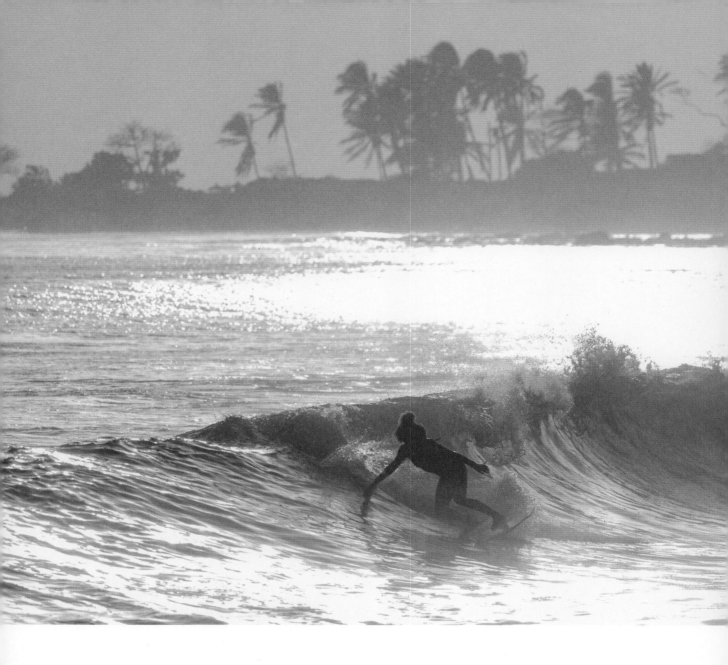

"They are always so surprised to see someone who is not white surfing, even though they are in Senegal!"

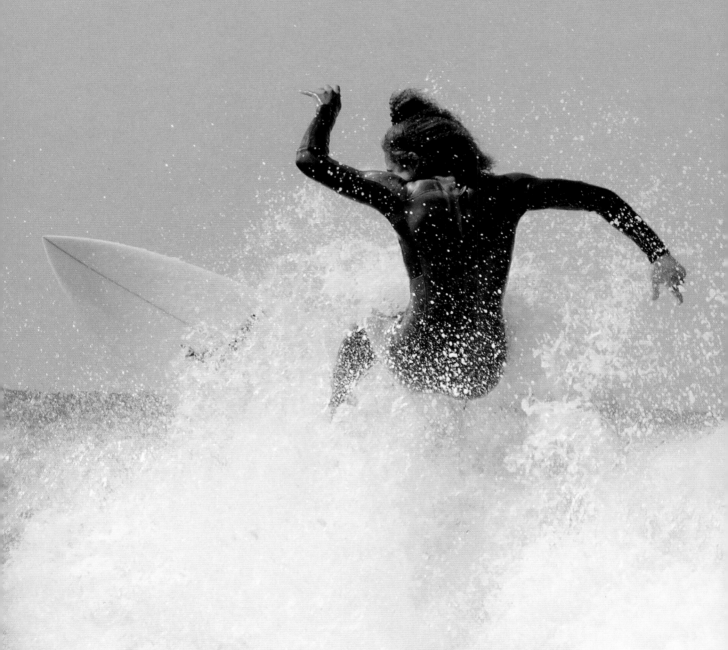

"I want people to come to Senegal not just for the waves but to meet with locals, really get to know the people and the country."

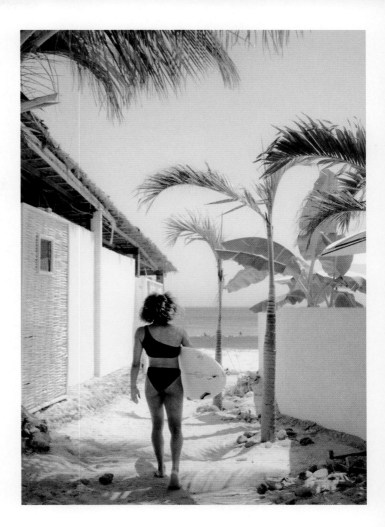

warm, it's not expensive. I want people to come to Senegal not just for the waves but to meet with locals, really get to know the people and the country."

Imane's mother, Missira, is engaged in a number of humanitarian projects in Dakar, and Imane herself advocates for education and environmental sustainability in the city. "I'm very concerned about sustainability," she says. "Especially here, the pollution of the ocean is so, so bad. And it hurts you directly when you're surfing. You can see plastic bags and bottles, the pollution in the air." Yet Imane has high hopes for what she sees as the intertwined future of surfing and Senegal. She is optimistic about the formation of the national surf team and believes that an appearance at the Olympics will inspire more people to come to the country to surf. She's hoping after the surfing, they'll stay to invest. To that end, Imane is working toward developing programs that include funding surf camps for locals. "They want to surf, but they don't have the money to do it," she says.

For now, though, Imane is focused on envisioning a future for herself that balances business, travel, and plenty of time on the waves. "I'd like to work abroad," she says. "But I also want to come back and surf here and work here. I want to invest in the potential of Senegal."

The DEVOTED

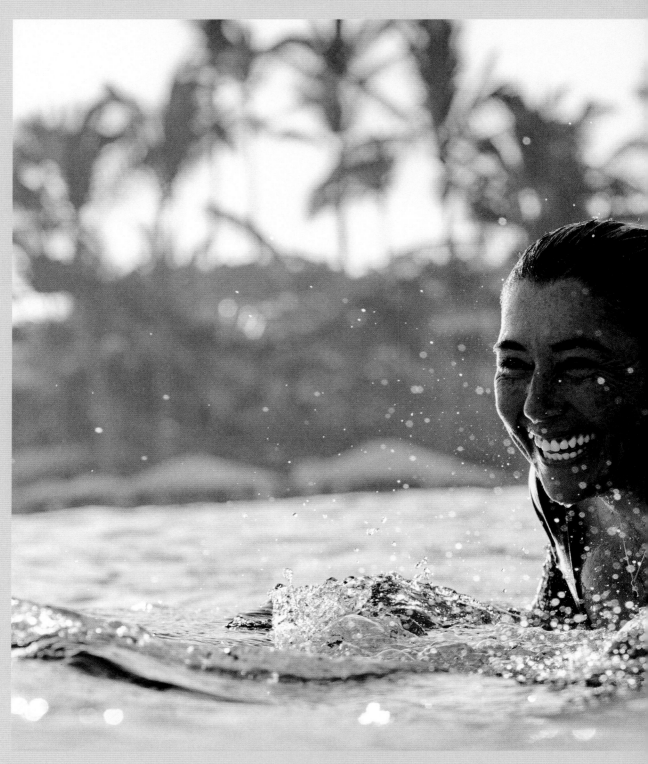

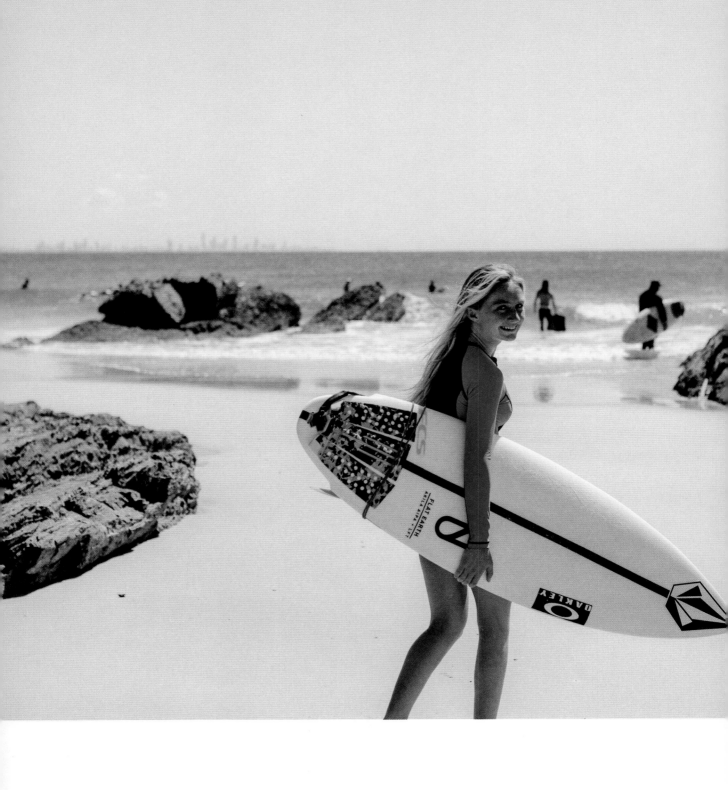

Sierra KERR

Coolangatta, Australia

Sierra Kerr never stops smiling. On the cusp of adolescence, at an age when many kids might begin to show the first signs of cynicism or self-doubt, Sierra retains a pure sense of joy, her enthusiasm uncontained. At thirteen, she has traveled much of the world, seen things most children her age could hardly imagine, and done things on her surfboard that few people, if any, will ever do.

Asked for a word to describe the way she surfs, Sierra doesn't hesitate. "Radical," she says, "and hopefully also explosive. That's what I hope it's like." She completely dominates in the water, executing fearless charging front-side grabs and alley-oop aerials. Her determined rail-to-rail surfing and comfort with getting barreled by waves of consequence seem far beyond her years. "The wave of my life would be a big barrel," she says breathlessly. "I would go super deep, and I would come out and be like, 'Oh my gosh!' Then I would do a couple turns and then do a big air and then I'd be like, 'Okay, I'm happy for the day.'"

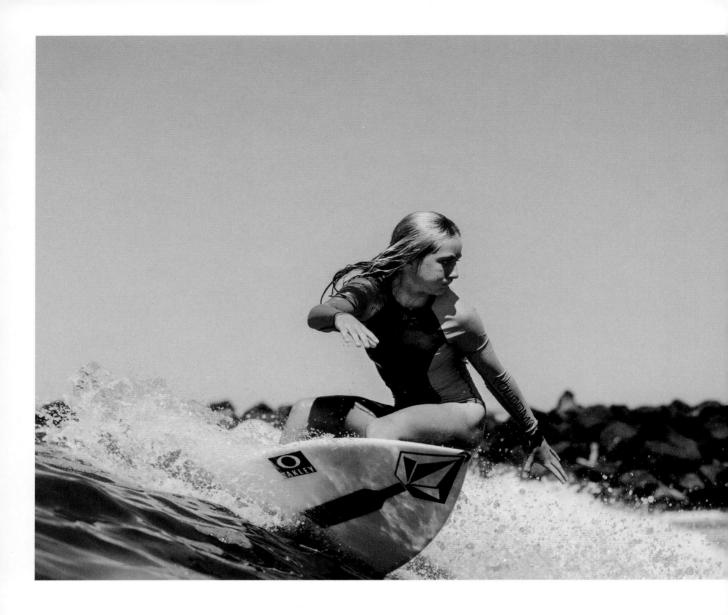

The daughter of Australian professional surfer Josh Kerr, one of the best progressive freesurfers in the world, Sierra was born in Coolangatta, Australia, home of the infamous Snapper Rocks. The family now calls Southern California home base (although they're now spending more time in Australia), but Sierra has spent much of her young life on the road with her mom, Nikki, traveling to her father's competitions. Perhaps unsurprisingly, when asked which places in the world are her favorite to visit, she is apt to answer in terms of the quality of the surf. "My favorite place is Australia because I was born there," she says. "It has a special place in my heart. But the next favorite place is probably Indonesia because it's a world-class wave. It's so warm and usually not very crowded. It's so fun."

"Fun" seems at the top of the family's to-do list, in fact—a priority. It's a word that comes up often in conversation with Sierra, but for her "fun" entails something more than a sense of enjoyment; it's an attitude and an approach to life. "I've been inspired by a lot of the women surfers when I was at my dad's contests. They all said,

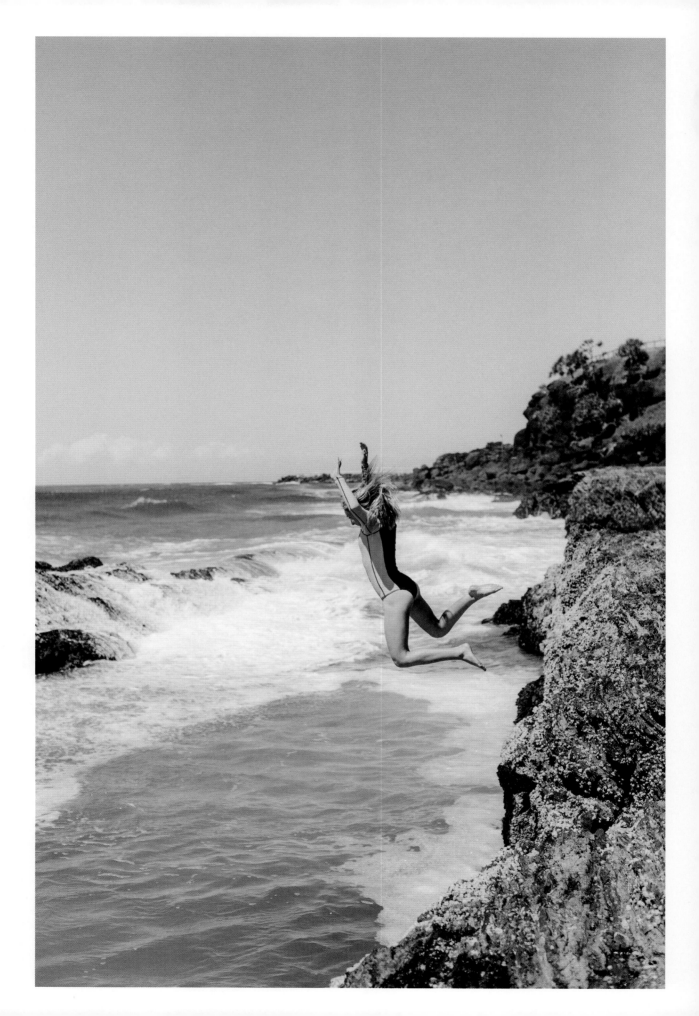

'Keep having fun. That's most important. Just have fun no matter what.'" For Sierra, sport is still play, and surfing is just one of the things she loves to do alongside a host of other hobbies. "You don't have to only be focused on one thing," she says. "Skating, rugby, golf, surfing, wake-surfing, I do all that stuff. Just try a bunch of different things and figure out what you like."

The family's itinerant lifestyle has offered Sierra the privilege of experiencing cultures outside her own, exposing her to other perspectives but also highlighting inequalities. "When you're traveling, especially in Third World countries, you learn so much; you see different cultures and you get to see that some people don't have what you have," she says. "And that's something I really think about. I want to help people. I want other people to have the opportunities that I have."

Sierra and her family help raise awareness and funding for a children's homeless shelter in San Diego, California. On Instagram, alongside videos of her busting fins out through the lip, you'll also find images of Sierra dropping off toys or clothes to kids in need. "If I post a photo of me giving the presents away, I hope it helps inspire other people to do the same thing," she says. "If you see one person doing it, then you might be able to do it, too, and then it creates a chain. And the more people you can get helping, the better the world will be." At thirteen, she already realizes that those opportunities are to be appreciated and, if possible, to be shared and passed on.

Sierra wants to be a great surfer. "The best I can be, the best in the world," she says; but more important, she would really like to help *everyone* have a chance to have as much fun as she's having.

"I've been inspired by a lot of the women surfers when I was at my dad's contests. They all said, 'Keep having fun. That's most important. Just have fun no matter what.'"

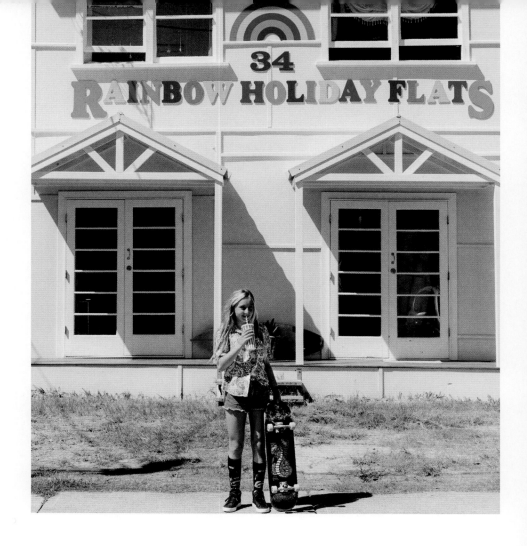

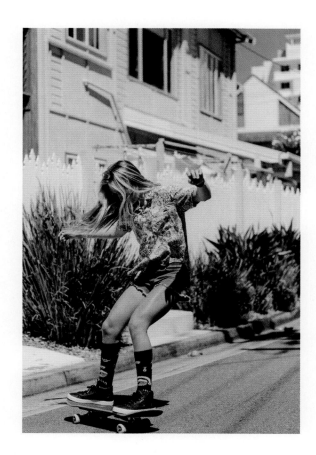

How to pull into a barrel, step-by-step . . .

Paddle, stand up, look at the section in front of you. If it looks like it will throw over, adjust your line so you can thread through the barrel, and continue looking up at the lip line. Keep making adjustments as needed. Hopefully, come out stoked!

The woman you most admire . . .

My mom. She's so loving and supportive. She does everything for me and never expects credit for it. I always say thank you, though.

The most important lesson you've learned from your mom?

She always says love your family, be kind to everyone, be safe, watch your surroundings, and always go to the bathroom before you leave the house (haha).

What makes you feel powerful?

Being a kind person.

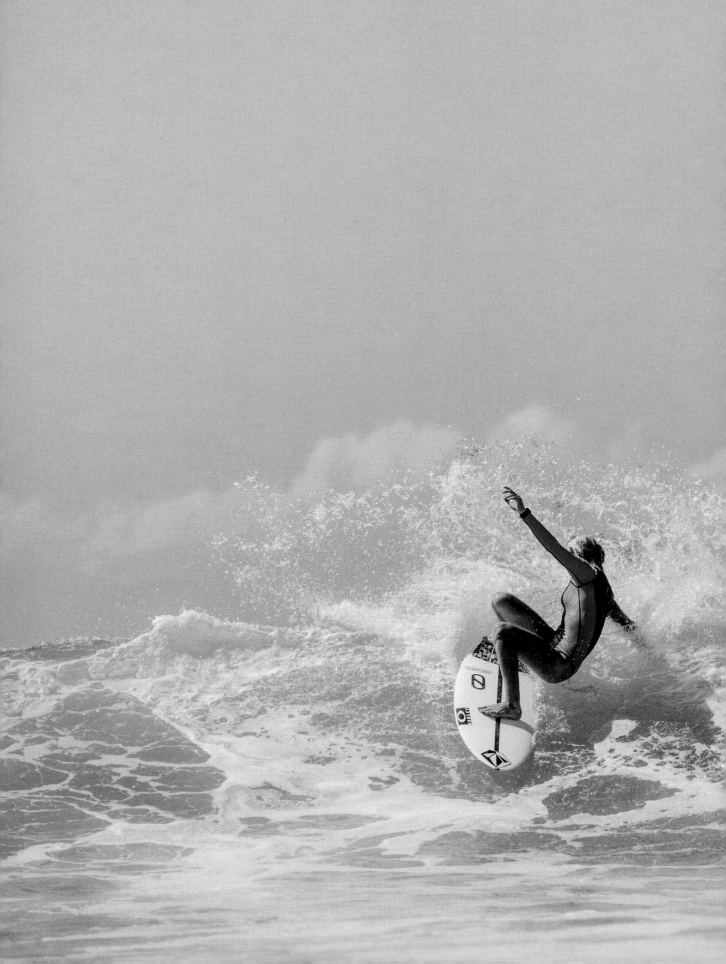

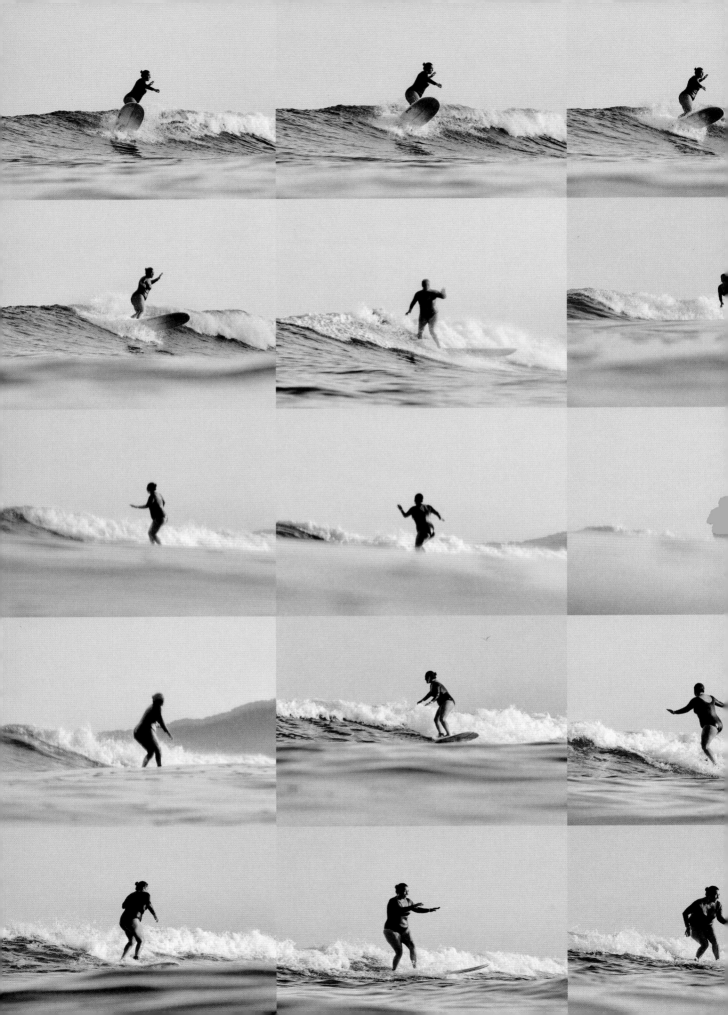

Risa Mara
MACHUCA

Sayulita, Mexico

Most mornings, if you look out across the crescent curve of Sayulita Bay, Mexico, you'll spot Risa Mara Machuca charging the waves. You will recognize her by her wide smile and the fuzzy mop of a rescue mutt, Chia, who prefers to ride in front of her mistress, just at the tip of the nose, ears flapping in the salted breeze. Risa's name translates as "laughing ocean that smashes," and this is exactly how she surfs. She likes to say she was conceived on the water, her American mother and Mexican father falling in love on his fishing boat as it swayed off the coast of Rivera Nayarit.

Watch Risa on the waves, and it isn't hard to believe that she is some sort of saltwater deity. She is the type of person who makes everything seem easy, a natural leader commanding with relentless enthusiasm. Meet her, and you know immediately that she is in control not only of her board but of the town itself—Sayulita's Mistress of Ceremonies and Head of the Department of Fun. She helps program the annual Sayulita Film Festival. She leads beach cleanup initiatives, encouraging awareness in clever and creative

ways such as a public art fish sculpture that doubles as a recycling bin or interactive ashtrays. She promotes the annual fundraiser, the Trashion Fashion Show, in conjunction with the Creative Center, to raise money for the community center in town. "We make clothes out of recycled trash," she says. "It's a great time."

Risa also runs a free surf camp for local kids in the summer called Mar Y Vida, enlisting restaurants to donate lunches and rallying both individuals and businesses in the community to chip in funds for boards and wetsuits. "We give them free camp, and they get to surf in the morning and they also get lessons in ocean awareness and safety skills," she says. "There's so many people here that want to give and donate. There's always fundraisers going on." More often than not, these local initiatives are instigated by Risa herself. She arrived in Sayulita in 2010 and has woven herself seamlessly into the tightly knit community.

Born in the United States, Risa grew up going back and forth from New York to Mexico, straddling both cultures. Encouraged by her

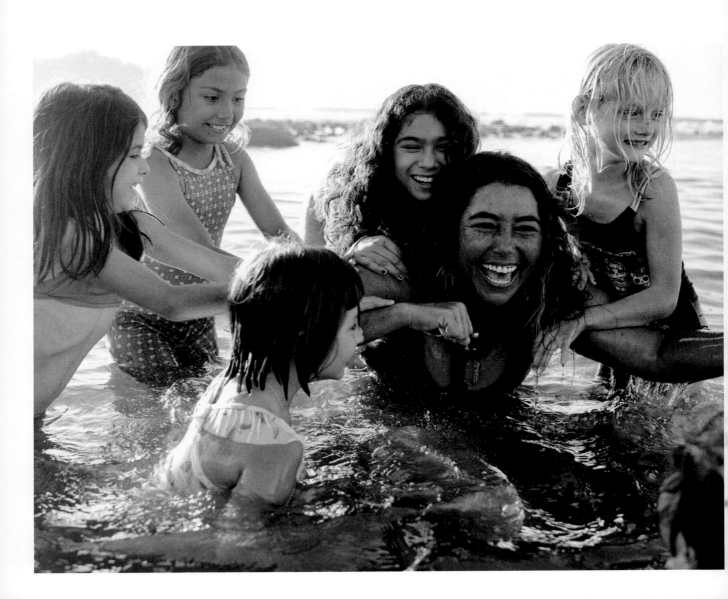

parents, she explored an interest in film and would go on to win awards at several festivals while she was still in college. Risa moved to Hollywood to make her way as a director, found success, and fell in love—then had her heart broken. "I had broken up with the person that I thought I was going to marry," she says. "And I just said, 'Fuck it. I'm taking a sabbatical. I'm going to learn how to surf, and I'm taking a board with me.'"

Risa traveled to Costa Rica, Belize, and Cuba, her board under her arm. "Ultimately, surfing helped save me," she said. "It saved me from heartbreak in the beginning, but it was also empowering. My dad was a fisherman, my mom was a beach hippie, and I've always been connected to the ocean not just physically but spiritually as well. Surfing gave me strength that I had inside but I needed to get back, because I had lost that confidence in myself."

When Risa arrived in Mexico a few years later to take care of her ailing father, she intended to visit for just a month or so; but when he passed away, she inherited a stretch of land near the ocean in San Blas and decided to stay in Mexico, settling in Sayulita. Mexico had always felt like home, but now it was also where the memory of her father still resonated. "I usually surf very early," she says. "I get there at the same time as the fishermen. A lot of them knew my father, so for me, it's a way to remember him. On the water, I feel that connection."

"Surfing gave me another path in life. It's given me my work, my career. It gave me my inner strength, my inner power. And it gave me back a part of myself that I had lost along the way."

The most important lesson you
teach your kids at surf school . . .

*The most important lesson surfing
taught me—patience. Also, as in life,
look where you want to go.*

Hardest-won lesson you've
learned about starting a
business . . .

*Get started and don't wait for
everything to be perfect.*

Your surf kit . . .

*Fu wax, Zinkle (I make a reef-safe
zinc with biodegradable glitter sold
locally in Sayulita), Vaseline, duct
tape, hat, fin key, comb, lip balm,
Chias surf vest, and goggles.*

Is there anything that scares you?

Not living out my dreams.

A decade later, surfing has become not only a way to honor her father
but a way of life. Risa now makes her living surfing, running tours
and lessons with her partner. Despite the fact she was a latecomer
to the waves, she has dominated the sport as she dominates most
things. In 2015, she became the first woman to win the national
Mexican longboarding championships. "I was the first woman to beat
the men in a heat for a final," she said. "I actually had to surf against
the guys because there were no women competing at the time!" Risa
won again in 2017 and has represented the country three times
in the Pan American Games. Meanwhile, she continues to work in
film, making shorts and documentaries on surf culture as well as
a surf-focused narrative film.

Most recently, Risa founded the upcycled beachwear line Belle
Curves, which promotes body positivity, encouraging women of all
shapes to feel confident in the water. The brand is a vivid reflection
of Risa herself—her innate creativity, her concern for environmental
causes, as well as the boldness and self-assurance she's gained
through her time on the waves. "I would say I've finally grown into
my own name," she says, flashing one of her big smiles. "Surfing
gave me another path in life. It's given me my work, my career. It gave
me my inner strength, my inner power. And it gave me back a part
of myself that I had lost along the way."

Kaori
MAYAGUCHI

Shiribeshi, Hokkaido, Japan

Kaori Mayaguchi is the future of Japanese surf culture, a waterwoman in absolutely every sense of the word. She embraces body and board surfing, free-diving, and snowboarding. She says that "water cycles"—the deep snowdrifts in the mountains of Hokkaido or swells in Shikoku—are "at the core of my life. Everything I've learned about the world, about friendship, love, philosophy—comes from my experiences with water."

Raised in Japan and Hawaii, Kaori has never strayed far from the sea. "There is a saying here that translates into something like 'Nothing good comes from leaving the ocean,'" she says. Even as a child, her concept of "home" directly correlated to the water. Her family relocated often, following the path of her father's windsurfing pilgrimages. "I don't even know where my hometown is," she says, with a laugh.

Kaori was born in Kyoto on the coast of the Sea of Japan. At age five, her family moved to the Pacific coast, and when she was twelve, they headed farther east, this time to the islands of Hawaii. It was in Maui that Kaori first found her way onto a board, surfing her first competition in Oahu at thirteen years old. At sixteen, she and her family returned to Japan, choosing to settle in Shikoku because it was "a good environment for surfing."

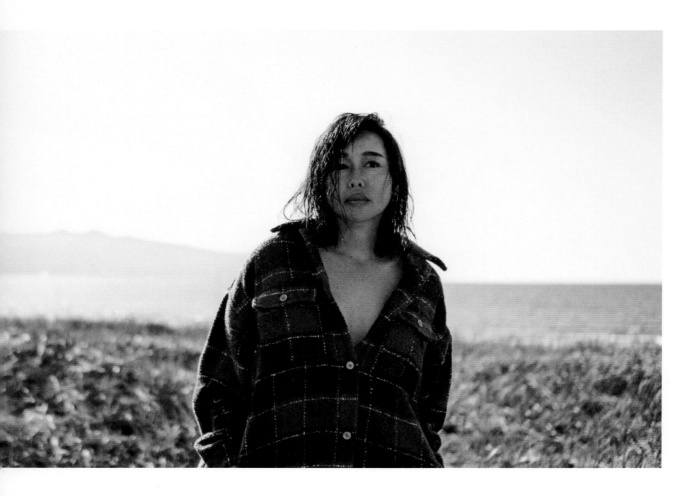

"Everything I've learned about the world—about friendship, love, philosophy—comes from my experiences with water."

By this time, Kaori had gone pro, surfing for the Japanese National League and on the WSL circuit and was a three-time JPSA (Japanese Professional Surfing Association) champion. At twenty-five, she quit competing. "I wanted to do real surfing, chase the good swells," she says, "not just surf scheduled conditions, which were often bad." She continued to travel the world to surf and snowboard (which she calls "snow-surfing"), eventually opening a surf shop and hotel in Shikoku, which she runs with her family.

Kaori also promotes Japanese surfing on a global level, as the country's first female surf announcer *ever*. In both her life and her career, she has continually redefined what it means to be a Japanese waterwoman. "There is a culture of ama [female divers for shellfish] in Japan," she says. "It is not unusual for women to be in the water, so there isn't necessarily prejudice toward women surfing. Still, the ratio of men is overwhelmingly large; there are very, very few female surfers. Often, I'm the only woman in the lineup."

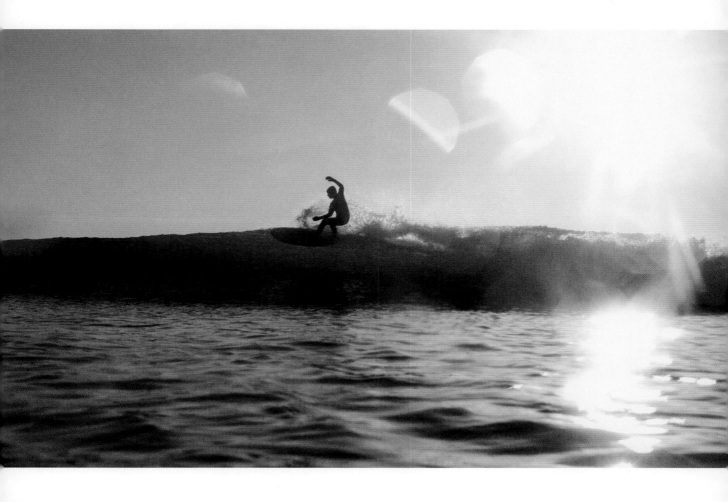

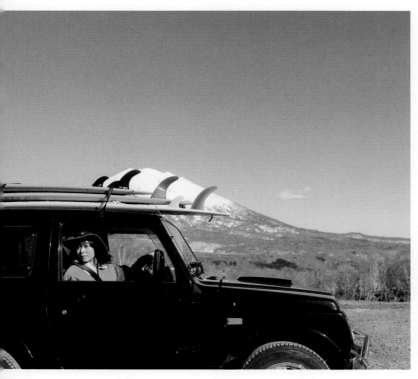

Something people may not know about surf culture in Japan . . .

The NSA (Japan Surfing Association) has over 13,000 members, and there are about 900 teams all over Japan.

The woman you most admire in the world and why . . .

My mom. She gave birth to me when she was seventeen, and still my parents respect and love each other so much.

Postsurf rituals . . .

I say arigato (thank you) to the ocean. Not just in my mind, I also say it aloud.

Cold or warm water surfing?

Bikini surfing in warm water with just friends is the best. But if it's crowded, I'd choose cold water surfing with fewer people.

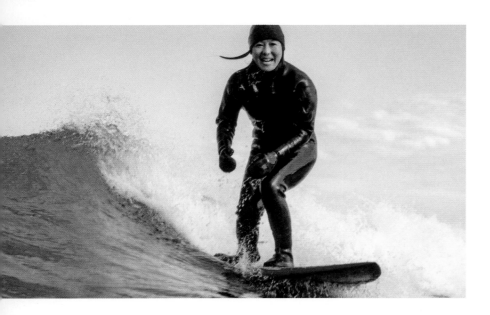

A decade ago, in the months and years following the 2011 Tohoku earthquake and tsunami, Kaori was often the *only* person in the water. When the massive 140-foot waves swept across the islands, surfing was forgotten. Triggered by a massive earthquake, the impact devastated the country. Twenty-five thousand people lost their lives. Miles of coastline were destroyed. "We lost surf beaches where I used to go often," she says. The meltdown of a nuclear power station led to radioactive leaks that affected the waters around Japan. Friends of Kaori's fled their homes, never to return. "Japanese people saw the horror and heartlessness of the ocean," she says. For months, Kaori was unsure if she would ever be able to surf in Japan again. Finally, hesitantly, she ventured back into the water. "I went surfing alone in an empty lineup," she says. "For me, it was like going to church. I prayed for Japan and for the ocean to return to a peaceful place." The experience prompted action and, for Kaori, an even deeper understanding of the natural world. "I realized how important it is to be in the water."

Kaori now works with the Nippon Surfing Association and volunteers with Surfrider Foundation Japan, advocating for sustainability while encouraging others, particularly young women, to engage with nature and to overcome their understandable fear. "I use my voice to promote surfing in Japan because I believe that when people experience the sea, they will want to protect it," she says. Kaori gets on her board each day, documenting her adventures. "I want as many people as possible to have love for nature and to know how valuable nature is," she says. "My goal is to spend a lifetime learning and teaching ways to preserve the environment." She continues to share her experiences, on the waves and in the mountains, in the hope that others will be inspired to do the same.

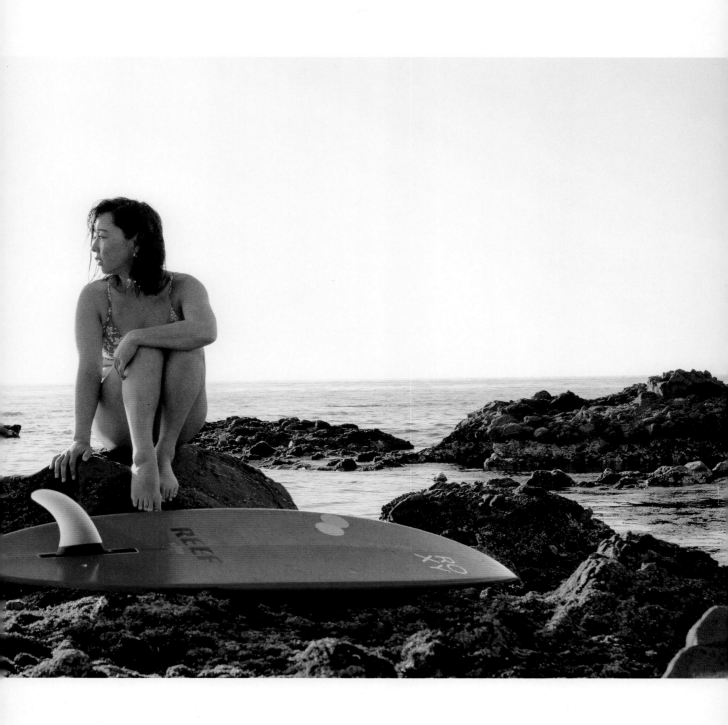

"I went surfing alone in an empty lineup. For me,
it was like going to church. I prayed for Japan
and for the ocean to return to a peaceful place."

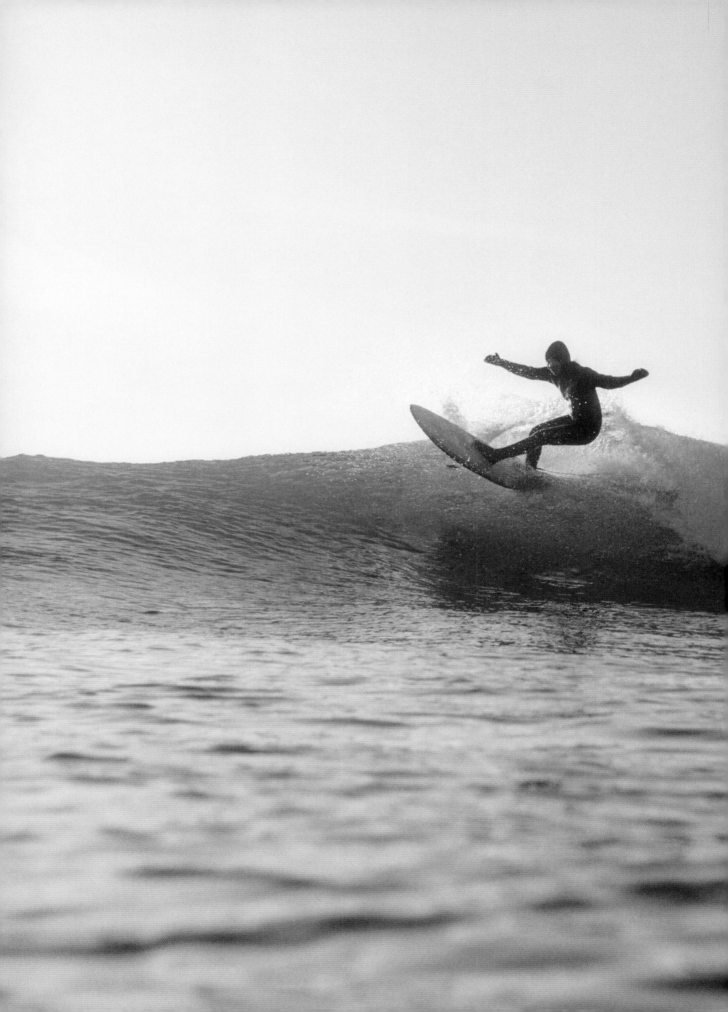

"I use my voice to promote surfing in Japan, because I believe that when people experience the sea, they will want to protect it. I want as many people as possible to have love for nature and to know how valuable nature is. My goal is to spend a lifetime learning and teaching ways to preserve the environment."

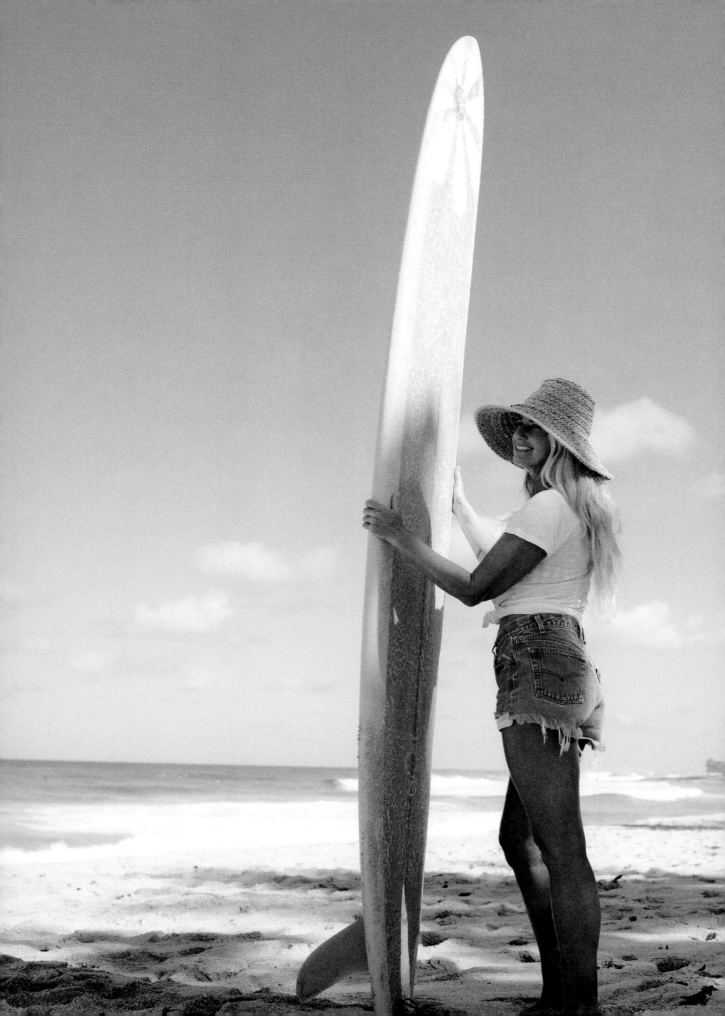

Alexandra
FLORENCE

Alexandra Florence likes to remind her sons how quickly life can change, using her own experience as case in point. She first arrived in Hawaii in what she calls "the wild west days" of the 1980s. She was barely sixteen, having left school on the East Coast to travel on her "big adventure" of self-discovery. "I ended up getting married, having three children, and getting divorced, all in the matter of five years," she says. "I always tell my kids, 'Look how fast your life can change!'" This evolution from Jersey Shore expat to Hawaiian surf mom may have come quickly, but Alexandra adapted fast—turning what might have been a challenge to many women into a natural continuation of her big adventure.

This is Alexandra's true talent—a spirit of exploration that has made her famous in the surf world as a nurturer and mentor not just to her three sons but to countless others. Over the years, her small beach house overlooking the thundering waves at Pipeline has served as a temporary home to a vast community of surfers, an extended ragtag family that she has looked after with the same

Who do you admire most in the world?

My sons and my dad and anyone who overcomes hardship of any kind and comes out tougher than ever.

What makes you feel powerful?

Accomplishing goals and challenges. Backcountry hiking, camping, and learning to live off the land. Big drops in surfing, skating, and snowboarding . . . independence.

Favorite surf films . . .

Beyond Blazing Boards, Magna Plasm, Searching for Tom Curren.

What are you hopeful for?

I have hopes that my children will live long, adventurous lives filled with love and have many children of their own. I hope cell phones die out and we go back to pay phones, that in the future we never look at a phone to see people's faces. I hope love wins!

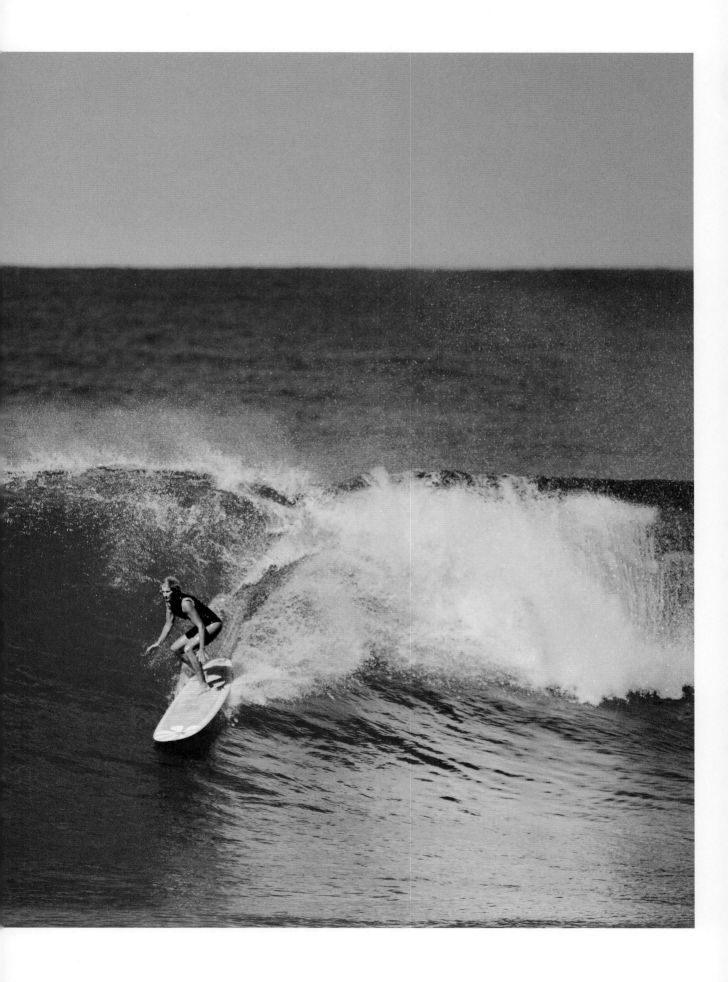

fierce tenderness she shows her sons. Alexandra cares for her boys with a balance of freedom and watchful protectiveness, the same practical but open-minded way that she was raised herself. "I was the youngest of five, and I had an amazing mom and dad," she says. "Both my parents were artists. We had art studios in our house growing up. We had art infiltrated through our whole being."

Alexandra grew up a block from the beach in Ocean Grove, New Jersey, in a hundred-year-old twenty-seven-room Victorian hotel. "[My dad] renovated it into one family home for me and my brothers and sisters," she said. "So we lived in this big, giant old hotel right on the beach. It really was an ideal childhood." Alexandra spent her youth in the water, beginning surfing at age ten. "I surfed throughout the summers on the East Coast, so when I moved to Hawaii, I just embraced it and the whole lifestyle of surfing," she says. She arrived at the North Shore and was immediately embraced by the usually insular community. "I met a lot of the North Shore heavies right away. I never had any issues; I just felt a lot of aloha," she says. "And I think it goes differently for a lot of people; but for me, it was like, 'Wow.' They're caring, and they looked out for me."

When Alexandra decided to divorce her husband, it was partly that sense of community that gave her the strength to leave the relationship, which she acknowledges was abusive. "I am grateful I had the guts to get out of that," she says. "I don't have animosity toward my ex-husband. People make mistakes; that's his loss, my gain." Looking back, she has realized that "those hardships made my life better in a lot of ways, just learning, and coping and dealing with those kinds of issues. You can't have the great parts without the bad."

A single mother looking after three young boys all under the age of five, with very little money or professional qualifications, Alexandra asked her father for advice. "He told me to put my head down, march forward, and soldier on. And so I did; I ran a tight ship." She found part-time work, went back to college, and focused on being the best mother she could to her sons. She acknowledges how hard it was. "My life started at 5:00 a.m. and didn't end until the kids went to bed.

"It's brought me a lot of joy, family time, and togetherness, and we enjoy the ocean together on so many levels beyond surfing. It's always given me peace, and I believe it's the same for my children."

"We just went to the beach every day, all day, rain or shine, until they were tired. And they were the best times of our lives and the hardest times. Financially, it was most challenging. We had nothing, but we had everything nature had to offer. And in return, it just took care of my family."

Even past when the kids went to bed, I was doing homework. With the nights I worked, I was getting off when the bar closed at 2:00 a.m. and then I'd have to get back up at 5:00 a.m. to get the kids off to school."

In between working long hours and studying photography at the University of Hawaii, Alexandra and her boys spent the rest of their time by the water. "I always managed to live really close to the beach," she says. "I didn't have money for babysitters really, so we just went to the beach every day, all day, rain or shine, until they were tired. And they were the best times of our lives and the hardest times. Financially, it was most challenging. We had nothing, but we had everything nature had to offer. And in return, it just took care of my family." Surfing and nature offered the kind of respite and healing that they all needed as they rebuilt their family. "It's brought me a lot of joy, family time, and togetherness," she says, "and we enjoy the ocean together on so many levels beyond surfing. It's always given me peace, and I believe it's the same for my children."

Now Alexandra's sons—John, Ivan, and Nathan—are grown men, and all three are world-renowned surfers (and skaters and snowboarders). Their skill as athletes, as well as their deep connection to nature, they owe almost entirely to their mother. "Honestly, the secret is to invest time in your kids and hawk them like no other. Watch every move they make because when they become teenagers, they get tricky," Alexandra says with a

laugh. "As your kids grow up, they need you in different areas. So you have to just be there the best you can as their needs change. My priority was my family. That's the way I was raised. I just tried to parent like my parents."

Although the boys have since moved out of their Pipeline treehouse, the four see each other regularly, sitting down together for family meals and often traveling far and wide. Alexandra manages her sons' lives in much the same way she's raised them, instilling in them a respect for others and for the natural world. "It's a lot of attention and it's a lot to handle," she says of her sons' success. "Our main thing is finding pleasure again. It's just finding that joy again in nature and the ocean. Bringing it back to the basics."

To that end, Alexandra surfs (and skates and snowboards) with her sons as often as she can. She also races dirt bikes and has plans to climb Mount Everest. And, ever the nurturer, she has plans to create a foundation for troubled youth on the North Shore of Oahu. "I think there are teenagers who need a lot of attention here in Hawaii, kids struggling from bad homes," she says. "I spend a lot of time at the skate park, and I've become quite close with a lot of the kids there. I just try to help as much as I can to give them guidance." For Alexandra Florence, the next part of the adventure beckons.

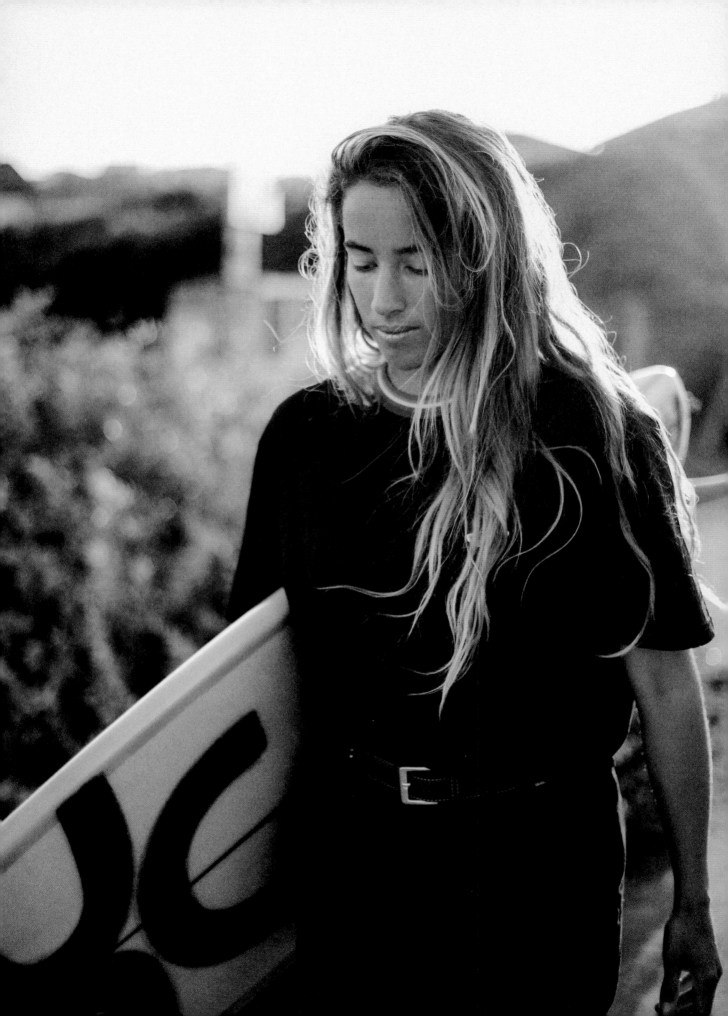

Lee-Ann CURREN

Biarritz, France

Despite being part of a serious surf dynasty, Lee-Ann Curren has chosen to make her mark through redefinition not emulation. Her mother, Marie, was a European title holder, her father is the enigmatic pro Tom Curren, and several relatives from each generation have made a name for themselves in the surfing world. Lee-Ann, though, is completely, authentically herself, freesurfing, songwriting, and performing across Europe and beyond.

Although she surfed competitively for Roxy starting at age fifteen, Lee-Ann soon crossed over to the more expressive pursuit of freesurfing. "My strengths were more being creative than being a great competitor," she says. "I feel the contest surfing is super fascinating and fun to watch and it really drives the sport forward, but I've got more potential trying to go surf really good waves and make a video and participate in all the creative aspects as well."

By twenty-two, Lee-Ann had turned her back on the perfection-seeking grind of the pro tour and focused instead on an exploration of style and creative expression. In the water, what she seems to

love most about surfing is the swell itself, in all its endless variety and seeming imperfection. She is a freesurfer in the truest sense, finding the unexpected line in each wave, experimenting with board lengths and fins, her approach always guided by a mix of imagination and creativity.

Lee-Ann's first experiences in the water were on her home break in her mother's native Biarritz. "I was very young, probably four or so," she says. "It was not really exactly surfing but getting comfortable in the water and in the shore break." By nine, she was surfing with her father while on visits with him to the West Coast. Back home in France, Lee-Ann would surf with her mother and stepfather, guidance freely offered to her from the array of expat pro surfers who had made the coastal village their home.

This unconventional transatlantic upbringing gave Lee-Ann a unique opportunity to explore not only very different waves but very different cultures as well. "I think that shaped me, having two nationalities, just hearing different languages and really different countries, people with different habits," she says. Lee-Ann and her brother rarely traveled with their father on the international surf circuit, but they were always in attendance when he competed in France. "We would see the contests in Biarritz, like the Quiksilver Pro, the Gatz Pro. That was our experience of being in that world; but the rest of the time, it was just normal, like school and a normal kid's life."

At least as normal as one could expect from a childhood spent traveling back and forth between the golden glow of the central Cali coast and a beautiful Basque fishing village turned high-end holiday escape. "Biarritz is a cool mix of the typical Basque fisherman town and then there's that Paris influence," she says. "There's a lot of people from Paris or Bordeaux who come here on holidays since, for centuries, really." Lee-Ann still lives in the area and surfs through the long summer days and into the gray winter. "I live twenty minutes from Hossegor, which has really good sand banks and barrels, kind of a bit easier version of Mexico," she says. "Not as crazy as Puerto Escondido but still some super powerful beach breaks."

It is obvious that what draws Lee-Ann to the water is this unpredictability: the waves never the same, the swell a blank slate waiting for her to shape and color. This fascination has defined her career. Lee-Ann's creativity is on display not just in her surfing but also with her forays into music and filmmaking. In her first surf movie, *Titan Kids*, shot in a favela on the north coast of Brazil, Lee-Ann explored how surfing offers escape and transformation to young people growing up amid poverty, drugs, and violence. Made in collaboration with Brazilian pro Andre Silva, who grew up in the community, the film is a poignant and intimate portrait of surfing as a means of redemption.

That Lee-Ann's other passion is music comes as no surprise. Having begun at age twelve, she plays her guitar like she plays with the waves: experimentally, instinctively. Her music career has evolved alongside her surfing, each providing an outlet for her curiosity and her thoughtful, contemplative approach. She has an artist's sense of romance and loves the winters in Biarritz. "I like being on the empty beach in the storm," she says. "Or surfing when it gets you cold and tired. I like that vibe, when it's darker and more mystical."

The allure of making films and music for Lee-Ann is in going deep, in exploring the endless possibilities and variations, as it is with her surfing. Her inspirations for both are varied as well. In the waves, she looks to her father, her close friend Stephanie Gilmore, and 1990s legend Lisa Andersen. In music, she cites a wide range of influences—from Joni Mitchell to the Cure—and she describes her own recordings, fittingly, as dream wave. "I'm kind of a master of none," she says. "I like recording stuff and making a bit of a patchwork. Sometimes guitar, either electric or acoustic. Or I start with bass and synths. Experimentation, self-expression, both in the studio and in the water. As well as the freedom, of course, to explore and to discover." As Lee-Ann describes it, "Surfing and music . . . they're both an escape."

Favorite three places to surf in the world . . .

Tahiti because it is perfection in nature. Iceland because it's raw and always an adventure. Morocco because of the perfect rights, amazing food, and nice people (and it's close to France).

Music you surf to . . .

Music by Pat Curren (my little brother).

Your greatest strength . . .

I'm never bored.

Favorite person to be in the lineup with . . .

My girlfriend, Lucie.

Megan
CRAWFORD

Venice, United States

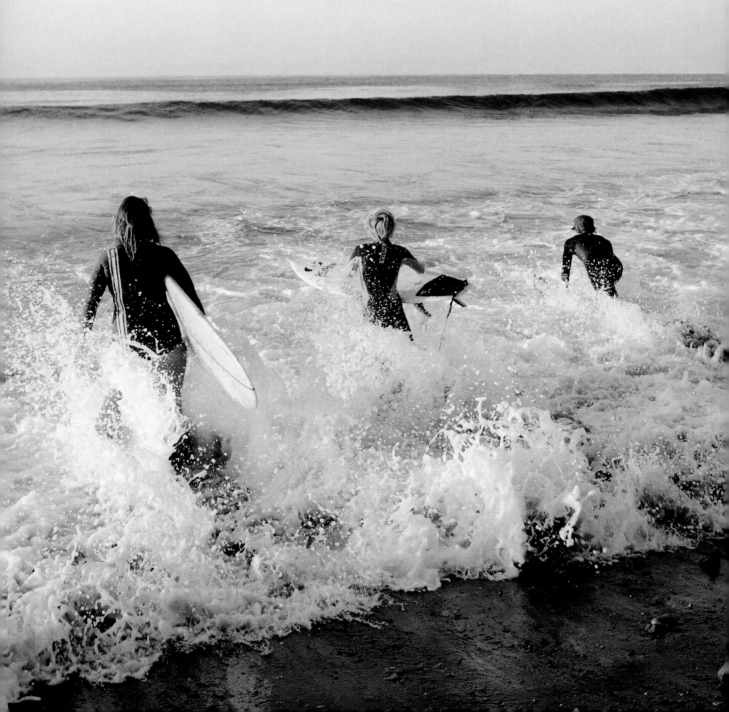

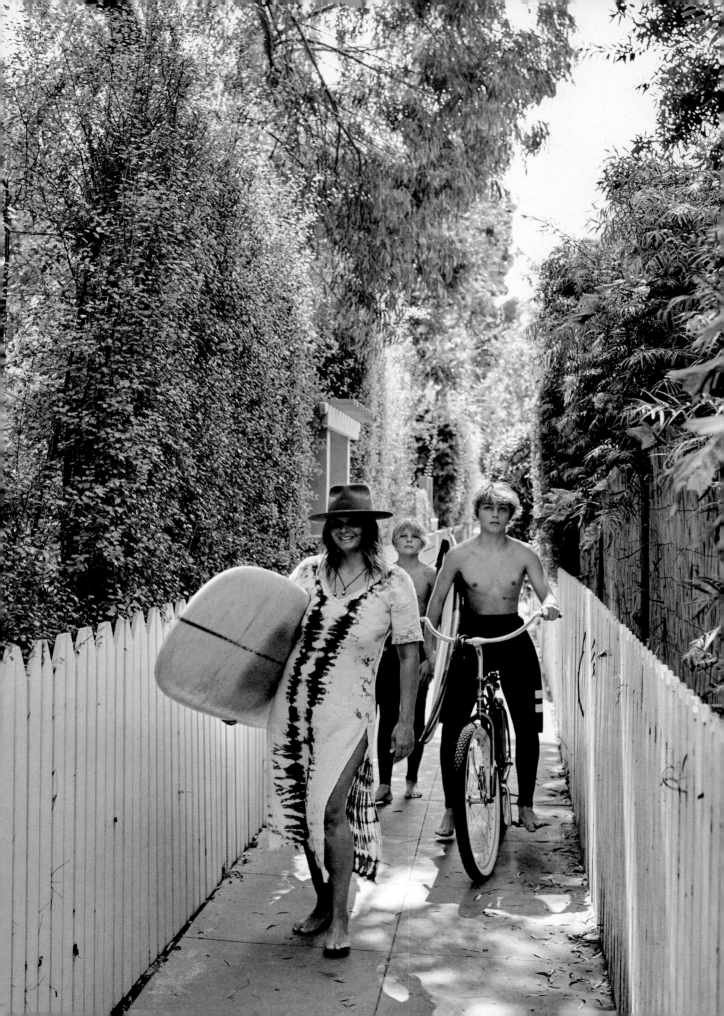

The rambling boho bungalow that Megan Crawford shares with her two boys, Henry and Will, is perhaps not the sleekly modern spread one might expect of a Hollywood insider. As an exec for the revered Creative Artist Agency, Megan spends her days handling the release of studio blockbusters and the careers of A-list talent. Her home reveals a completely different side. Instead of driven intensity, there is a mellow vibe of the classic California kind. An array of sea-salted surfboards lean on the low-slung porch. A few steps away, the Venice Beach boardwalk beats with life, a distant din of skateboard wheels, and a bit farther, the low meditative crash of waves.

It was in these waters, the gray Pacific down the block, where Megan first began to surf—a practice that started as a way to spend time with her boys but became something much more. "I started around eight years ago," she says. "The season before I split from my husband. My sons wanted to learn, and I wanted to feel competent with them. But after the split, surfing took on a different meaning. It became more of a sanctuary." For Megan, the ocean offered both connection and respite. It was a space free of phones, screens, and judgment and demands—save the ones she placed on herself. "I'd go out to surf and tell myself, 'Today you're going to catch a wave. One and done. But you're going to get one,'" she says. She set about learning the waves with the same resolute approach she brings to her career. But while her day job requires influence and authority, surfing asks the opposite. On the board, ego is shattered and submission demanded. You don't *take* the wave, you let the wave take *you*.

Megan honed her skills at Topanga, a tucked-away spot fringed with palms off the Pacific Coast Highway known for both its long right-hand point break and its intimidating localism. It's here she spends her early mornings on a 9'2" longboard shaped by Karina Rozunko, catching waves and watching other formidable women doing what they love. "Female surfers bring some truly spectacular style and can be just as competitive as the men," she says. "They're fighting for that position in the lineup and earning their space. They're not bringing something that's soft and docile."

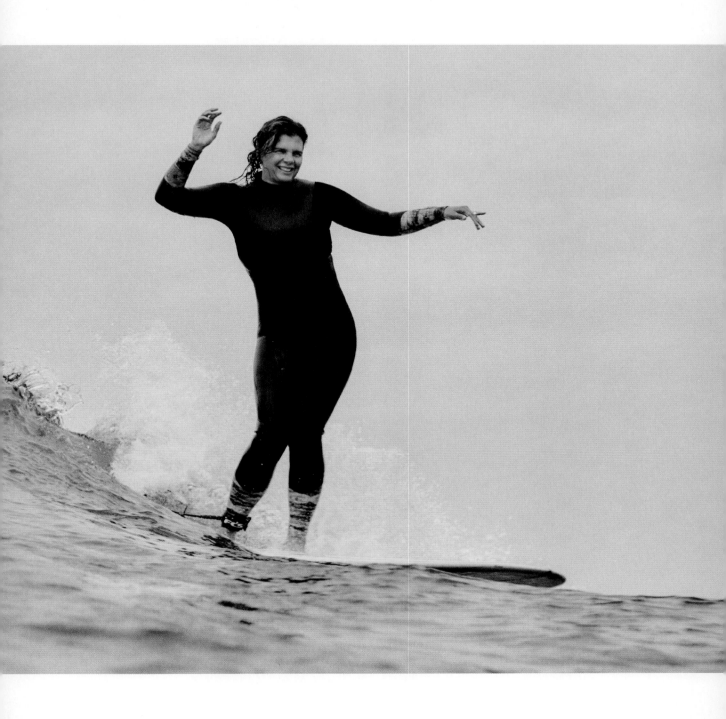

"Female surfers bring some truly spectacular style and can be just as competitive as the men. They're fighting for that position in the lineup and earning their space. They're not bringing something that's soft and docile."

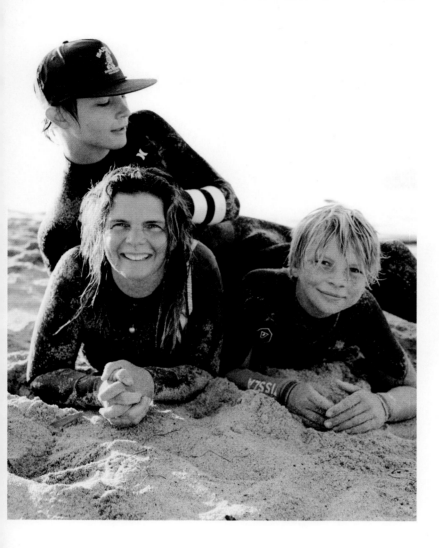

What do women bring
to the lineup?

Humor, style, and elegance.

What have you learned
from surfing?

*Let go of the ego. And that how you
surf is a reflection of the type of
person you are.*

Favorite surf breaks . . .

*Cangu in Bali. Cloud 9 in the
Philippines. Arugam Bay in Sri
Lanka. Bocas Del Toro in Panama,
and Sayulita and Saladita in Mexico.*

A quote to live by . . .

*Helen Mirren once said she'd
advise her younger self to say
"fuck off" more and "stop being
so bloody polite."*

For Megan, surfing has marked profound shifts in her own life and her family life as a form of daily meditation and inspiration for travel, adventure, and philanthropy. She works with her children to choose their surf destinations to align with volunteer work for nonprofits like A Walk on Water, which provides surf lessons to children with disabilities. "Many of these kids have never been in the water," she says. "They're often nonverbal and they're terrified. But then they catch a wave and they are utterly stoked." It's a catharsis shared by Megan and her sons. "As delighted as we are to see these athletes get the ride of their lives, it's equally euphoric for us."

Another nonprofit, the Waves For Water project, has taken them to El Salvador and the Philippines. "I always wanted to travel with my children, raise them as global citizens," she says. "If you're going to where clean water is not a given, you raise funds to bring water filters to those communities. My sons will tell you it's the highlight of their entire trip. If you're traveling for a wave, you exercise social responsibility that comes with that privilege."

These shared surf journeys have deepened the family bond and fostered an ever-evolving circle of new friends. The Crawfords' sprawling Venice compound now hosts visitors from around the

world, most arriving with surfboards in hand. For Megan, it has also allowed for a redefinition, a way of balancing work and home, travel with family, and much needed time alone. Like many other women who find surfing as adults, the practice has presented her with a way of pushing past challenges and into personal transformation. "The concept of learning something new that you suck at for a long time is a real practice in getting to know yourself," she says. "But when you learn to catch your own wave, it's the proudest moment ever."

Ultimately, Megan's time on the waves has eased the transition from an old life into a new one and provided her a method of moving forward without inhibition or self-judgment. "The personal challenge, and something I'm really working on, is no longer valuing yourself by what other people think," she says. "I'm not perfect at it, but it is very freeing."

"I always wanted to travel with my children, raise them as global citizens. If you're going to where clean water is not a given, you raise funds to bring water filters to those communities. My sons will tell you it's the highlight of their entire trip. If you're traveling for a wave, you exercise social responsibility that comes with that privilege."

ACKNOWLEDGMENTS

Here's to the exceptionally dynamic, accomplished, and smart community of women who helped me bring this book to life. In times of unprecedented upheaval and uncertainty when we mourned the loss of our brothers and sisters. In times of social and political crisis when we despaired for our children, for the planet, for humankind, for the future. We women do what we do best. We rally. We hold each other up. We pivot. We prevail. We surf!

The actual women making waves. You are my sheroes. Thank you for saying yes, for allowing us to capture your joy and discuss openly your pain. It's this courage and humility that I want to honor in each and every one of you. I am forever humbled, grateful, and indebted.

Kelly Snowden and Emma Campion. What a team! Unwavering support, an abundance of trust, two fantastic humans. Thank you, Kelly, for your thoughtful and precise editing and thank you, Emma, for your design excellence and expressive storytelling. I won the lottery with you two.

Ten Speed Press and Penguin Random House teams. Thank you for believing in this first-time author and for giving me the opportunity to produce this dream project. Thank you also to Zoey Brandt, Ashley Pierce, Mari Gill, Jane Chinn, Jana Branson, and Brianne Sperber. My deepest gratitude and respect for you all.

Jessica Hundley. Your enthusiasm, energy and positive collaboration for this idea from start to end made the writing process an absolute joy. Your approach to storytelling and ability to extract the human experience is a testament to your vast experience and the lovely person you are.

Contributing rockstar photographers. What a wildly talented, creative, collaborative, worldly collective of female genius. I treasure each and every last photograph you created for this book, and I cannot thank you enough for making this book a beautiful expression of something we are all passionate about and are deeply connected by.

Lisa Far Johnstone. My friend, surf sister, and contributing editor of this book, elevating each story with intelligence and insight. Thank you for being my barometer and passionate advocate on global social justice issues and for always challenging us to be more conscious, more active, louder, stronger.

My people. To everyone who opened their address books to me; brainstormed ideas; offered feedback; listened to my pitch and my problems; provided connections, access, support, advice; and believed in me. I could not have done this without you. Thank you so very much. And a special shout out to Chris Chatham for all of the "meaningful consultation."

Dan Einzig. Your creative lens and entrepreneurial spirit helped me to take the words from the page and visualize a project beyond my dreams. You counseled, coached, and leaned in at home so I could travel, write, wrangle, stress, procrastinate, edit. Never complaining. Always complimenting. Thank you for being my rock, my compass, my heart, and the very best father to our boys. I love you forever.

Ralphy, Flynn, and Louis. My salty crew of feminists. I'm sorry I chewed your ears off with book plans over the summer. I'm sorry I missed Thanksgiving, that I was stressed at Christmas, exhausted at Easter, and virtually absent for all of May. I love you fiercely.

My amazing parents. Your creative energy, work ethic, resourcefulness, unwavering support, and unconditional love shaped who I am, and I love you both very much.

Julia. My beautiful sister, the reason I started to surf. I feel your protection surrounding me; I see you in the waves. Not gone, always there. For anyone suffering from mental illness who doesn't know where to start, visit the World Health Organization (www.who.int), and I strongly encourage you to look at your local / state / country support systems.

PHOTOGRAPHERS

ANA CATARINA
www.anacatarinaphoto.com
@anacatarinaphoto
p. 150, 152–54, 157, 159

NAOKO HARA
www.n-hara.com
@_nhara
p. 234, 236–40

EVIE JOHNSTONE
www.eviejohnstone.com
@eviejohnstone.stylist
p. 62, 64–8, 82, 85, 86, 88, 192, 193 (bottom), 196, 198

ALLY B. MARTIN
www.allybmartin.com
@allybmartin
p. 8, 190, 193 (top), 194, 195, 199

ANNE MENKE
www.annemenke.com
@annemenke2
p. 4, 12, 15, 16, 18, 20, 22, 24–7, 29, 31–7, 39, 50, 52–8, 60, 61, 90, 92–9, 140, 143–49, 160, 162, 163, 165, 166, 168, 172–74, 176, 178–82, 183–89, 200, 202, 204, 206, 207, 216, 226, 228–33, 242, 245, 247, 249, 250, 260, 261, 263–67, 270, 272

CAIT MIERS
www.caitmiers.com
@caitmiersphotography
p. 2, 6, 10, 70, 72, 74–80, 110, 111, 113–18, 120, 122–28, 130, 132–35, 137–39, 218, 220–24

CAMILLE ROBIOU DU PONT
www.camillerdp.com
@camillerdp
p. 100, 102–5, 107–9

NICOLE SWEET
www.nicolesweetphoto.com
@nicolesweetsports
p. 1, 170, 208, 210–12, 214, 215

CÉCILIA THIBIER
www.thibiercecilia.com
@ceciliaphotographie
p. 40, 42, 44, 45, 47, 48, 252, 254–56, 258

ABOUT THE AUTHOR

LARA EINZIG received her bachelor of business and marketing at Australia's Queensland University of Technology before launching a career in fashion marketing that took her to London for twelve years. After that, she founded a creative direction consultancy in Los Angeles. Lara is on a mission to bring equality in the water and to inspire women around the world to live a life of purpose. An avid surfer, Lara lives with her husband and three boys in Venice, California.

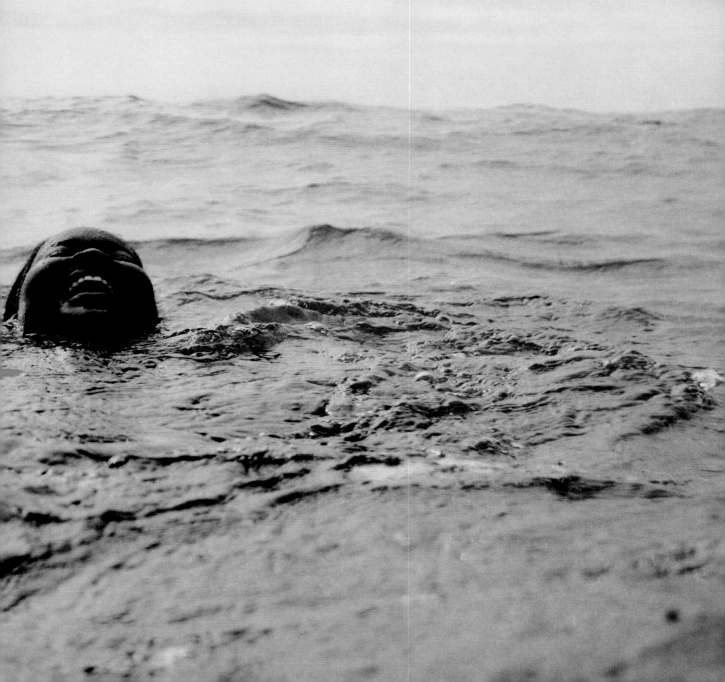

"*We are powerful, strong, and resilient. We get back up and break down barriers that don't serve us. If we fall, we will be there to pick each other up because this road does not have to be traveled alone. These times cannot destroy our joy or yearning to create and BE joy in this world.*"

—Natalie J. Greenhill, MD

Editor: Kelly Snowden | Production editors: Ashley
 Pierce and Leigh Saffold | Editorial assistant:
 Zoey Brandt
Designer/Art director: Emma Campion | Production
 designers: Mari Gill and Faith Hague
Typeface(s): Branding with Type's BW Beto, SilkType's
 Silk Serif, and The Northern Block Ltd.'s Corbert
Production and prepress color manager: Jane Chinn
Copyeditor: Amy Smith Bell | Proofreader: Hope Clark
Publicist: Jana Branson | Marketer: Brianne Sperber

10 9 8 7 6 5 4 3 2 1

First Edition

The remarkable women in this book have inspired me to rethink my purpose, as well as to sit in the discomfort of asking the important questions, ones that will create individual and system level change. What do I stand for? What am I willing to sacrifice? What kind of world do I want to leave my children? I retreat to the ocean time and again, believing the answers lie there, as I continue to reckon with its powerful and profound ability to keep us alive and to save us from our own destruction.

And so, I am honored to partner with the Surfrider Foundation for *Women Making Waves* and proud to be redirecting a percentage of sales to them. Founded in 1984 by a group of visionary surfers in Malibu, California, Surfrider is a nonprofit organization fiercely dedicated to the protection and enjoyment of our world's ocean, waves, and beaches for all people. Their sweeping mission is shared—directly or indirectly—by every woman I interviewed for this book, and I have deep admiration for the network of activists who work tirelessly to achieve it.

Please join me in making a donation, becoming a member, or volunteering. Help us fight the good fight to reduce plastic, protect our ocean and coastlines, preserve vital ecosystems, ensure our water is healthy and clean, and allow beach access for *everyone* along all coasts. Learn more at surfrider.org

While Surfrider's grassroots heritage and U.S. headquarters are in Southern California, Surfrider's network is a global community, with international affiliates making progress in Europe, Japan, Australia, Argentina, Morocco, and Senegal.

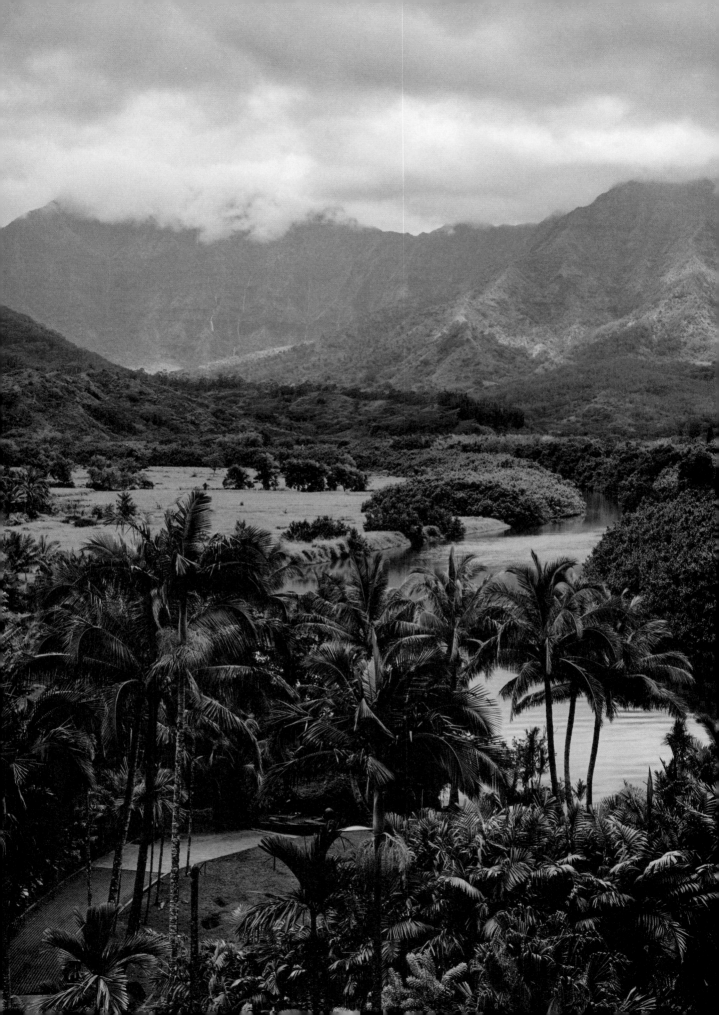